9/04

D0910670

Old Testament Figures in Art

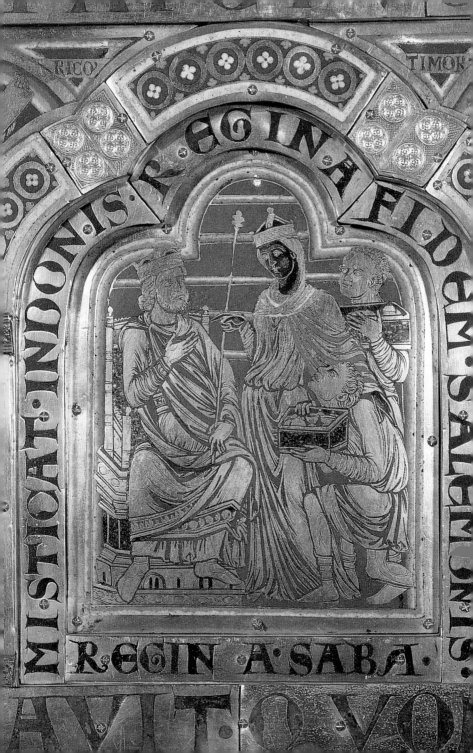

Chiara de Capoa

Old Testament
Figures in Art

St. Louis Community College
at Meramec
Library

Edited by Stefano Zuffi
Translated by Thomas Michael Hartmann

The J. Paul Getty Museum
Los Angeles

Italian edition © 2003 Mondadori Electa S.p.A., Milan.
All rights reserved.
www.electaweb.it

Original graphic design: Dario Tagliabue
Original layout: Donata Perticucci
Original editorial coordinator: Simona Oreglia
Original editing: Antonella Gallino
Original photo research: Daniela Balbo
Original technical coordinators: Paolo Verri,
 Andrea Panozzo

First published in the United States of America in 2003 by
Getty Publications
1200 Getty Center Drive, Suite 500
Los Angeles, California 90049-1682
www.getty.edu

English translation © 2003 The J. Paul Getty Trust

Christopher Hudson, *Publisher*
Mark Greenberg, *Editor in Chief*
Robin H. Ray, *Copy Editor*
Thomas Michael Hartmann, *Translator*
Hespenheide Design, *Designer and Typesetter*

Printed in Italy

Library of Congress Cataloging-in-Publication Data
De Capoa, Chiara.
 [Episodi e personaggi dell'Antico Testamento]
 Old Testament figures in art / Chiara de Capoa ; edited
by Stefano Zuffi ; translated by Thomas Michael
Hartmann.
 p. cm.
Includes indexes.
 ISBN 0-89236-745-8 (pbk.)
 1. Bible. O.T.—Illustrations. 2. Christian art and
symbolism. I. Zuffi, Stefano, 1961– II. Title.
 N8020.D4 2004
 755'.4—dc22
 2003016254

Page 2: Nicholas of Verdun, *Solomon Meets the Queen of Sheba*, 1181. Klosterneuburg, altar of the abbey church.

Right: Limbourg Brothers, *The Creation, the Temptation, and the Expulsion of Adam and Eve from Paradise*, 1410–16. Miniature from *Très riches heures du duc de Berry*. Chantilly, Musée Condé.

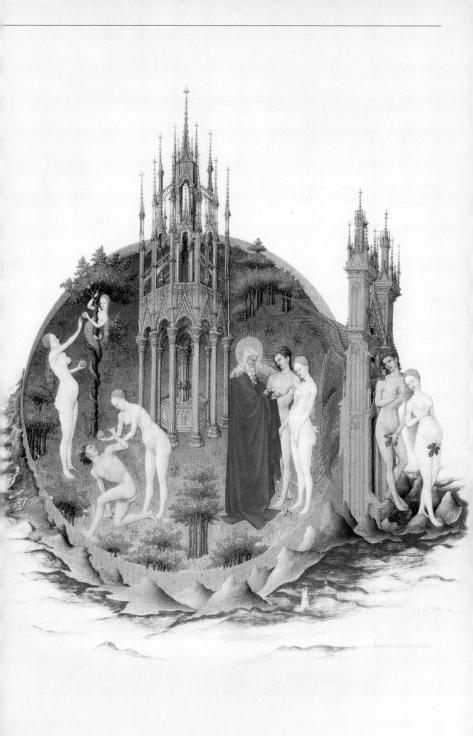

Contents

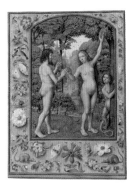

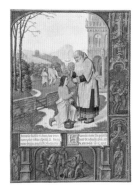

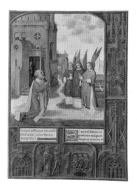

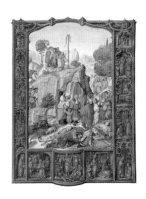

Introduction

The Old Testament, which was composed in Hebrew and Aramaic, became the written work of the Jewish people, whose religion generally proscribes the representation of God, humans, or any living being in its art. As a result of this prohibition, Hebrew art is essentially aniconic and thus devoid of any figurative representation.

Christian art, on the other hand, stood apart from the Hebrew tradition. Throughout the Middle Ages, the decoration of churches was promoted with the twofold objective of paying homage to God and providing didactic illustration of the Christian faith to a population that was predominantly illiterate.

The iconography of the Old Testament, therefore, is diffused almost exclusively by means of Christian sacred art. Representations of subjects such as Noah's Ark, Jacob Wrestling the Angel, and Susannah and the Elders surfaced during the paleo-christian era, and other subjects would assert themselves in the centuries that followed. One common feature of most of the Old Testament episodes that enjoyed popularity in art was their revival in the New Testament, where they were reread from a christological perspective. In fact, many Old Testament figures and episodes were interpreted, especially during medieval times, as prefigurations of Christ or salient moments of his life. The many characters in whom the Savior was recognized include Joseph; Moses, who was considered one of his direct prefigurations; David, who was Jesus' ancestor; and Jonah, whose adventure in the whale bears a certain affinity to Christ's death and resurrection. In the same way, episodes such as Passover, the Gathering of Manna, and the Passage of the Red Sea were seen as referring respectively to the Last Supper, the Eucharist, and baptism.

Within this rich panorama of references between the Old and New Testaments, and faced with such a wealth of available material, this volume will dwell upon a number of figures and episodes. Continuing in the spirit of the other volumes of this series, the Old Testament images selected are those that have occurred most often as icono-

graphic prototypes within Christian sacred art. The sequence of the books within the Bible has been respected as much as possible in structuring the text, beginning with those episodes taken from the Pentateuch, then the historical books, those of wisdom and poetry, and finally the prophetic books. Each figure or episode is accompanied by an accessible identification table and a summary of the biblical passage in which it was described.

To complement the many scriptural references, this volume also offers comparisons with other cultures whose legends or myths are analogous to the episode under study.

In addition to the thirty-nine books of the Jewish Scriptures that make up the canon of the Old Testament, the deuterocanonical books were also used as sources to analyze the episodes. These are the seven books called the Septuagint, which were added to the Hebrew canon in the Greek Bible (compiled about A.D. 150). For the most part, these books were adopted by the early Church. The choice of sources was dictated by the iconographic success of the episodes described here. For instance, the well-known story of Susanna and the Elders was narrated in a deuterocanonical addition to the biblical Book of Daniel.

The text here has been embellished with masterpieces of art that, as much as possible, have been laid out chronologically and diversified in kind in order to demonstrate the vast diffusion that the representations of Old Testament subjects experienced in Western art throughout the ages.

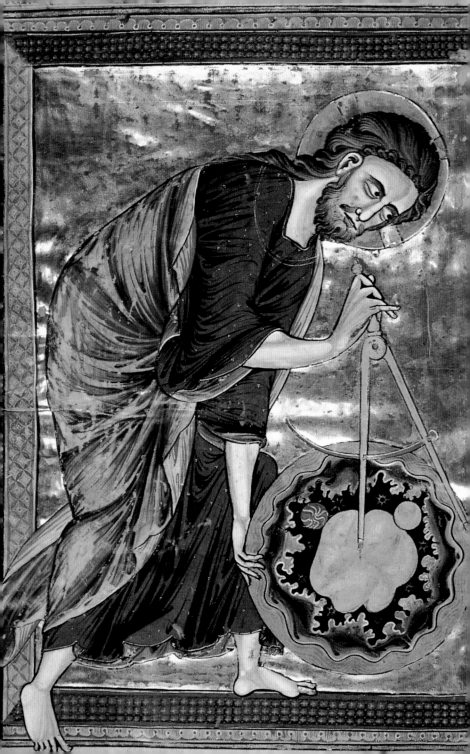

FROM THE CREATION TO THE TOWER OF BABEL

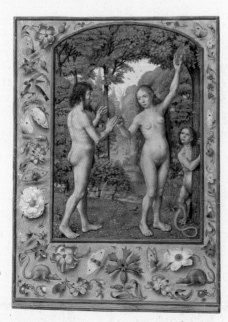

◄ *God the Creator*,
ca. 1220. Miniature from
a *Bible moralisée*.
Vienna, Österreichische
Nationalbibliothek.

► Bruges School illuminators,
The Fall of Man, late fifteenth
century. Miniature from the
Grimani Breviary. Venice,
Biblioteca Marciana.

The first display of God's work, the Creation, has been portrayed mainly in illuminated manuscripts and in the monumental art of the twelfth century.

The Creation

The Book of Genesis opens with a page of poetry: the tale of God's creative work that begins with the original void. The creation of the universe commences with the formation of the heavens and the earth and the separation of light from darkness, which God calls "day" and "night." The next day God the Father divides the waters above the firmament from those below, and on the third day, he separates the waters below from the submerged dry land. The Creator then sees fit to give life to every species of vegetation that reproduces and bears fruit. On the fourth day, in order to separate day from night, God decides to create great lights, the sun and moon, and in order to distinguish the seasons, he places stars in the sky. On the fifth day God decides to populate the waters and the skies with every sort of living creature and gives life to fish and birds, which he encourages to be

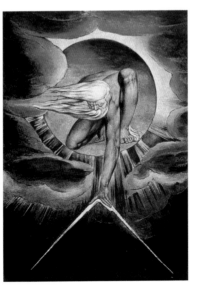

fruitful and multiply. The day after, God establishes that the earth will also bring forth living creatures of every kind and creates them. Lastly, to dominate all the creatures of the sea, sky, and land, God decides to create humankind. Having finished his creation, on the seventh day the Lord rests. God consecrates that day and blesses it, as a sign that his creative work is done.

◀ William Blake, *The Origin of the World*, 1824. Manchester, Whitworth Art Gallery.

The Place
The original void

The Time
The beginning of the world

The Figures
God

The Sources
Genesis 1:1–2:3

Variants
The creation of the universe. The various phases of creation can be joined in a single episode or developed into a number of scenes. To symbolize his work as Creator, God is often portrayed measuring the earth with a compass. In other examples he is shown simply as eyes, hands, and feet, shining the light of creation over the darkness of the void.

Diffusion of the Image
Quite widespread, especially in illuminated manuscripts, decorated door panels, and Gothic stained-glass windows

Surrounded by twelve angels belonging to the hierarchy of cherubim, God the Father points with his right hand toward the universe. Because of their wisdom, the cherubim are often linked to the mendicant order of Dominicans. This has led to the theory that this predella was made for a church of that order.

This episode, in which the angel (who, quite unusually, is shown nude) expels the first man and woman, is set in the Garden of Eden, where a number of symbolic plants flower. Carnations and strawberries are often depicted in paradise. The rose entwined around an orange tree indicates the state of innocence in the earthly paradise. The lily is a symbol of purity.

Seven trees with golden fruit form the background of this scene of the Expulsion from Paradise.

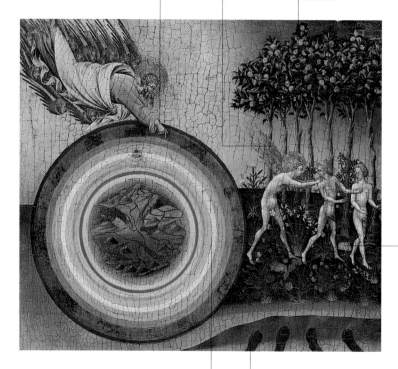

The spheres are not merely representative circles; they comprise the entire universe. From the central sphere of the earth, the universe progresses in a series of concentric spheres of different colors: the green sphere is for water, blue for air, red for fire, followed by a sphere for the seven planets, and a final one for the zodiac.

The four rivers of paradise—the Pishon, Gihon, Tigris, and Euphrates—are shown in the lower part of the composition.

▲ Giovanni di Paolo, *The Creation of the World and the Expulsion from Paradise*, 1445. New York, The Metropolitan Museum of Art, Robert Lehman Collection.

Two rabbits symbolize both lasciviousness and innocence.

The larger light represents the sun, which "governs the day."

The smaller light is the moon, which "governs the night."

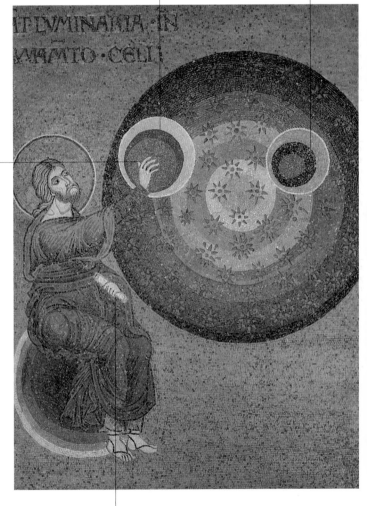

God commands, "Let there be lights in the dome of the sky to separate the day from the night; and let them be for signs and for seasons and for days and years, and let them be lights in the dome of the sky to give light upon the earth."

God the Father is depicted on the fourth day creating lights to indicate the various seasons. He holds the scroll of the Law in his hand. In addition to the two great lights of the sun and the moon, he sets the stars in the heavens.

▲ *The Creation of the Stars*, ca. 1174. Mosaic. Monreale (Sicily), cathedral.

In this twelfth-century miniature, the narrative unfolds over the seven days that correspond to the Christian liturgical week. Nevertheless, the illuminator was not particularly faithful to the biblical text, as seen in the depictions of the seventh and eighth days.

On the first day God, whose spirit is represented by a dove flying over the waters, creates light and separates it from darkness.

On the third day God gathers the waters below the heavenly vault, allowing the earth to emerge.

On the fifth day God generates the fish of the sea and the birds of the sky.

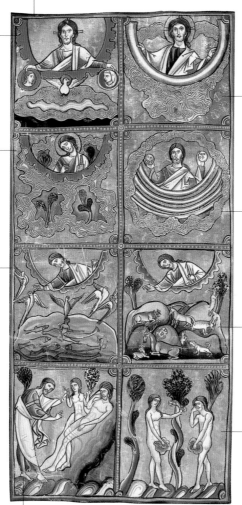

On the second day, God establishes the firmament amid the waters, dividing the waters below the dome from those above it.

On the fourth day God creates the lights of the firmament: the sun, the moon, and the stars.

On the sixth day God creates all types of living creatures that exist on the earth.

The Temptation is depicted on what corresponds to the eighth day. The panel shows the moment when Eve offers Adam the forbidden fruit, which the tempting serpent had given to her.

This panel of the miniature depicts the creation of Adam and Eve on the seventh day. In the Bible, however, it is written that God rested on that day.

▲ The Creation, late twelfth century. Miniature from the Bible de Souvigny. Moulins, Bibliothèque Municipale.

The Creation

At the very top of the left frame is a biblical citation from Psalm 33: "He spoke and it came to be" (Ipse dixit et facta su[n]t).

The Creator is shown with a crown and beard within a swath of clouds. The earthly globe takes center stage, while the figure of God appears in the background.

Plants grow on the earth; the animals have yet to appear. Distinct vegetable and mineral formations have been created.

▶ Hieronymus Bosch (Hieronymus van Aken), *The World on the Third Day of Creation*, 1503–4. Exterior panels of the *Garden of Earthly Delights* triptych. Madrid, Museo del Prado.

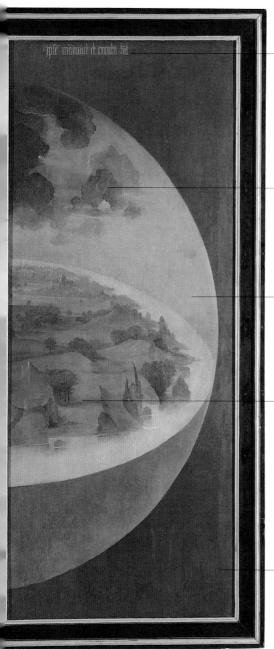

ipse ma[n]davit et creata su[n]t

At the top of the right frame is another citation from Psalm 33: "He commanded, and it stood firm" (Ipse ma[n]davit et creata su[n]t).

The composition's perspective is a "bird's-eye view."

The world is inserted within a crystal sphere, a symbol of the universe's fragility.

This work appears to be an early example of landscape painting as an end in itself.

This is a unique composition that portrays the world on the third day of Creation, when God gathers the waters below the heavenly vault so that the earth emerges. After separating the earth from the waters, he makes plants and flowers grow.

The Creation

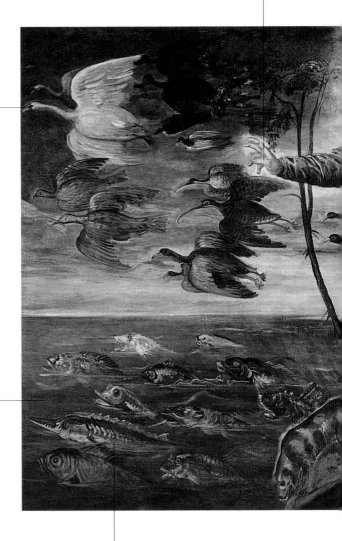

God the Father is shown on the fifth day, after creating the fish of the sea and the birds of the sky. He blesses them, saying, "Be fruitful and multiply and fill the waters in the seas, and let birds multiply on the earth."

The Creator creates "every winged bird," dividing them into their various species. Here they are shown darting through the sky.

God creates the great whales and "every living creature that moves" in the sea.

The animals' rapid movements aptly express the biblical passage "Let the waters bring forth swarms of living creatures, and let birds fly above the earth across the dome of the sky."

The land animals created on the sixth day run freely
behind the Eternal Father. On that day he says,
"Let the earth bring forth living creatures of every
kind: cattle and creeping things and wild animals of
the earth of every kind."

▲ Jacopo Tintoretto, *The Creation
of the Animals*, ca. 1550. Venice,
Gallerie dell'Accademia.

The myth of the Creation of Man took on new importance in Christian art, where, according to medieval tradition, Adam was seen as prefiguring Christ.

The Creation of Man

The Place
The original void

The Time
At the beginning of
the world on the
sixth day of Creation

The Figures
God, Adam, and
sometimes an angel

The Sources
Genesis 1:27, 2:4–7

Variants
The Creation of
Adam

**Diffusion of the
Image**
Vast, especially in
cycles of works
depicting the stories
of Genesis

▼ Mariotto Albertinelli, *The
Creation of Adam and Eve
and the Temptation*,
1513–15. Private collection.

It seems useful here to distinguish between two passages of the biblical text that narrate the Creation of Man. The first concerns the creation of humankind, the second the creation of the first man.

God completes the creation of humankind on the sixth day. This is described in the first chapter of the Book of Genesis, where it is written that God creates humankind in his image, in "male and female" form. The creation of the first man, however, is narrated in the second chapter of the same book. There it is told how God forms man from the dust of the ground and blows the "breath of life" into his nostrils so he becomes a living being. Man is generated in the image and likeness of God because he represents the height of creation.

Depictions of the Creation of Man are quite widespread in Christian art and generally show the figure of God the Father introducing his vital breath into Adam's nostrils. Sometimes, God infuses life into the first man by simply touching him with his hand. One variant shows the Lord placing alongside Adam a tiny winged figure, symbolizing the breath of life.

After forming Adam out of the dust of the earth, God the Father is shown imparting life to him by means of a ray of light, which originates from his mouth.

On the sixth day God creates beasts and cattle of every kind, which are typically more intelligent than fish and winged creatures. These animals seem to be gazing toward the Creator.

After creating the animals, God says, "Let us make humankind in our image, according to our likeness; and let them have dominion over the fish of the sea, and over the birds of the air, and over the cattle, and over all the wild animals of the earth, and over every creeping thing that creeps upon the earth."

The body of man, whose skin color suggests his clay origins, receives life thanks to the divine spirit. The ray that connects the faces of God and Adam also expresses a likeness that, based on the biblical words, links the first man and his Creator.

▲ *The Creation of Adam,* ca. 1174. Mosaic. Monreale (Sicily), cathedral.

The Creation of Man

The figure of Adam, partly reclining on the ground and waiting to be invested with the divine spirit, sums up the vicissitudes of every human being.

This is the culminating moment of Creation, the starting point of human history.

The compositional and symbolic center of this scene is the meeting point between the two fingers. God's is strong and energetic, while Adam's is still inert.

Adam has a trusting, adolescent face. He waits for the Creator to infuse him with life. Without it, his body lacks strength.

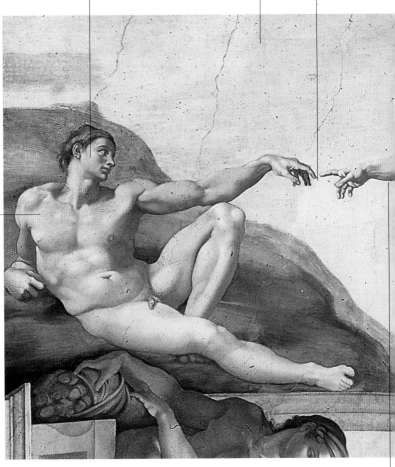

In a gesture charged with extraordinary energy, God the Father infuses Adam with life.

The Creator's gaze is calm and concentrated on the movement of his right arm. He stretches out to reach Adam's finger. The lines of his face are perfectly refined, emphasizing his stern expression. Thick hair and a long beard infuse the entire figure with dynamism.

As God advances toward Adam, he floats within an immense crimson cloak. A number of angels are also gathered inside it.

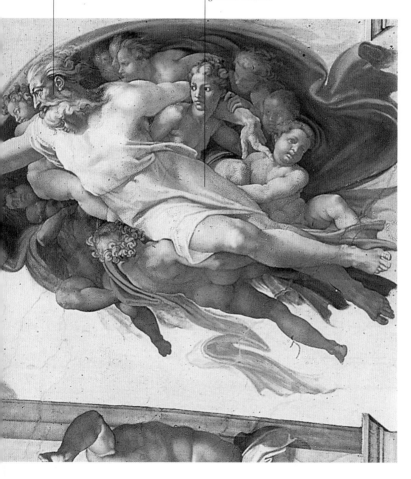

▲ Michelangelo Buonarroti, *The Creation of Adam*, 1508–12. Vatican City, ceiling of the Sistine Chapel.

The Creation of Man

An angel, with arms crossed
over his chest, waits behind
the Lord during the creation
of the first man.

God the Father, presented in profile with a
beard and long hair that falls over his shoulders,
holds a staff in his left hand and gives life to
Adam's body with his right.

The first man is called Adam, which
derives from the Hebrew adam, indicating
that he is linked to the earth (adamah).
Man, in fact, is closely connected to
matter. However, thanks to the infusion
of the breath of life, he gains conscious-
ness. The name "Adam," therefore, is
meant to indicate all humanity.

▲ Lorenzo Maitani, *The Creation of
Adam*, ca. 1320. Facade relief. Orvieto,
cathedral.

Completely naked to recall his material origins, Adam takes the small winged figure in his arms.

God the Father is portrayed with a cruciform nimbus—a typical attribute of Christ—and a scepter, a symbol of authority. He infuses man with the breath of life.

The soul is represented here as a tiny winged being that God gives to man, a figure that can also be found in the Egyptian figurative tradition. This episode is based on the words of the biblical text "[He] breathed into his nostrils the breath of life; and the man became a living being."

▲ *The Creation of Adam*, ca. 1215–25. Mosaic. Venice, San Marco.

In Christian art, the representation of the Creation of Woman from man's rib takes its origins straight from the biblical text.

The Creation of Woman

The Place
The earthly paradise

The Time
After the Creation
of Man

The Figures
God, Adam, and Eve

The Sources
Genesis 2:21–25

Variants
The Creation of Eve.
In depictions of the
Creation of Woman,
God removes a rib
from Adam as he
sleeps in order to
create Eve. Never-
theless, the woman
is often represented
receiving life next to
the sleeping Adam.
More rarely, she
appears standing
before God with her
hands clasped.

**Diffusion of
the Image**
Vast, especially in
cycles portraying
the stories of
Genesis

▶ Donatello, *The Creation
of Eve*, 1405–7. Sculpture
in glazed terra-cotta.
Florence, Museo dell'Opera
del Duomo.

In the first chapter of the Book of Genesis, which describes God's Creation of Man, the text specifies "male and female he created them." God blesses them and orders them to be fruitful and to dominate every species of vegetation and all living beings of the sea, earth, and sky.

In the second chapter, after having created man and the animals, God creates a new human creature that is gifted with dignity: woman. He makes her out of the same material from which man is made.

To do so, God causes Adam to fall into a deep sleep and removes one of his ribs. From it, he makes Eve. He leads her to Adam, who recognizes her as "bone of my bones and flesh of my flesh." He decides that she will be called "Woman *(isshah)*, because she was taken out of Man *(ish)*." For this reason, a man leaves his parents and joins his wife. At this point, before the Temptation, Adam and Eve are naked, but they do not feel ashamed.

The diffusion of this subject in art was very widespread, especially in illuminated manuscripts, door-panel sculptures, and Gothic stained-glass windows.

Two musician angels adorn the upper part of the panel, which has an embossed gold background.

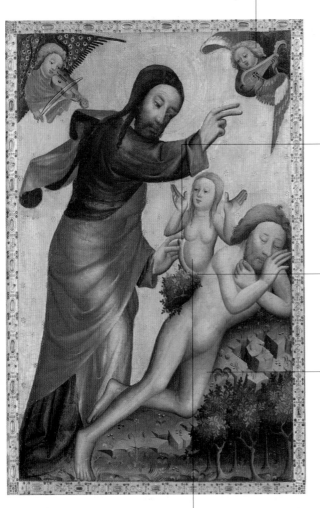

In his commentary regarding the birth of Eve from Adam's rib, St. Anselm of Aosta writes, "Not from his foot as a servant, not from his head as a mistress, but from his side as a companion."

This image of the Creation of Eve by Bertram von Minden was inspired directly by the biblical passage that narrates how God created Eve from Adam's rib.

Adam is portrayed after God has caused him to fall into a deep sleep. The absolute uniqueness of woman is celebrated in the love song that is one of the Bible's most poetic passages, in which Adam praises Eve as "bone of my bones and flesh of my flesh."

▲ Bertram von Minden, *The Creation of Eve*, 1379–83. Panel from the Altar of St. Peter. Hamburg, Kunsthalle.

The tiny figure of Eve, who is born from Adam's rib, extends her open hands toward the Creator. The Hebrew name "Eve" contains a reference to the word "living" (hawwah). Adam calls his wife "Eve" since she is mother of all living things. The proper names of characters in the Bible are, in fact, often linked to their personal characteristics.

The Creation of Woman

This scene is set in a rural landscape populated by numerous animals.

God the Father, recognizable by his long, flowing beard and aged appearance, impresses the spirit of life on Eve's nude body by making a sign on her forehead.

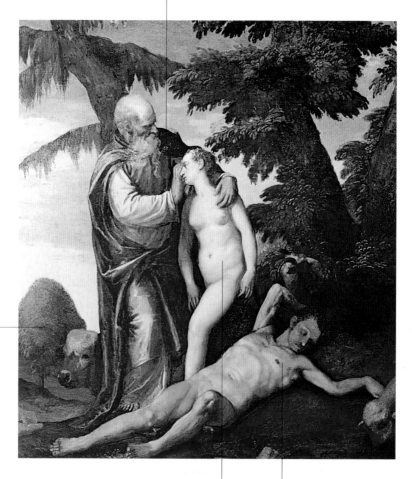

Eve is standing naked. The nudity of Adam and Eve emphasizes their humanity. Before their sin, these two progenitors accept their nakedness peacefully, as they do their humanity. After their sin, the clothes that they put on represent an attempt to recover their lost dignity.

Adam lies in deep sleep, naked before the viewer.

▲ Paolo Veronese, *The Creation of Eve*, ca. 1570. Chicago, Art Institute.

Generally speaking, the tree is a symbol of life. The tree of life is the most ancient of symbols, traditionally signifying immortality, while the tree of the knowledge of good and evil is a symbol of moral decision.

Eve is portrayed with long hair that falls down her back. She reaches her arms toward the Creator.

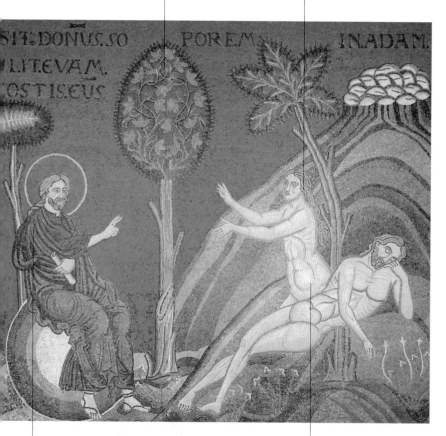

God the Father, the scroll of the Law in hand, brings Eve forth from Adam's sleeping body.

The creation of woman represents the second attempt to overcome man's solitude. After the creation of animals, he is still unhappy. The woman's presence erases his anxiety and loneliness, since she represents a "helper fit for him."

The Creation of Eve, ca. 1174.
Mosaic. Monreale (Sicily),
Cathedral.

In Christian art, the earthly paradise has four rivers running through it. It is often shown behind a wall. Originally, gardens were enclosed spaces reserved for repose.

Adam and Eve in the Garden of Eden

The Place
The earthly paradise

The Time
After the Creation
of Man

The Figures
God, Adam, Eve,
and often animals

The Sources
Genesis 2:8–16

Variants
Eden, or the earthly
paradise. The representation of nature
varies notably
according to where
the work of art originated: northern
European painting
features mainly
forests with flourishing vegetation, while
works from southern
regions more commonly show the garden as a desert oasis.

**Diffusion of
the Image**
Widespread, especially in northern
European painting
from the seventeenth
century

After finishing the creation of man, God begins a luxurious garden in Eden. The word "Eden" is Sumerian in origin and means both a flat, steppe-like region, in which a garden would be an oasis, and a fertile spot with abundant trees.

The garden (*gan* in Hebrew) lay in the East, on land that was irrigated and cultivated. The Hebrew term was translated in the ancient Greek version of the Bible with the word *paradeisos*, originally a Persian word, from which the expression "earthly paradise" derived.

The garden, which was located in Eden, represents the ordered and peaceful world that God created for man to cultivate and keep. Nevertheless, the first man and woman are

expelled from the garden because of their sin. Every species of plant and animal lives there. In the biblical source, paradise is not described as a precise location, but it is a valuable image and serves to represent a world in which man is in harmony with nature.

A number of scholars, however, in an attempt to identify an existing geographical area that matches the scriptural information, have placed the Garden of Eden near the Persian Gulf.

At the center of the composition is the fountain of life, a Gothic monument to judge from its distinctive shape.

The palm tree with the serpent coiled around it has been identified as the tree of the knowledge of good and evil.

The cactus behind Adam must symbolize the tree of life.

In this panel, Bosch presents a distinctive iconography that is rich in detail. Adam is already alert, and God is introducing Eve to him.

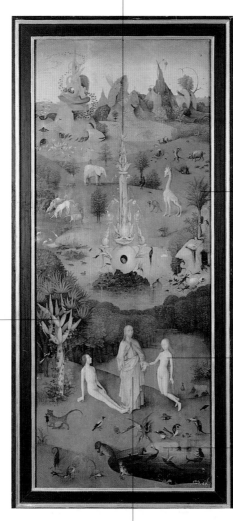

Certain elements in this paradise point to the imminent arrival of sin: a number of rare plants and animals have begun to devour each other.

▲ Hieronymus Bosch (Hieronymus van Aken), *The Garden of Eden*, 1503–4. Left panel of the *Garden of Earthly Delights* triptych. Madrid, Museo del Prado.

◄ Jan Brueghel the Elder, *The Garden of Eden*, ca. 1610. Madrid, Museo del Prado.

The image of the Creator, who is portrayed here as Christ, is linked to an ancient tradition according to which God created the world through his Word.

Adam and Eve in the Garden of Eden

Adam is often shown giving names to the animals, following God the Father's order. Name-giving in the ancient Near East was an act of special importance, strongly associated with wisdom. Indeed, "knowledge" means knowing the names of things, in order to understand their role and their place in the cosmic order.

Scholars have identified this landscape as being near Bassano, between the convent of San Francesco and the Lazzaretto area.

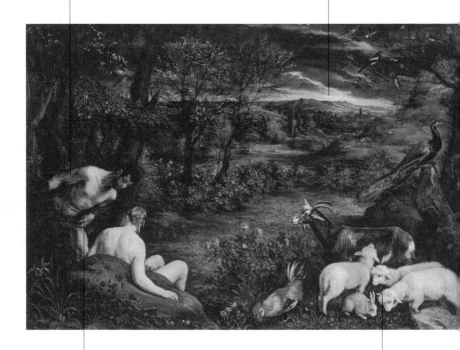

Adam is covered only by a few leaves. Eve sits next to him with her back turned toward the viewer. The moment depicted is just before the Temptation.

Among the animals depicted in the right part of the composition are a rabbit, a chicken, some sheep, a ram, a peacock, and numerous birds in flight.

▲ Jacopo Bassano, *Adam and Eve in the Garden*, ca. 1570–75. Rome, Galleria Doria-Pamphili.

The Garden of Eden represents a sort of "ultimate goal," an ideal that humanity strives to restore.

God the Father is shown departing into the clouds after placing Adam and Eve in the earthly paradise.

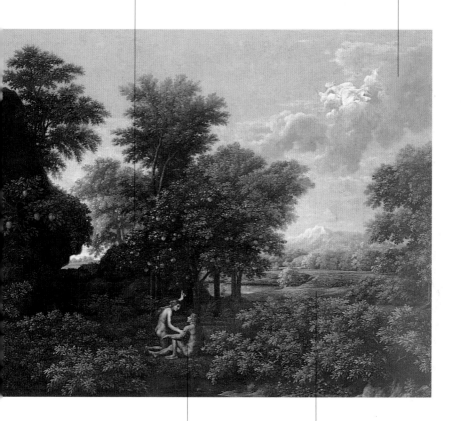

Adam sits on the ground while Eve kneels and points to the tree of the knowledge of good and evil. She invites him to pick the forbidden fruit there. Adam's bronze body contrasts with his partner's fairness.

In this panel the biblical episode becomes an opportunity to depict a landscape dense with spring vegetation. It is an enchanted garden that has yet to be contaminated.

▲ Nicolas Poussin, *Spring (Adam and Eve in the Garden of Eden)*, 1660–64. Paris, Musée du Louvre.

The tree of knowledge is shown as either an apple or fig tree with the serpent coiled around it. Sometimes the serpent is on the ground, where God the Father condemns it to crawl.

The Temptation

The Place
The earthly paradise

The Time
After the Creation of Woman, and after Adam and Eve arrive in the Garden of Eden

The Figures
Adam, Eve, the serpent, and frequently other animals

The Sources
Genesis 2:16–17, 3:1–7

Variants
Original sin

Diffusion of the Image
Extremely vast, whether in cycles portraying the stories of Genesis or as an isolated subject

After placing Adam in the earthly paradise, God gives the first man a single warning: "You may freely eat of every tree of the garden; but of the tree of the knowledge of good and evil you shall not eat, for in the day that you eat of it you shall die."

Despite God's order to not eat from the tree of the knowledge of good and evil, Eve succumbs to the serpent's temptation. The shrewd creature draws her in by promising that she and Adam will, like God, know good from evil. Eve eats the forbidden fruit and then gives it to Adam. In that moment their eyes are opened. They become aware of their nakedness, they experience shame, and they cover themselves with fig leaves.

Typically Adam and Eve are portrayed standing near the tree of the knowledge of good and evil. Eve picks the fruit, takes a bite, or offers it to Adam.

Based on a theme that is popular in many cultures (including the Canaanite cult), the woman is transformed from a companion into a temptress.

◄ Peter Paul Rubens, *Adam and Eve* (detail), 1628. Madrid, Museo del Prado.

The parrot is a symbol of wisdom and praise for the Creator.

A mountain goat leans over a cliff. It symbolizes the eye of God, which sees everything from on high.

Adam raises a branch of an ash tree, which symbolizes the tree of life. His other hand is held out to Eve, who is about to hand him the apple that the serpent holds in its mouth. For the first man's body, Dürer was inspired by a reproduction of the Apollo Belvedere.

The elk is characterized by black bile, which, if it increases to excess, leads to madness. This animal expresses the melancholic temperament.

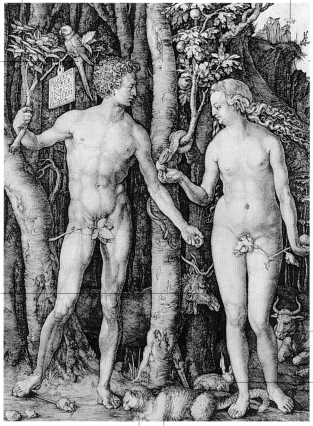

Because of its calm demeanor, the ox represents the phlegmatic disposition.

The rabbit symbolizes the sanguine, sensual temperament, since it is a happy, lucky creature and a lover of life's pleasures.

The cat signifies the choleric temperament, dominated by yellow bile.

The presence of four principal animals (the rabbit, cat, ox, and elk) serves to portray the doctrine of the four humors and the rupture of equilibrium that took place on account of original sin.

▲ Albrecht Dürer, *Adam and Eve*, 1504. Engraving.

The Temptation

The serpent, seen here with an animal's face, holds the apple in his mouth. The choice of the serpent as the animal that tempts man derives from the fact that in ancient Eastern civilizations it was the symbol of immortality and fertility. It also evoked the idolatrous cults of the Canaanites, the indigenous people of the Holy Land.

God's command not to eat from the tree signifies that only he may decide what is good and what is evil. In original sin, man attempts to become a moral arbiter. In doing so, he runs counter to the divine plan, which reserves this task exclusively for God.

The moment represented here is immediately before the original sin, when Eve, having taken the fruit offered her by the serpent, hands it to Adam. She is leaning on the tree of the knowledge of good and evil. The only covering on the young woman's body is a leafy twig.

► Jacopo Tintoretto, *The Temptation*, ca. 1550. Venice, Gallerie dell'Accademia.

*This detail renders the moment after the original sin: the
expulsion of Adam and Eve from paradise, which is carried
out by a fiery angel. Naked and running, Adam and Eve head
for dark, unexplored territory.*

The Temptation

The tree of the knowledge of good and evil is not one listed in botanical treatises. It symbolically represents moral choices over which only God has power. God alone decides what is good and what is evil. In this case, the tree of knowledge is an apple tree, around which the serpent coils, facing Eve.

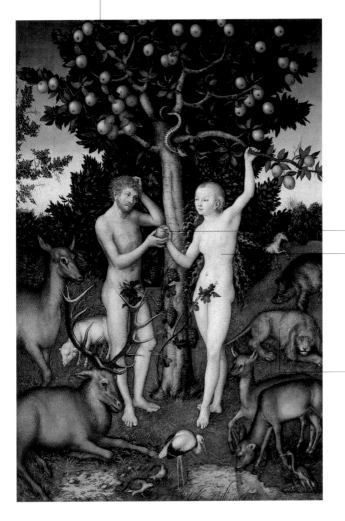

Adam and Eve are standing in front of the tree of the knowledge of good and evil. After picking the fruit, Eve hands it to Adam. The two progenitors are naked, covered only by some leaves that are growing around the trunk of the tree.

Before their original sin, Adam and Eve were naked and peaceful, a sign of their status as created beings. The clothes with which they cover themselves afterward represent an attempt to recover their lost dignity.

Numerous animals, depicted here with great naturalistic detail, populate the Garden of Eden, where this scene takes place: a horse; a pig, the symbol of lust; a lion, which contrasts with the lamb at the other side of the composition; a fawn; and a stag, among others.

▲ Lucas Cranach the Elder, *Adam and Eve*, 1526. London, Courtauld Institute Galleries.

▶ Hugo van der Goes, *The Fall of Adam*, 1470. Vienna, Kunsthistorisches Museum.

Adam covers his nudity awkwardly with one hand while he waits for Eve to give him the apple with the other. His face, with its serious expression, seems to illustrate the painter's intense religiosity.

Eve, who also moves somewhat awkwardly, holds an apple in her right hand. With her other hand, she gathers more of the forbidden fruit to give to Adam.

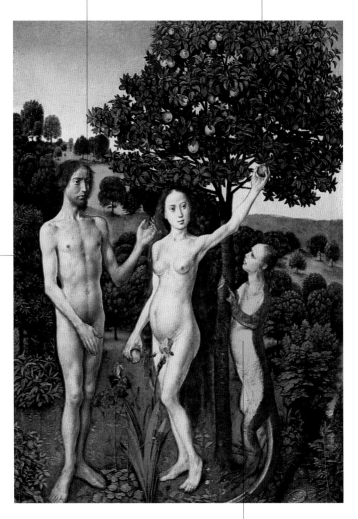

The consequences of original sin fall on all three of the main characters in this biblical episode: the serpent is condemned to crawl on the ground and to eat dust for all time; Eve is to experience the pains of childbirth and to be subject to Adam, who is fated to work hard for the rest of his life.

The serpent is shown here as a sort of lizard with four legs and a woman's face, clinging to the trunk of the tree. As biblical interpretation developed over time, the figure of the serpent came to be identified with Satan. It is called "shrewd" or wise, since it offers an alternative vision of the world and God. In the East, the serpent was a sexual symbol.

Depictions of the expulsion from the earthly paradise show Adam and Eve with sad and desperate faces, covering their nakedness with their hands or leaves.

The Expulsion from Paradise

The Place
The earthly paradise

The Time
After the original sin

The Figures
An angel, Adam, and Eve

The Sources
Genesis 3:8–24

Variants
The preceding scene of Adam and Eve's reproach and the following scene of Adam at work are often linked with this episode.

Diffusion of the Image
Quite widespread, whether in cycles depicting the stories of Genesis or as an isolated subject

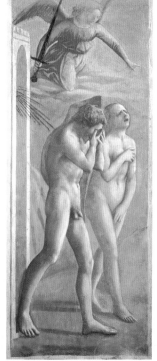

▶ Masaccio, *The Expulsion of Adam and Eve from the Garden of Eden*, 1424–25. Florence, Santa Maria del Carmine, Brancacci Chapel.

After having committed the original sin by eating the forbidden fruit, Adam and Eve hear God arriving and hide among the trees. The Lord calls to them and, realizing that they have eaten the forbidden fruit, asks Adam to explain. The first man blames Eve, who in turn justifies herself by explaining that the serpent tricked her. God then condemns the serpent to crawl upon the ground, the woman to suffer the pains of childbirth and to be subjugated to the man, and the latter to work for all time. Dressing them in animal skins, God expels them from the earthly paradise so they will not also eat from the tree of life, which would give them immortality.

To defend the tree of life, he places cherubim and a dazzling sword in front of the Garden of Eden. An angel brandishing a sword is shown expelling the two progenitors from the gate of paradise.

In episodes that follow the Expulsion from Paradise, Adam works the earth while Eve helps him or holds a spindle. Sometimes their two children, Cain and Abel, play near Eve. In some cases the figure of Death appears, indicating their loss of immortality.

The tree of knowledge depicted by Domenichino, like the one on the Sistine Chapel ceiling, is a fig tree. Ancient Jewish traditions, found in the Life of Adam and Eve, determined the choice of species.

A clear reference to the figure that Michelangelo frescoed on the vault of the Sistine Chapel, God the Father is shown in flight within a wide cloak held up by five cherubs. The Creator accuses Adam of having eaten the fruit of the tree of knowledge.

Based on a passage in Jeremiah (5:8), the horse symbolizes the beginning of lust.

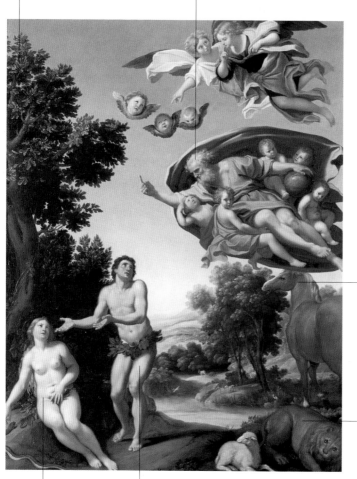

The lion lies beside the lamb, illustrating the possibility of peaceful coexistence between the two animals, as put forward in Isaiah (11:6–8).

Eve, in turn, does the same to the tempting serpent shown beside her.

Adam lays the blame on Eve for eating the forbidden fruit.

▲ Domenichino, *The Reproach of Adam and Eve*, 1623–25. Grenoble, Musée de Grenoble.

The Expulsion from Paradise

Brandishing a long sword, an angel expels Adam and Eve from paradise. Its varicolored wings exalt the idea of divine majesty and of God's great power.

Numerous plants are depicted in paradise, among them the tree of life. In the ancient Eastern world, the fruit of this tree could bestow immortality.

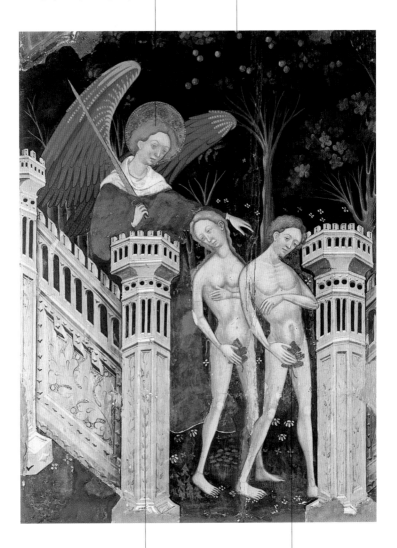

▲ Ramón de Mur, *The Expulsion of Adam and Eve from the Garden of Eden*, 1402–12. Detail from the retable of Guimerá. Vich, Spain, Museo Episcopal.

The gate and walls show that paradise was located within an enclosed space.

Adam and Eve, their faces marked with sorrow, are shown naked. They cover themselves with fig leaves.

Death, a consequence of original sin, helps Adam with his work. This figure, which has been introduced into the life of man, will not abandon him until the day of the Last Judgment.

After original sin, Adam is condemned to toil on the earth. The first man is shown working the soil with a staff.

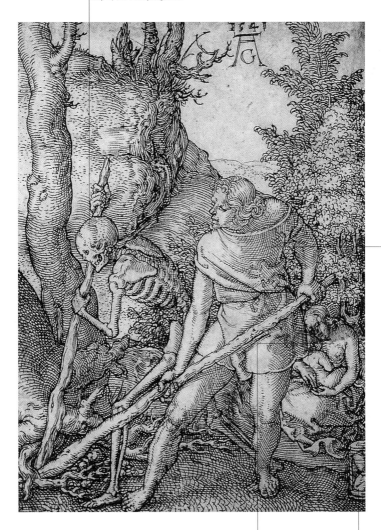

▲ Heinrich Aldegrever, *Adam and Eve Working Together with Death*, 1541. Engraving.

Eve is portrayed breastfeeding one of her two sons.

The hourglass symbolizes the inexorable flow of time.

The Expulsion from Paradise

God the Father accompanies the two progenitors beyond the gate of paradise. Before casting them out, the Creator clothes Adam and Eve in animal skins and gives them a spindle and a hoe, the tools with which they are to work.

The gate of paradise symbolizes the radical passage from the good, now lost, that mankind experienced within the garden into the suffering that awaits it outside.

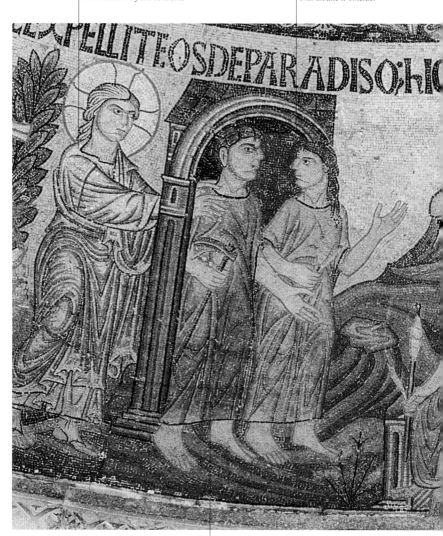

In the East, it was the father who made clothing for the family, as a sign of protection and dignity. For his creations Adam and Eve, God behaves like a father who seeks to defend and confer dignity upon his children.

Eve is shown seated on a sort of throne, holding a spindle and gazing at Adam, to whom she is now subject.

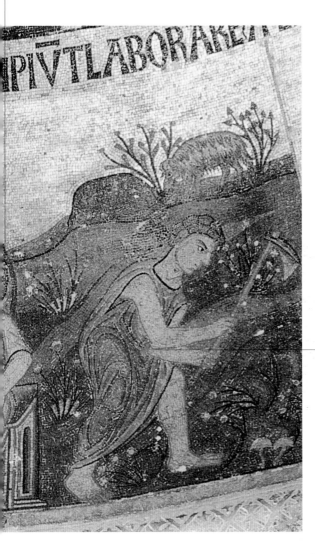

PIVTLABORAREI

Adam's work is hard and painful because of the sin that he committed. Work has its dignity, and it is the destiny that God allotted to man.

▲ *The Expulsion and Work of Adam and Eve*, 1215–25. Mosaic. Venice, San Marco.

The Expulsion from Paradise

The fall of the rebellious angels, who are represented as large insects, is depicted here. According to an extra-biblical tradition, a battle between the good and bad angels had in fact already occurred when the world was created, at the moment when light was separated from darkness.

God the Father, wearing priestly vestments, creates Eve from Adam's rib.

Adam and Eve eat the forbidden fruit that the serpent, shown here with a female face, has offered to the woman.

The gate of paradise appears as a stone arch.

The angel is shown brandishing a sword to cast out Adam and Eve.

◄ Hieronymus Bosch (Hieronymus van Aken), *Original Sin*, ca. 1504. Left panel of *The Haywain* triptych. Madrid, Museo del Prado.

► Antonio Canova, *Adam and Eve Mourn for Abel*, 1818. Study in terra-cotta. Possagno, Gipsoteca Canoviana.

The conflict between the just and the wicked is represented through Cain and Abel. It is no accident that Christian tradition associated Abel with Christ and Cain with Judas.

The history of man opens with the story of Cain and Abel.

Cain and Abel

After Adam and Eve ate the forbidden fruit, humankind is free to decide what is good and what is evil. From this point on, violence spreads, and the murder of Abel by his brother's hand becomes a symbol of the blood spilled by humanity.

Two sons are born from the union of Adam and Eve: Cain, who embodies the figure of the sedentary farmer, and Abel, the more fragile of the two, who represents the nomadic shepherd. Each offers a sacrifice to God based on his own activity. Cain offers a sheaf of wheat, Abel the best lamb from his flock. The Creator accepts Abel's offering, but he rejects Cain's. The latter then becomes enraged, and, despite the Lord's warning to avoid sin, he takes his brother out into the fields and kills him. When questioned by God, Cain lies, saying that he knows nothing of his brother's whereabouts. But the spilled blood cries out to the Lord, who condemns Cain to wander for eternity. Realizing his guilt, Cain repents and fears being slain himself.

The Place
In the fields

The Time
When Cain and Abel become adults

The Figures
Cain and Abel; Adam and Eve, who mourn the death of Abel

The Sources
Genesis 4:1–15

Variants
Cain's and Abel's sacrifices are sometimes shown before Abel's death. After the second-born son is murdered, the following scenes can appear: Adam and Eve crying over Abel's death; Cain wandering; and Lamech killing Cain after he mistakes him for a wild animal.

Diffusion of Image
Fairly widespread in works by artistic schools and in a variety of periods

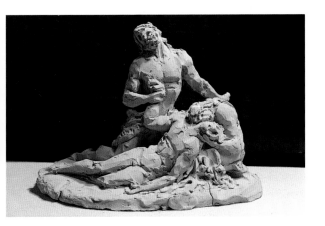

Cain and Abel

Abel represents the nomadic shepherd who offers the Lord the best lamb from his flock.

The tree with rich, verdant branches illustrates Abel's righteousness.

The sacrificial lamb can also be seen as a symbol of the mystical Lamb of God.

The chestnut in its husk points to the Resurrection and humanity's salvation.

The goldfinch is a symbol of the Passion of Christ, which is prefigured in the Old Testament with Abel's murder.

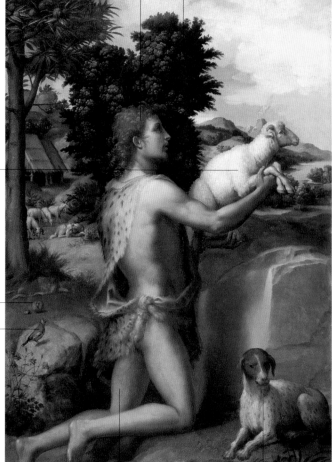

▲ Giovanni Antonio di Francesco Sogliani, *The Sacrifice of Abel*, ca. 1533. From a cycle of paintings in the Cathedral Tribune. Pisa, cathedral.

Abel is often compared with the Good Shepherd.

Besides herding flocks, the dog is also a symbol of fidelity, which here can be taken to mean faith in God.

The withered tree behind Cain is there to illustrate his wickedness.

Cain embodies the figure of a sedentary farmer and offers God a sheaf of grain.

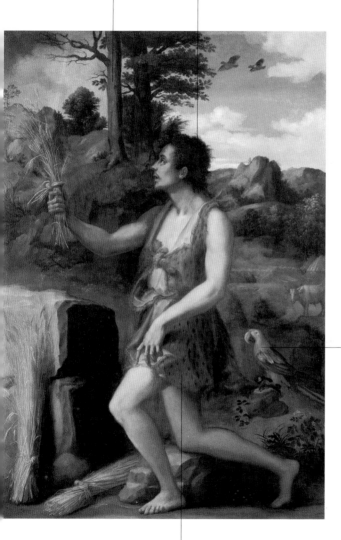

The parrot in the foreground symbolizes the sin that Cain commits in murdering his brother.

▲ Giovanni Antonio di Francesco Sogliani, *The Sacrifice of Cain*, ca. 1533. From a cycle of paintings in the Cathedral Tribune. Pisa, cathedral.

Like his brother, Cain is dressed in animal skins.

Cain and Abel

Here Cain appears to strike his brother with a club. Typically artists portray Cain with a number of attributes, including the club and a jawbone of an ass, an object also used by Samson to slay the Philistines.

This bloody scene has been rendered from below, with greatly exaggerated perspective, producing a highly illusionistic effect.

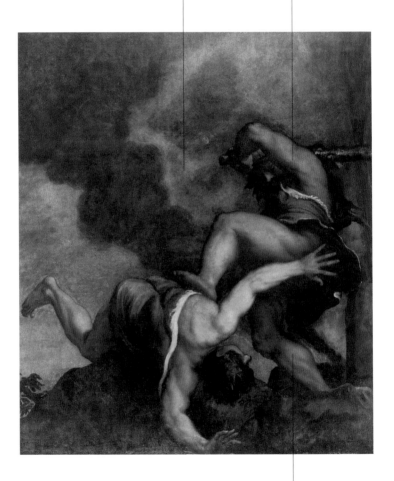

▲ Titian, *Cain Kills Abel*, 1542–44. Venice, Santa Maria della Salute, sacristy.

Despite the crime he committed, human civilization begins with Cain: he is the forefather of the race whose members originated many arts and trades.

After murdering his brother, Cain realizes the sin he has committed and repents. The gesture of tearing his hair shows his dismay at the brutality of his act.

In a sky darkened by clouds, an enormous red sun appears, rising just above the horizon.

Already elderly, Adam opens his arms and looks at Cain with desperation and disgust.

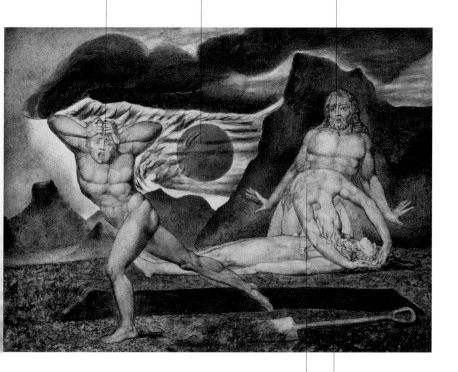

Eve stretches over the body of her dead son, her arms arched as a sign of protection.

The shovel in the fore-ground can take multiple meanings: it can represent the work of Adam and Eve, or the tool with which Cain attempted to hide the body of his slain brother.

▲ William Blake, *The Body of Abel Found by Adam and Eve*, ca. 1826. London, Tate Gallery.

Cain and Abel

Cain is trying to escape. From heaven, God places a sign on his head so that no one will kill him. In this manner, he prevents a bloody vendetta from spreading. The hunter Lamech later mistakes Cain for a wild animal and kills him.

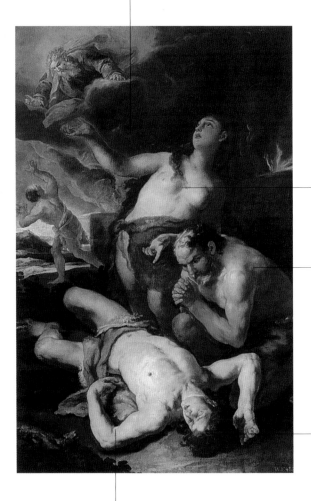

Dressed in animal skins, Eve turns her desperate gaze toward God the Father, almost as if she seeks an explanation for this ruthless crime.

With his hands clasped and an expression rich with pathos, the sorrowful old Adam regards the body of his slain son.

The fatal wound can be seen clearly on Abel's forehead.

Abel is shown in the foreground with his wounded face toward the viewer, as he lies lifeless on the ground. The depiction of this subject seems to allude to Christ's sacrificial death.

▲ Johann Michael Rottmayr, *Lament for Abel*, 1692. Vienna, Österreichische Galerie, Lower Belvedere.

The archangel Michael denies Seth the oil of mercy, but in exchange he gives him some seeds from the tree of sin to place in the mouth of Adam, who dies three days later. A great tree grows from the seeds placed under the patriarch's tongue. It lives until the time of Solomon, when it is felled by order of the king. The wood from this tree is used first to build a bridge that the Queen of Sheba admires when she visits Solomon and then for Christ's cross.

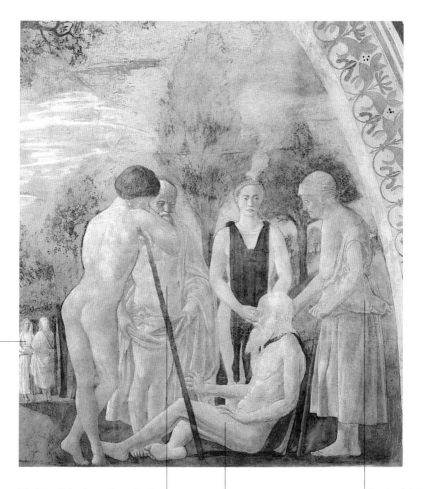

Adam's son Seth, who was born after Cain and Abel, is shown with gray hair, listening attentively to his father's last words.

Adam, who is near death, is presented in profile, seated on the ground. The first man asks his son Seth to go to the angel at the gate of the earthly paradise to request the oil of mercy.

Standing behind her husband, Eve supports his head.

▲ Piero della Francesca, *The Death of Adam*, ca. 1452. From the *Stories of the True Cross* cycle. Arezzo, San Francesco.

In this episode, which has been depicted ever since the beginnings of Christian art, the sons of Noah are shown cutting wood for the ark. Noah oversees its construction.

Noah's Ark

The Place
On the earth

The Time
Before the Flood

The Figures
Noah and his sons, Shem, Ham, and Japheth. Sometimes the wives of Noah's sons also appear.

The Sources
Genesis 6:14–22

Variants
The episode of building the ark is often associated with the scene that follows it: the loading of the animals into the ark.

Diffusion of the Image
The ark has been an extremely popular subject in Christian art ever since its depiction in the Roman catacombs. Eventually it spread to medieval and Renaissance art.

▶ Jacopo Bassano, *The Sacrifice of Noah*, 1574. Potsdam, Sanssouci, Castle Collection.

Observing the wickedness of mankind and the corruption of the earth, God regrets creating them and decides to destroy the entire human race and all the animals. The only person he wishes to save is Noah, a just and upright man who follows God's dictates. Turning to Noah, God orders him to gather resinous wood and to build a great three-tiered ark, complete with a door and a roof, sealed with pitch. He tells Noah that those who are to enter are Noah himself, his wife, his sons, and their respective wives, together with seven pairs of each clean-living being and one pair of each unclean being. God plans to make it rain on earth for forty days and forty nights, eliminating everything that he had created from the surface of the earth.

Depictions of this episode show Noah's sons helping their father build the ark. They often appear sawing wood for its construction. Representations of the ark evolved over the centuries. They began with the stylized images seen in Roman catacombs. Later, medieval illustration of the ark typically represented it as a sort of floating house. Finally, in the Renaissance, the ark came to resemble a real boat.

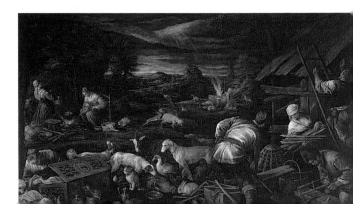

Staff in hand, Noah gathers the animals and leads them toward the ark. He is one of the Bible's most important patriarchs and was seen as prefiguring Christ.

The ark is described as a great wooden boat with several levels.

People watch, amazed, as Noah gathers the animals to bring them into the ark.

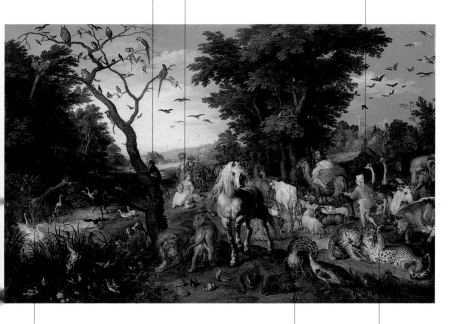

The scene is set near a stream, which has been inserted to point out the flood's imminent arrival.

The peacock is a symbol of incorruptibility and resurrection. It alludes to Christ, who, like Noah, saves the living in the ark of the Church.

This painting features numerous exotic animals. Jan Brueghel was able to study live specimens of these creatures thanks to his position as court painter to Archduke Albert and the infanta Isabella Clara Eugenia, which he assumed in 1610. Nevertheless, the representation of certain animals (lions, horses, leopards) suggests that the artist was inspired by the works of his friend Peter Paul Rubens.

▲ Jan Brueghel the Elder, *The Entry of the Animals into Noah's Ark*, 1613. Los Angeles, J. Paul Getty Museum.

Noah's Ark

Noah's ark is compared with the Church itself, which offers the faithful a way out and leads them to salvation. The association between the ship and the saving role of the Church was taken up again in the New Testament, where, for example, Jesus walks on the water and the disciples are brought to safety in a boat.

Noah is shown with a long, flowing beard as he oversees the construction of the ark.

The ark has been a common subject in Christian art from the beginning. Its image, in fact, resembles the boat that brings the deceased to the Underworld in Greek and Egyptian mythology. In the emerging Christian art it came to symbolize the concept of resurrection.

Noah's three sons, Shem, Ham, and Japheth, cut the wood to build the ark and transport the materials.

▶ Made in Brussels, *The Building of the Ark*, ca. 1550. Tapestry. Kraków, Wawel Castle.

Sitting on the ark under construction, an angel indicates the respect that Noah's family shows for the divine will.

Tools are shown in the foreground together with a dog, a symbol of domestic fidelity.

The wives carry out some finishing work on the pieces of wood.

In depictions of the Flood, the ark floats upon the waters, with animals on the gangplank or peeking out the windows. Human figures often gesticulate wildly amid the waters, but in vain.

The Flood

The Place
On the earth

The Time
It begins when Noah is six hundred years old and lasts for a period of months.

The Figures
Noah, his family members, the animals of the ark, and the creatures that perish

The Sources
Genesis 7, 8:1–19

Variants
Sometimes the successive episodes to the Flood include scenes of Noah letting the dove fly away, the dove returning with an olive branch, and God ordering Noah to leave the ark.

Diffusion of the Image
Widespread in Christian art. Many of its diverse elements are common to the popular traditions of many cultures, particularly the Greek myth of Deucalion and Pyrrha.

Upon completing God's commands, Noah withdraws into the ark with his wife, sons, and the animals. Then the Lord makes it rain for forty days and forty nights, until water covers the mountains of the earth, and the ark rises and floats upon the surface. Every living thing perishes, and only Noah and his family remain on earth. The waters cover the land for a hundred and fifty days. Then God, remembering Noah, causes the wind and rain to abate. Gradually the waters subside and the ark alights on the summit of Mount Ararat. As the days pass, the peaks of other mountains begin to reappear. Noah opens the window of the ark and lets a raven fly out, but it does not return. Then three times he sends out a dove to verify that the waters have indeed subsided. The first time, the bird returns to Noah in the ark because it does not find any dry land to perch on. The next time the dove returns with an olive branch in its mouth, signaling that the waters have lowered to ground level. On its third release, it does not return.

Thus assured that the surface of the earth has drained, Noah takes the roof off of the ark and brings forth his family and all the animals so that they can grow and multiply.

This ark presents distinctive
features, such as its casket
shape and a door of huge
dimensions, which faces toward
the viewer. The door is ornate,
with decorations typical of the
architecture and decorative arts
of the period in which Baldung
Grien lived.

A padlock fastens the
enormous door, to which
several desperate men
attempt to cling.

The sky appears
threatening, rent by
flashes of lightning.

Animals peer
out from a tiny
open window in
the upper part
of the ark.

◄ English-Hebrew illuminator,
Noah in the Ark, late thirteenth
century. London, The British
Museum.

▲ Hans Baldung Grien, *The
Flood*, ca. 1525. Bamberg,
Historisches Museum.

The artist pays great attention to
portraying the agony of the people
and animals that are condemned to
drown. They are shown in grotesque
positions that illustrate their super-
human efforts to stay alive.

The Flood

This fresco represents one of the highest
testimonies to Paolo Uccello's artistic
maturity. In this work, he demonstrates his
extraordinary ability to use perspective for
expressive purposes.

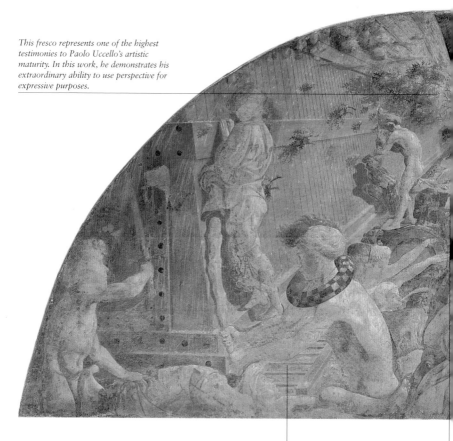

The Flood is portrayed
at the left, with figures
being swept away by
the waters.

▲ Paolo Uccello, *The Flood and the Recession
of the Waters*, 1447–48. Florence, Santa
Maria Novella, Verde Cloister.

In presenting two episodes of
the story within this one scene,
Paolo Uccello has structured the
composition from a dual point
of view, multiplying the optical
effects and using extremely bold
foreshortening.

In the Christian tradition of
the early Church fathers,
the Flood is compared to
Christian baptism.

The story of a great flood
occurs in the myths of many
different peoples. In the
Greek myth, Deucalion and
Pyrrha withdraw into an ark
for nine days and are the
only ones to escape the
destruction of the entire
human race. As with Adam
and Eve, a new race of
humans is created beginning
with these two figures.

Noah is portrayed in
the foreground after
emerging from the
ark at the Flood's
end. He gives thanks
to God for having
saved him and his
family.

The recession of the
waters allows Noah to
leave the ark.

The Flood

The ark is shown as a huge floating building that is entirely enclosed. Animals peer out of the open windows at the top of the building and from the rear.

Many attempt in vain to take shelter in the ark, into which, by divine command, Noah has gathered his family and the animals.

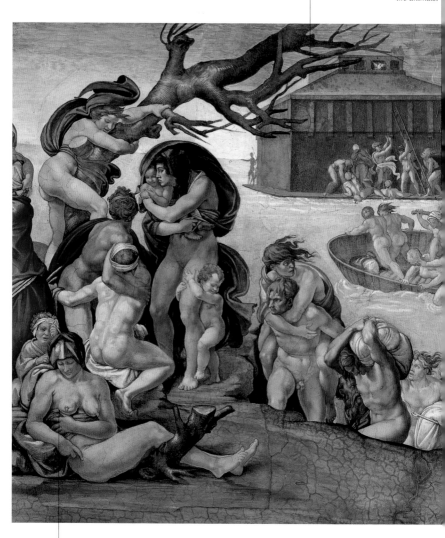

In the foreground, men, women, and children crowd the high ground, seeking desperately to save themselves from this terrifying act of divine wrath.

A boat loaded with people seems on the point of capsizing into the water.

A number of people take shelter under a makeshift tent. It has been erected on a crag that still stands above the encroaching waters.

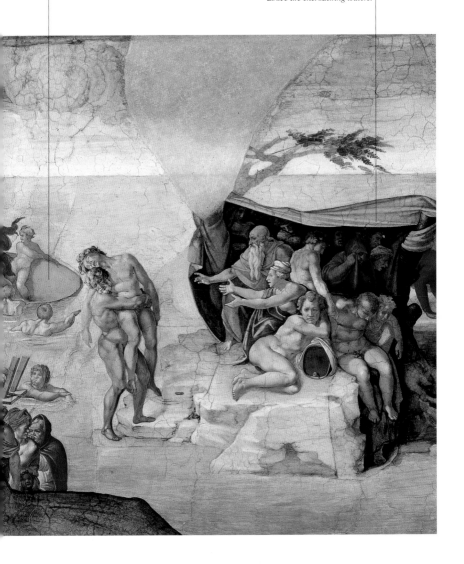

▲ Michelangelo Buonarroti, *The Flood*, 1508–12. Vatican City, ceiling of the Sistine Chapel.

The Flood

The first time the dove exits the ark, it does not find a dry surface to perch on. The next time, it returns to Noah with an olive branch in its beak, indicating that the waters have subsided to ground level. In the end, it does not return.

After the Flood ends, Noah frees a dove to check whether the waters have subsided. Here Noah, identifiable by his long, flowing hair, is shown peering out of the ark and releasing the bird.

Animals peer out of the ark at the end of the deluge. Noah is releasing them, having made sure that the waters have subsided.

The ark is represented as a multi-tiered structure with numerous windows.

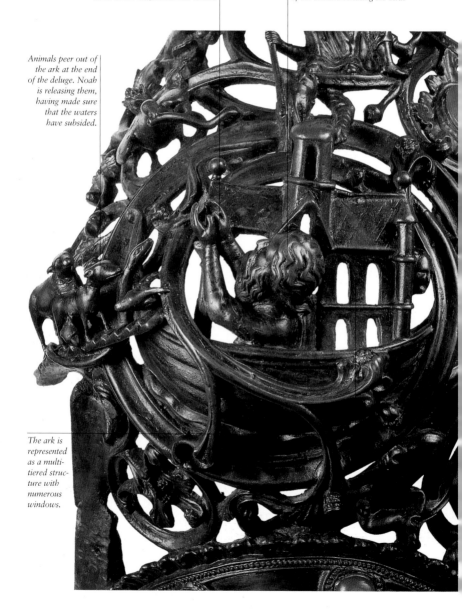

On an altar built for the occasion, Noah and his family make a sacrifice in thanksgiving to God, who permitted them to survive the deluge.

The Sacrifice of Noah

As soon as he leaves the ark with his family and the animals, Noah builds an altar. He sacrifices one of every kind of clean animal and winged creature in thanksgiving to God. Catching the scent of Noah's sacrifice, God vows: "I will never again curse the ground because of man, for the imagination of man's heart is evil from his youth; neither will I ever again destroy every living creature as I have done."

God then blesses Noah and his children, inviting them to be fruitful, to multiply, and to subjugate every living thing on the earth. In addition, the Creator sanctions a covenant with Noah, his children, his descendants, and every creature with them. As a sign of this covenant, he causes a rainbow to appear among the clouds.

This is the first biblical passage in which God stipulates a covenant with humankind. It anticipates the pacts that God will draw up with Abraham, with Israel on Sinai, in Shechem in the Promised Land, and then with David.

After the Flood, the earth is repopulated by Noah's three sons, Shem, Ham, and Japheth.

◄ Made in Lorraine, *Noah Receiving the Flying Dove*, ca. 1200. Detail from the Trivulzio Candelabra. Milan, cathedral.

The Place
Outside the ark

The Time
After the Flood

The Figures
Noah; his sons, Shem, Ham, and Japheth; and their wives

The Sources
Genesis 8:20–22, 9:1–17

Variants
The rainbow and the sacrifice of Noah; the covenant of God with Noah

Diffusion of the Image
This iconography is not very common. It is found mostly in cycles of paintings that portray the episodes of Noah's life.

◄ Giovanni Antonio di Francesco Sogliani, *The Sacrifice of Noah*, ca. 1531. From a cycle of paintings in the Cathedral Tribune. Pisa, cathedral.

65

The Sacrifice of Noah

God the Father, identifiable by his long, flowing beard, appears in the sky surrounded by numerous cherubs. He has decided never again to punish mankind with another flood.

The brilliant rainbow that appears in the sky after the Flood is a sign of God's covenant with Noah or with the new humanity.

The wooden ark that Noah and his family abandoned after the end of the Flood can be seen on the mountain.

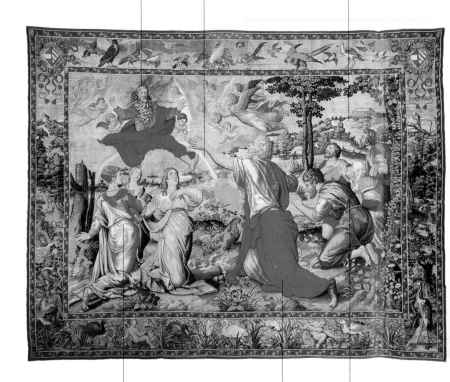

The wives of Shem, Ham, and Japheth seem to be posed in a sort of thanksgiving dance to the Lord.

After leaving the ark together with his family and the animals, Noah celebrates a sacrifice of every kind of clean animal and bird as a sign of thanksgiving to God. Here Noah is shown kneeling with his arms open toward God the Father.

The three sons of Noah and their wives kneel in a sign of thanksgiving and adoration of God.

▲ Made in Brussels, *God's Promise to Noah*, 1567. Tapestr Amsterdam, Rijksmuseum.

In this episode, Noah's youngest son, Ham, sees his father lying naked in his tent. Usually his brothers Shem and Japheth are shown covering their father's nakedness.

The Drunkenness of Noah

After emerging from the ark with his family, Noah begins to farm and to cultivate a vineyard. One day, after drinking too much wine, he becomes inebriated and lies naked in his tent. Ham, his youngest son, sees him and tells his brothers. At this point, Shem and Japheth take up a cloak and approach Noah, walking backward so as not to see his nakedness, and they cover his body. When Noah awakens from his state of drunkenness and learns of Ham's actions, he curses Canaan, Ham's son, saying, "Cursed be Canaan; a slave of slaves shall he be to his brothers."

Some have interpreted this episode as Ham having violated his father's privacy with an incestuous act. In fact, in biblical language, the expression "saw his nakedness" means "to carry out a sexual act." But in this case, the brothers afterward "cover the nakedness" of their father. Therefore the story is probably only intended to condemn the youngest son's lack of respect toward his father.

What is surprising is the fact that Noah's curse was cast not upon Ham himself, but upon his son Canaan.

The Place
In Noah's tent

The Time
After the Flood

The Figures
Noah and his three sons, Shem, Ham, and Japheth

The Sources
Genesis 9:20–27

Variants
The mocking of Ham

Diffusion of the Image
This iconographic subject is rather widespread in Christian art. It was interpreted as prefiguring the Mocking of Christ on the cross.

▶ Nicolò Ranverti (attributed), *The Drunkenness of Noah*, ca. 1420. Venice, Palazzo Ducale.

The Drunkenness of Noah

As a sign of respect, Noah's sons Shem and Japheth try to cover their father with a cloak without looking at his nudity.

Generally wine and the vine are signs of prosperity and joy. The Promised Land, in fact, is a land of vineyards, and the vine a symbol of fertility. It was treasured and became a symbol of Israel, which God chose to be his vineyard, even though it betrayed the Lord's expectations.

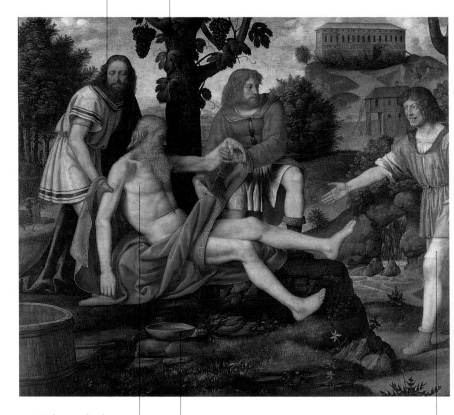

Noah is seated under a vine-laden tree. He is depicted in an unseemly position on the ground, completely naked and unconscious due to his state of drunkenness.

▲ Bernardino Luini,
The Mocking of Ham,
1510–15. Milan, Brera.

A bowl of wine is shown near Noah. Drunkenness is often condemned in the Bible. Nevertheless, the duty to respect one's father is fundamental.

The youngest son, Ham, realizing what has happened, mocks his father. When Noah wakes from his drunken state and learns what has occurred, he curses Ham's son Canaan.

The story of Babel is intended as a symbolic tale. It represents the dispersion of humankind and its loss of unity due to pride.

The Tower of Babel

The eleventh chapter of Genesis opens with the story of the earth's inhabitants, who all share the same language and use the same words.

One day, as men migrate from the East, they find the land of Shinar, where they settle on a plain and decide to build a city. There they prepare bricks and bitumen, with which they intend to erect a tower "with its top in the heavens," saying, "Let us make a name for ourselves, lest we be scattered abroad upon the face of the whole earth." The Lord, coming down to see the city and the tower that the sons of men are building, decides to punish their pride. Since they are all one people and speak a common language, God says, "Come let us go down, and there confuse their language, that they may not understand one another's speech."

After confusing their language, God scatters them throughout the world so that they cannot finish building the tower. From that moment on, the city is called Babel, since the Lord mixed all the languages of the earth there.

The Place
In the land of Shinar, which probably can be identified as the region of Sumer, in the southern part of Mesopotamia

The Time
During an imprecise era after the Flood

The Figures
A number of men and sometimes Nimrod, the conqueror of Babylonia from the second millennium B.C.

The Sources
Genesis 11:1–9

Diffusion of the Image
Quite widespread, especially in northern European art

▶ Jan van Scorel, *The Tower of Babel* (detail), ca. 1540. Venice, Galleria Franchetti alla Ca' d'Oro.

The Tower of Babel

At the top of a high ladder, God the Father, together with an angel, regards the building erected by the "sons of Adam."

Mankind attempts to build a city and a tower whose top touches the heavens. The tower is built with bitumen and bricks that have been dried in the sun.

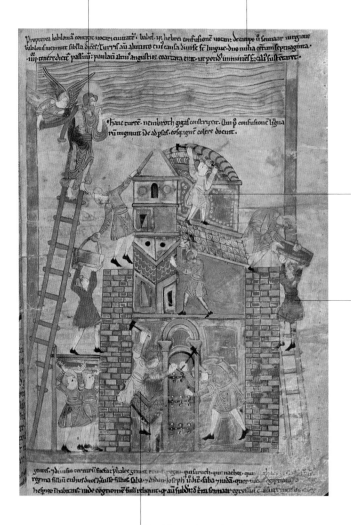

A man places a brick at the top of the building.

Many laborers have been employed to carry bricks and buckets of mortar.

Two laborers devote themselves to the tower's gate, where they install wrought iron.

▲ English illuminator, *The Building of the Tower of Babel*, 1030–40. Miniature from *Metric Paraphrases of the Pentateuch and the Book of Joshua*. London, The British Museum.

This Tower of Babel has been based on Mesopotamian ziggurats, which were made up of brick terraces, at the top of which a temple dedicated to the divinity was erected.

The Tower of Babel is portrayed in diverse ways in artistic representations. For example, it can be shown as a multilevel building whose top is accessible through a system of stairs, or, as in this case, as a terraced building encircled by a spiral walkway.

On a rocky spur, men are preparing blocks of marble, which will then be brought up the tower in horse-drawn carts.

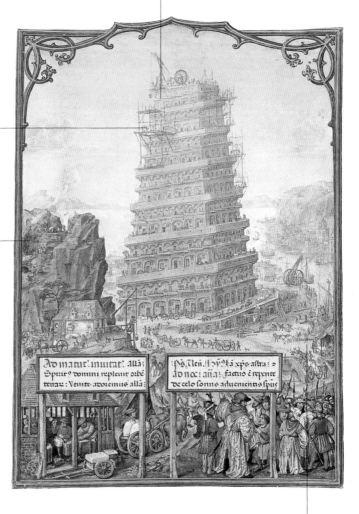

In a clearing just in front of the tower, men unload wood that has arrived by sea.

▲ Bruges School illuminators, *The Tower of Babel*, late fifteenth century. Miniature from the Grimani Breviary. Venice, Biblioteca Marciana.

The Tower of Babel

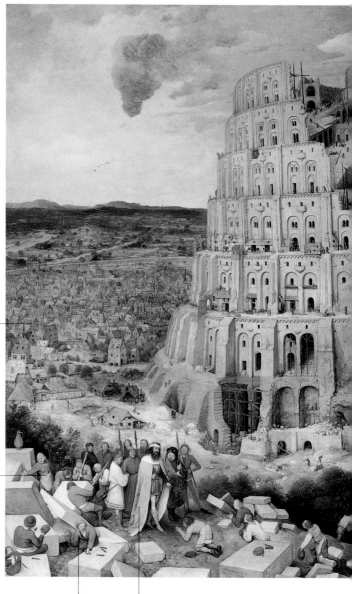

The biblical city of Babel is situated on the plain of Shinar. The name "Tower of Babel" was quite likely given to the ziggurat of Babylon, a tower built with terraces of decreasing size, at the top of which stood a sanctuary. Stairs allowed passage from one terrace to another.

To represent the confusion of language that God caused, the figures belong to different races.

The confusion of languages is a punishment from God, who is indignant at the construction of the Tower of Babel.

The legendary figure of Nimrod—the famous hunter, warrior, and conqueror of Babylon in the second millennium B.C.—is shown in this panel, acting as a "manager" for others who carry bricks and pitch.

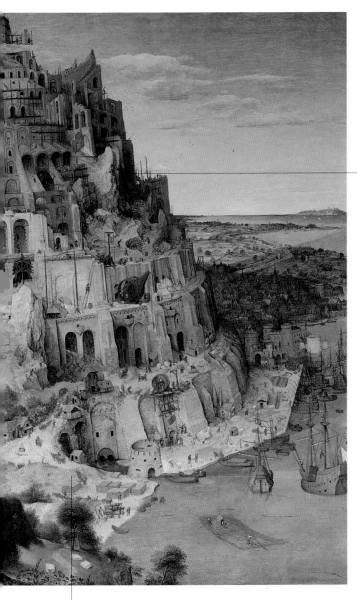

The tower is depicted as a huge, unfinished building with multiple levels that are accessible through a system of stairs.

Harmony will return at Pentecost, when, as the evangelist Luke narrates, all the nations and languages will unite in praise. The effusion of the Holy Spirit, in fact, will allow people to speak and profess faith in Christ in the various tongues. Only then will the confusion of Babel be overcome.

▲ Pieter Brueghel the Elder, *The Tower of Babel*, 1563. Vienna, Kunsthistorisches Museum.

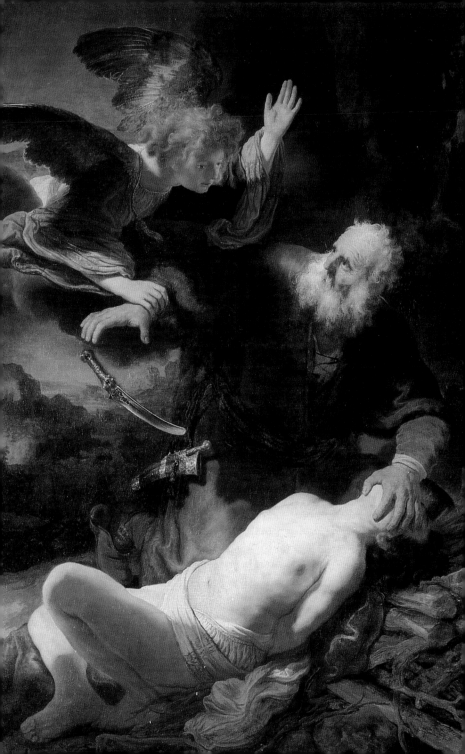

THE STORY OF ABRAHAM

◀ Rembrandt Harmensz. van
Rijn, *The Sacrifice of Isaac*,
1635. St. Petersburg,
Hermitage.

▶ Bruges School illuminators,
*Three Angels Foretell the
Birth of a Son to Abraham
and Sarah*, late fifteenth
century. Miniature from the
Grimani Breviary. Venice,
Biblioteca Marciana.

The first of the Old Testament patriarchs, Abraham is the fore-father of the people of Israel. He is revered by Jews, Christians, and Muslims alike.

Abraham

The Place
From Ur of the Chaldeans, Abraham sets out for Canaan; he first stops at Haran, and then at Shechem. After a brief stay in Egypt, he once again returns to Canaan.

The Time
Between the nineteenth and seventeenth centuries B.C. The Bible recounts that Abraham lived for 175 years.

The Sources
Genesis 11:26–25:10. There are numerous references to him throughout the Bible.

Attributes
He is portrayed with a flowing beard and white hair. His attributes are his son Isaac, the sacrificial knife, and a ram.

Diffusion of the Image
Quite widespread in artistic representations, both paintings and sculptures, especially the episode of the sacrifice of Isaac

▶ *Abraham*, fourteenth century. Mosaic. Venice, San Marco, baptistery.

Abraham, the son of Terach, is a native of Ur of the Chaldeans, where he marries his half-sister Sarah. After the death of his brother Haran, he and his family emigrate toward the land of Canaan. When they reach the region of Haran, Terach settles there, while Abraham, who has received the Lord's calling, decides to leave for Canaan with Sarah and their nephew Lot. He stops at Shechem for ten years.

When famine arrives, Abraham takes refuge with Sarah for a time in Egypt at the court of the pharaoh. Once again called by the Lord, Abraham returns to Canaan, where he becomes rich and powerful. The flocks of Abraham and Lot multiply abundantly. But their shepherds begin to quarrel among themselves, and the patriarch and his nephew decide to part ways. After Abraham saves Lot and the inhabitants of Sodom from an enemy army, three angels tell him that he is to have a son. Despite her barrenness and advanced age, Sarah gives birth to Isaac. She forces Abraham to send away Hagar, the slave she had offered her husband as a concubine, as well as Ishmael, the son born from their union. Tested by God, the patriarch is about to sacrifice his beloved son Isaac when an angel stops him. As a reward, the Lord blesses him and his descendants.

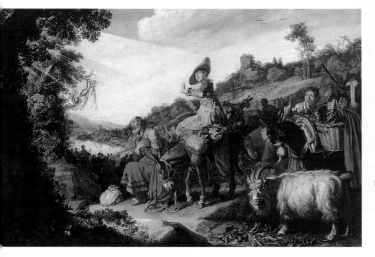

The life of Abraham is a continuous peregrination to fulfill the will of God. The patriarch reaches the land of Canaan, his original goal, by following his vocation.

The Departure for Canaan

From Ur of the Chaldeans, Abraham emigrates with his entire family toward the land of Canaan. Nevertheless, when they reach Haran (still within Mesopotamia), his father, Terach, and his family decide to settle there. Abraham, however, receives a specific calling from the Lord, who orders: "Go from your country and your kindred and your father's house to the land that I will show you. And I will make of you a great nation, and I will bless you and make your name great, so that you will be a blessing." The patriarch sets out with his wife, Sarah, and his nephew Lot, son of Haran, his brother, in order to accomplish his mission and to reach the land of Canaan. Crossing the country, he spends ten years at Shechem, at the oak of Moreh, where he builds altars in the name of the Lord.

The episode of Abraham departing for Canaan shows the patriarch preparing for the journey together with his family. The animals are packed with household goods.

The Place
The Chaldean city of Ur, in Mesopotamia

The Time
Around 1850 B.C.

The Figures
Abraham; his wife, Sarah; his nephew Lot; and animals

The Sources
Genesis 11:26–12:9

Variants
God orders Abraham to depart for Canaan; Abraham settles in Canaan

Diffusion of the Image
This iconography occurs infrequently in art.

◀ Pieter Lastman, *God Appearing to Abraham on the Road to Shechem*, 1614. St. Petersburg, Hermitage.

Melchizedek, the priest of Jerusalem, brings Abraham bread and wine as a sign of hospitality. This episode has been seen as prefiguring the priesthood of Christ.

Abraham and Melchizedek

The Place
Salem, the ancient name of Jerusalem

The Time
After Abraham's triumph over Lot's attackers and his rescue of the inhabitants of Sodom

The Figures
Abraham, Melchizedek, and their men

The Sources
Genesis 14:18–24

Variants
The meeting of Abraham and Melchizedek

Diffusion of the Image
The episode in which Melchizedek brings Abraham bread and a chalice of wine was interpreted during the Middle Ages as prefiguring the Last Supper.

After living with his wife, Sarah, in Egypt for a time in order to evade famine, Abraham returns to Canaan, where he becomes "very rich in cattle, in silver, and in gold." After a number of quarrels break out among their shepherds, the patriarch separates from his nephew Lot, who sets out for the Jordan valley, where the city of Sodom is located. Abraham stays in the mountains.

Later on, plunderers attack the cities of the plains, and Lot and the inhabitants of Sodom are captured and robbed of their riches. Upon learning what has happened, Abraham gathers a large number of armed men, pursues the attackers, and defeats them, freeing Lot and winning back his goods.

As Abraham returns from this venture, the king and great priest of Salem, Melchizedek, comes out to meet him, bringing him bread and wine as a sign of hospitality. He blesses him,

saying, "Blessed be Abram by God Most High, maker of heaven and earth; and blessed be God Most High, who has delivered your enemies into your hand!" In exchange, Abraham gives Melchizedek a tenth of all his war booty.

► Peter Paul Rubens, *The Meeting of Abraham and Melchizedek* (detail), 1625. Washington, D.C., National Gallery of Art.

► Dieric Bouts, *The Meeting of Abraham and Melchizedek*, 1464–68. A detail from the *Last Supper* polyptych. Louvain, Saint-Pierre.

Offering bread and wine is an act of tribal hospitality that was reclaimed in the liturgy for the Eucharist. Indeed, Melchizedek offering bread and wine was interpreted as prefiguring the priesthood of Christ.

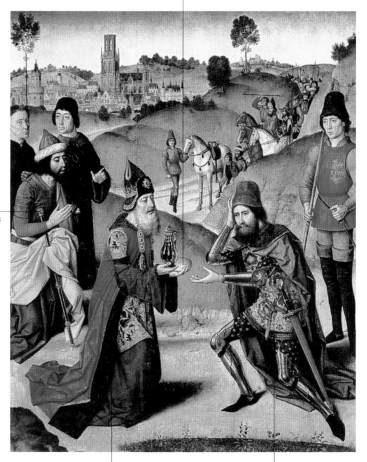

One of the sovereign's courtiers stands behind him, holding Melchizedek's scepter.

Melchizedek is shown kneeling, wearing a headdress similar to a miter. He offers Abraham bread and a pitcher of wine. His rich vestments are characteristic of Flemish painting.

Encumbered in his movements by the rigid armor covering his legs and arms, Abraham makes as if to kneel before Melchizedek. A long sword hangs from his waist.

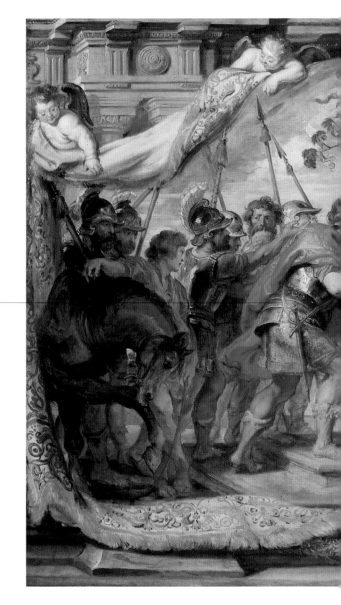

Accompanied by his soldiers, Abraham approaches Melchizedek to receive the gift that the priest offers. His powerful body is covered by armor that leaves only his legs and arms free.

▶ Peter Paul Rubens, *The Meeting of Abraham and Melchizedek*, 1625. Washington, D.C., National Gallery of Art.

Numerous festive putti hold up a sort of drapery that seems to envelop the scene.

The scene is set within a building with wide columns that is richly decorated with garlands, putti, and opulent carpets.

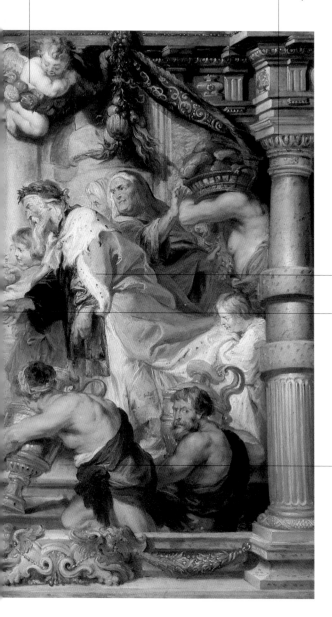

The high priest wears a crown on his head, and his shoulders are covered with an ermine stole.

Melchizedek offering Abraham bread and wine has been seen as prefiguring the Last Supper. In the same way, the blessing he gives the patriarch can be read in reference to the New Testament.

Two servants hold the huge wine amphorae.

The Church fathers saw a reference to the Trinity in the appearance of three angels before Abraham. Jewish tradition, in contrast, identified the three as the archangels Michael, Gabriel, and Raphael.

Abraham and the Three Angels

The Place
In the oak grove of Mamre, in the region of Hebron in Palestine

The Time
When Abraham is a hundred years old, just before the destruction of Sodom

The Figures
Abraham and three angels. In the scene of the feast of Abraham, Sarah is also shown hidden inside the tent.

The Sources
Genesis 18:1–19

Variants
Abraham welcoming the three angels to the oak grove of Mamre and accommodating them

Diffusion of the Image
This episode is often portrayed as prefiguring the Trinity (three angels) and the Annunciation (the prophecy of Sarah giving birth).

▶ Giovanni Domenico Tiepolo, *Angels Appearing to Abraham* (detail), 1773. Venice, Gallerie dell'Accademia.

One day, as Abraham sits at the entrance to his tent "in the heat of the day," or at midday, three men suddenly appear before him. Recognizing their angelic nature, Abraham runs to greet them and bows down to the ground, imploring them to stay. "Let a little water be brought, and wash your feet, and rest yourselves under the tree," he tells them, and then he asks his wife, Sarah, to cook flat bread. He takes a calf from the herd and has it prepared by a servant, and, bringing milk, he serves it to them with the meat. As they eat, the three men ask Abraham where his wife is, and he answers, "She is in the tent." Then one of the angels predicts to the patriarch, "I will surely return to you in the spring, and Sarah your wife shall have a son." Sarah, who has been listening at the entrance of the tent without showing herself, smiles.

Despite Sarah's advanced age, God keeps his promise. A year later, Sarah gives birth to a baby boy named Isaac.

The angels have frequently been inter-
preted as a symbol of the Trinity, and
their prophecy to Sarah has been seen
as prefiguring the Annunciation.

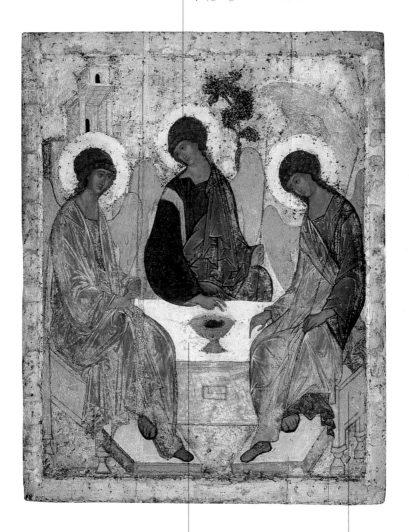

The angels reach
for a bowl of food
set on the table.

The three winged angels have halos
around their heads. Each one holds
a staff, perhaps to identify them
with the doorkeepers of the church.

▲ Andrey Rublyov, *Old
Testament Trinity*, 1411.
Moscow, Tretyakov Gallery.

Abraham and the Three Angels

As a woman, Sarah is not admitted to Abraham's conversation and banquet with the three guests, so she remains at the tent entrance. When the angels announce to Abraham that Sarah will bear a child within the year, the elderly woman smiles, expressing human doubt.

While the angels eat, Abraham is shown standing, as a sign of devotion and service. When one of the three men asks where Sarah is, the patriarch responds by pointing to his home, where his wife remains concealed.

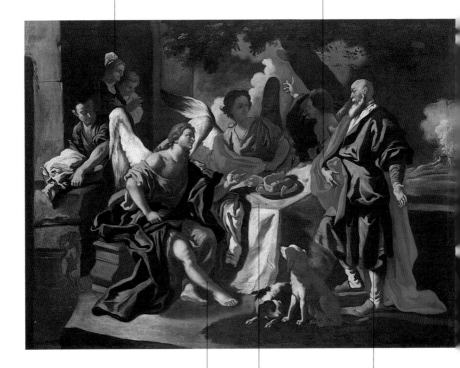

The angel in the foreground is barefoot because Abraham, as soon as he recognized the three as angelic figures, washed their feet.

The bread that Abraham asked Sarah to prepare has been laid on the table.

For the ancient Eastern peoples, hospitality was both a duty and an honor for the host.

▲ Francesco Solimena, *The Hospitality of Abraham*, ca. 1701. Milan, Brera (on loan to the Camera dei Deputati in Rome).

*This episode shows the elderly Sarah kneeling before the angel.
She smiles incredulously at the idea that in her old age she
might become a mother.*

Sarah and the Angel

While Abraham welcomes the three angels that suddenly
appear in front of his home, his wife, Sarah, remains within the
tent. Not allowing herself to be seen, she overhears what one of
the visitors tells her husband, announcing the birth of a son.
She smiles to herself, thinking, "After I have grown old, and
my husband is old, shall I have pleasure?"

Indeed, being already advanced in age, she has lost any hope
of having a son. At this point the angel asks Abraham: "Why
did Sarah laugh, and say, 'Shall I
indeed bear a child, now that I
am old?' Is anything too
hard for the Lord? At the
appointed time I will return to
you, in the spring, and Sarah
shall have a son." Then Sarah is
afraid and tells the angel, "I did
not laugh." But the divine mes-
senger answers, "No, but you
did laugh."

Sarah's laugh is a sign of her
disbelief. This gesture takes
form in the name of her long-
awaited son, "Isaac," which
means popularly "Yahweh
laughed." Abraham himself
smiles at the idea that Sarah
could become pregnant.

The Place
In the oak grove
of Mamre, in the
region of Hebron
in Palestine

The Time
When Sarah
is ninety

The Figures
Sarah and
the angel

The Sources
Genesis
18:10–15

**Diffusion of
the Image**
This iconogra-
phy is not very
common.

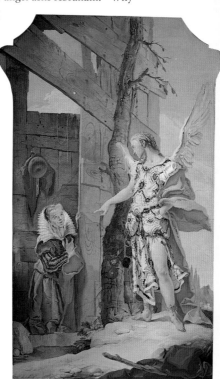

◀ Giovanni Battista
Tiepolo, *Sarah
and the Angel*,
1727–28.
Udine, Palazzo
Arcivescovile,
Galleria degli
Ospiti.

Sodom and Gomorrah

The Place
In the Jordan valley, where Sodom and Gomorrah lie

The Time
Toward the end of the third millennium B.C.

The Figures
Lot, his wife, his two daughters, and two angels

The Sources
Genesis 18:16–33, 19:1–38

Variants
The destruction of Sodom and Gomorrah; Lot fleeing Sodom with his wife and daughters; Lot being made drunk by his daughters

Diffusion of the Image
Widespread, especially, beginning in the Renaissance, the episode of Lot's daughters getting him drunk

▶ Albrecht Dürer, *Lot and His Daughters*, ca. 1496–99. Reverse side of Dürer's *Madonna and Child*. Washington, D.C., National Gallery of Art.

Abraham accompanies his three angelic guests to the top of a mountain so they can see the city of Sodom. Two of them go to Sodom, and at the city gates they meet Lot, who invites them to spend the night at his house. The people of the city crowd around Lot's house, demanding that he hand over his guests so the Sodomites can abuse them. When Lot refuses, they attack the house, but the angels blind them with a great flash of light. The angels then tell Lot that God is about to destroy Sodom and Gomorrah because of their wickedness, and the divine messengers lead him and his family toward the city of Zoar.

But Lot's wife is not saved. As they are leaving, she turns to look back at the city and is transformed into a pillar of salt. Lot and his daughters, afraid to stay in Zoar, go to live in a mountain cave. Left alone with their father and fearing that they will end up childless, the two women decide to get their

father drunk. Unbeknown to Lot, each lies with him for one night. The girls become pregnant and give birth to sons, Moab and Ben-ammi.

"When morning dawned," and Lot and his family are safe, God rains fire and brimstone down upon Sodom and Gomorrah and destroys the cities, their inhabitants, and all the vegetation. In the Old Testament, dust and ashes symbolize penance and atonement. The gravity of the Sodomites' sins lay in their lack of respect for the rules of hospitality.

The destruction of Sodom and Gomorrah is often interpreted as foreshadowing the condemnation of the wicked at the Last Judgment.

Although she had been fore-warned, Lot's wife turns around to look at the city in flames. She turns into a pillar of salt. The warning not to look back is common to many ancient tales, such as those of Virgil and Ovid. This was probably to point out that man is not allowed to watch divinity in action.

Lot and his daughters escape Sodom on an ass. The angels tell Lot: "Flee for your life; do not look back or stop anywhere in the valley; flee to the hills, lest you be consumed."

The other daughter concentrates on pour-ing wine for her father. The girls are depicted wearing clothes and head coverings typical of the fashions in the artist's time.

One of Lot's daughters lies with him outside their tent. The episode is set in the mountains, to which Lot and his daughters have withdrawn after the destruction of Sodom and Gomorrah.

▲ Lucas van Leyden, *Lot and His Daughters*, ca. 1520. Paris, Musée du Louvre.

87

Sodom and Gomorrah

The burning cities can be seen
in the background under a
shower of sparks. The sin of the
Sodomites consisted in failing to
respect the rules of hospitality,
which established the protocols
for welcoming guests in the
ancient Near East.

His eyes closed, Lot's face
betrays the state of intoxication
and unconsciousness in which
he finds himself as his daughters
lie with him.

The two young women are
shown nude in the arms of their
father, who has been intoxicated
by wine.

Lot's wife is being
transformed into a
pillar of salt. Only her
head and shoulders
are still human.

▲ Francesco Hayez, *Lot and His
Daughters*, 1833. Great Britain,
private collection.

The other daughter
is shown nude in
the background.

This episode illustrates the great
importance that the society of the
ancient Near East attached to
having descendants, as a means of
ensuring one's survival. Neverthe-
less, the prohibition against incest,
a very serious transgression, exists
in almost all cultures.

The chalice of wine
indicates that Lot is in a
state of intoxication.

Lot lies with one of his
daughters inside the tent
where he and the girls
have taken shelter. Both
figures are naked and are
portrayed in very sensual
poses.

The children of Lot's daughters are called Moab
and Ben-ammi, or "son of my people." They are,
respectively, the ancestors of the Moabites and the
Ammonites, two peoples who settled west of the
Jordan and were hostile to Israel. The biblical tale
of the origins of these two nations, springing as
they did from acts of incest, is meant to illustrate
their impure character.

▲ Albrecht Altdorfer, *Lot and
His Daughters*, 1537. Vienna,
Kunsthistorisches Museum.

Abraham's banishment of Hagar and Ishmael is an Old Testament story full of emotional tension.

Hagar and Ishmael

The Place
The land of Canaan

The Time
Abraham becomes father of Ishmael when he is eighty-six. After Isaac is born, he sends Ishmael and his mother, Hagar, away.

The Figures
Abraham, Hagar, Ishmael, and sometimes Sarah

The Sources
Genesis 16, 21:9–21

Variants
Three different biblical episodes may be represented: Sarah bringing Hagar to Abraham; Abraham letting Hagar and Ishmael go; and Hagar and Ishmael being saved by an angel in the desert.

Diffusion of the Image
This iconography occurs frequently in sacred art.

The elderly Sarah, who had given up any hope of bearing a son, decides to give Abraham her Egyptian slave Hagar as a concubine. The moment Hagar becomes pregnant, however, the slave girl begins to neglect her mistress. Sarah then treats her harshly, so much so that Hagar runs away into the desert. An angel finds the slave girl and urges her to return to her mistress and submit to her authority. Hagar returns to Sarah and soon gives birth to Ishmael. Later, as the angels had announced, Sarah becomes pregnant and gives birth to Isaac. Seeing that Ishmael, son of the slave Hagar, ridicules her son, Isaac, Sarah asks Abraham to send Hagar and Ishmael away. Otherwise Hagar's child will become Abraham's heir, on equal footing with Isaac.

Abraham hesitates, displeased at having to do such a thing, but God orders him to listen to his wife. So Abraham gives bread and water to Hagar and sends her and her son out into the desert. She becomes lost, and when their water runs out she lays the boy under a bush and sits some distance away so that she does not have to watch him die. Ishmael, however, cries out and weeps. God hears him and sends down an angel, who leads Hagar to a spring.

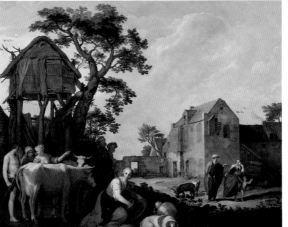

*After giving birth to Isaac, Sarah asks her husband
to send away Hagar the Egyptian slave and the child
born from their union so that her son will not have
to share his inheritance with Ishmael.*

The custom of having
children with a slave
girl when one's wife
was barren was quite
common in the ancient
Near East. In fact,
according to the laws
of the time, a son born
from the union of
Abraham and his
wife's slave would
have become Sarah's
legitimate child.

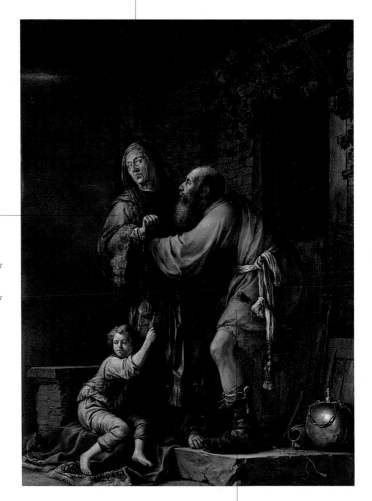

◄ Abraham Bloemaert, *The
Expulsion of Hagar and Ishmael*,
1638. Los Angeles, J. Paul Getty
Museum.

*Abraham tries in vain to
convince Sarah not to expel
Hagar and Ishmael.*

▲ Willem Bartsius,
*Abraham Pleading with
Sarah on Behalf of Hagar*,
1631. Los Angeles, J. Paul
Getty Museum.

Hagar and Ishmael

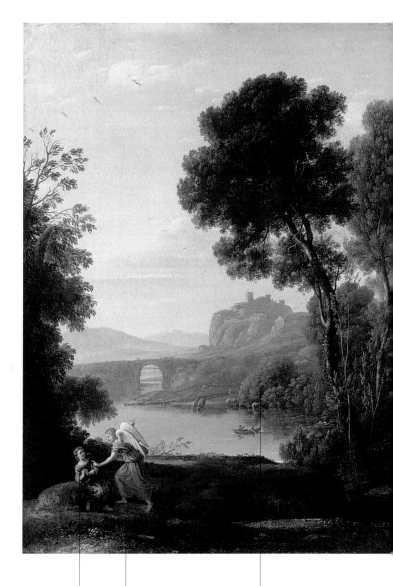

Hagar has fled to the desert because of the harshness shown by Sarah after Ishmael is conceived.

This episode depicts the moment when the angel finds Hagar. He promises her that God will multiply her descendants greatly.

This scene is set within a typical landscape of Roman hills rather than a desert. In fact, the episode became a pretext for depicting this subject, which was dear to the princely collectors of that time period.

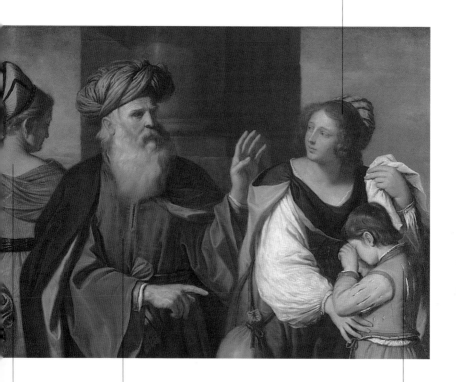

Turning away, Sarah makes sure that Abraham does what she has asked of him.

The elderly Abraham asks Hagar and Ishmael to leave his house. Here the patriarch's gesture toward his wife's slave and the son he had with her seems to be a sort of blessing.

Ishmael weeps in despair and is consoled by his mother.

◄ Claude Lorrain, *Landscape with Hagar and the Angel*, ca. 1660. London, National Gallery.

▲ Giovanni Francesco Guercino, *The Expulsion of Hagar and Ishmael*, 1658. Milan, Brera.

Hagar and Ishmael

Bowing to Sarah's request and the divine command, Abraham bids farewell to Hagar and Ishmael. Worried about their fate, he places his right hand on Ishmael's head, hinting at a blessing, while he seems to want to comfort the mother with his left.

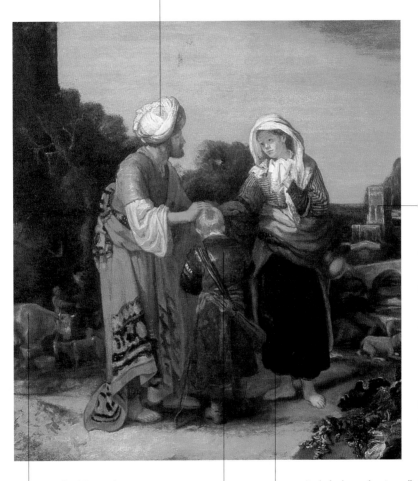

Farmers herd their cattle in the background.

In the background, a river valley with a stone bridge and a tower-like building are visible.

The young Ishmael, shown from behind, is the symbolic center of the composition. It is because of him that he and his mother must leave, since Isaac will otherwise not be assured of Abraham's inheritance.

Hagar takes the bread and the goatskin of water that Abraham gives her and prepares to depart. The woman's disconsolate expression betrays her concern.

Through the archangel Michael,
God opens the eyes of Hagar,
who is waiting for death.
Michael shows her a well, from
which she can draw water for
the boy to drink.

Hagar and Ishmael were left without water in
the desert of Beersheba. The angel sent by
God to save them says to her, "What troubles
you, Hagar? Fear not: for God has heard the
voice of the lad where he is. Arise, lift up the
lad, and hold him fast with your hand; for I
will make him a great nation." In adulthood,
Ishmael will become an archer and will found
the tribe of the Ishmaelites, nomads who lived
in northern Arabia.

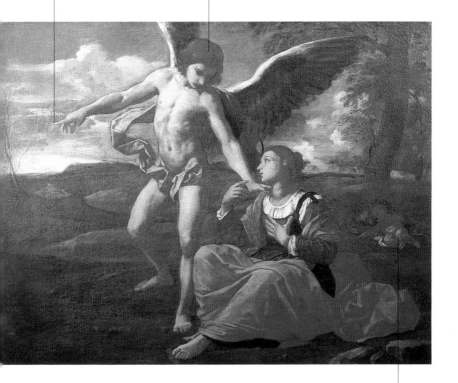

▲ Simone Cantarini, *An Angel Saving
Hagar and Ishmael*, ca. 1630. Fano,
Fondazione Cassa di Risparmio Collection.

◄ Barent Fabritius, *Hagar and Ishmael
Taking Leave of Abraham*, ca. 1650–60.
San Francisco, Fine Arts Museums.

Ishmael is portrayed as a tiny, naked child. Hagar has
placed him under a tree to wait for death. Ishmael's
name is linked to divine intervention and derives from
the Hebrew verb shama, "to hear," and from el, which
means "God." The rescue of Hagar and Ishmael signifies
that God listens to those who are in trouble.

This episode, among the most dramatic of biblical passages, is the one most often depicted from Abraham's life. The psychological conflict of the father became a testing ground for numerous artists.

The Sacrifice of Isaac

The Place
The land of Moriah, which has been identified as Mount Zion. According to Islamic tradition, this episode occurred where the Mosque of Omar stands today in Jerusalem.

The Time
When Isaac has grown to boyhood

The Figures
Abraham, Isaac, the angel sent by God, and a ram

The Sources
Genesis 22:1–19

Variants
Isaac tied to the altar; Abraham and Isaac sacrificing the ram

Diffusion of the Image
This episode is amply represented in Christian art, in both painting and sculpture.

When Isaac is older, the Lord wishes to test Abraham. He says, "Take your son, your only son Isaac, whom you love, and go to the land of Moriah, and offer him there as a burnt offering upon one of the mountains of which I shall tell you." The next morning Abraham rises, gathers together an ass and wood for the sacrifice, brings two servants and his son Isaac, and sets out on the journey. After three days of walking, he finds the place indicated by God, stops the ass and the servants, and continues alone with Isaac to carry out the sacrifice. Loading the wood on his son's shoulders, Abraham takes the knife and some firewood and makes his way uphill. Reaching the chosen place, Abraham builds an altar, lays out the wood, and, tying Isaac, he places him on top of the pyre. He takes the knife and is ready to strike his son when an angel of the Lord appears and stops him. Looking up, Abraham sees a ram with its horns ensnared in a bush. He offers it as a sacrifice in Isaac's place.

This subject owes its iconographic success in the Middle Ages to being read as a connecting episode between the Old and New Testaments. It was seen as prefiguring the Crucifixion of Jesus Christ, who was sent by his father to be sacrificed.

Having been placed upon the sacrificial altar, Isaac seems unaware of what is about to happen. In antiquity, human sacrifices, especially of children, were provided for in a city's "foundation rites" in order to appease the gods.

Abraham is presented in profile as he holds the young Isaac by the hair with his left hand and grasps a large sword with his right.

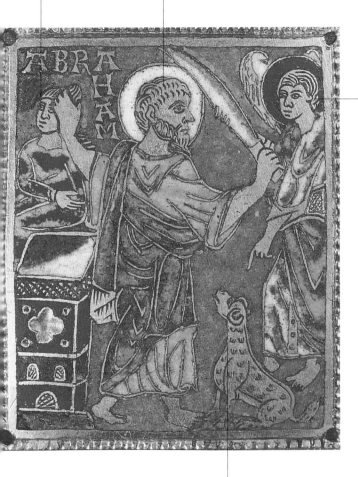

The angel intervenes at the last moment, halting Abraham's sword and showing the patriarch a ram to sacrifice in place of his son.

◀ Orazio Gentileschi, *The Sacrifice of Isaac* (detail), 1615. Genoa, Palazzo Spinola, Galleria Nazionale della Liguria.

The ram is depicted with its head turned toward Abraham, almost as if it wishes to offer itself as a substitute for the young boy.

▲ Rhenish goldsmith, *The Sacrifice of Isaac*, ca. 1200s. Enamel plaque. Florence, Museo Nazionale del Bargello.

The Sacrifice of Isaac

The servants that Abraham stopped, in order that he could continue the climb alone with his son, are separated from the emotional center of the scene by a rocky curtain.

The angel sent by the Lord bursts in from on high and halts the hand of Abraham, telling him, "Do not lay your hand on the lad or do anything to him; for now I know that you fear God, seeing you have not withheld your son, your only son, from me."

Isaac is shown kneeling on the altar with his hands tied and his naked chest turned toward the viewer.

The sacrifice of Isaac has been depicted widely, thanks to rich details furnished in the Bible and the emotional intensity that the scene expresses.

Abraham seems frozen by strong psychological conflict, as he is about to kill his son.

The biblical text tells how Abraham loaded the wood for the sacrifice on his son's back and carried the knife and some fire.

Abraham is shown in profile, with a long beard, a huge knife, and a flame lighted for the sacrifice. He is portrayed in a moment of meditation with his eyes closed, just before carrying out the terrible act.

Although this subject was widely treated in the history of art, Chagall's reading of it manifests a completely new interior life, as well as extremely deep piety.

Isaac, identifiable from his adolescent body, crosses his arms, as if to offer himself spontaneously to the divine will.

◀ Lorenzo Ghiberti,
The Sacrifice of Isaac,
401. Bronze panel.
Florence, Museo dell'
Opera del Duomo.

▲ Marc Chagall,
The Sacrifice of Isaac,
1960–66. Nice, Musée
Marc Chagall.

The Sacrifice of Isaac

The realism of Caravaggio dominates this scene. It is enhanced by the light fixed on Abraham, the hand of the angel, and the head of Isaac.

Abraham is shown raising the knife, about to strike his son, whom he holds down decisively by the neck.

The multiple details offered by the biblical text (the knife, the altar, the ass, the wood, and the ram) are presented once again in this scene.

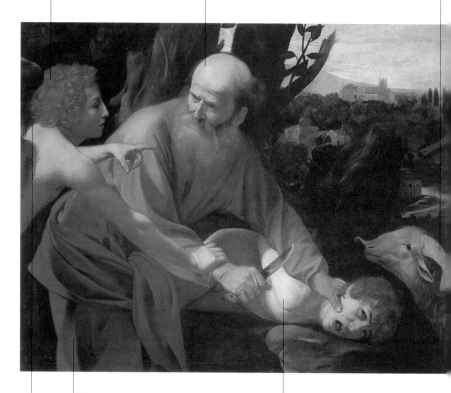

Taken as a whole, the scene of the sacrifice of Isaac was seen as prefiguring the Crucifixion of Christ, whom the Father sent to be sacrificed. Isaac carrying the wood anticipates the carrying of the cross on Calvary, and the ram with its horns entangled prefigures Christ crucified with the crown of thorns.

Isaac is lying naked upon an altar, where the wood has already been laid. Realizing his fate, he opens his mouth in a cry of terror at what is about to occur.

The angel, who is mostly outside the composition, halts Abraham's hand and points to the ram he is to sacrifice in the boy's place.

▲ Michelangelo Merisi da Caravaggio, *The Sacrifice of Isaac*, 1603. Florence, Galleria degli Uffizi.

The ram prefigures the Lamb of God.

Abraham invites his son Isaac to kneel down in front of the altar and join him in giving thanks to the Lord.

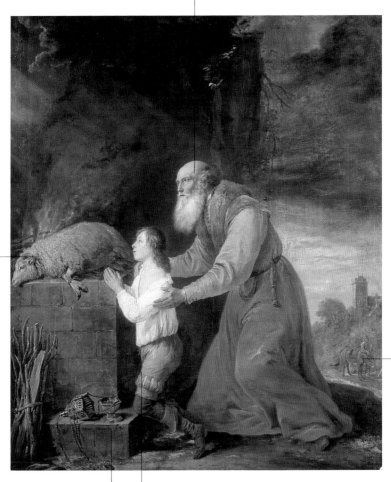

Some details are shown in the foreground, including wood and incense for the sacrifice.

Having gotten dressed again after evading danger, Isaac is shown kneeling before a ram tied upon an altar. The young boy who modeled for this figure may have been the painter's son.

The ass and the servants with whom Abraham and Isaac reached the place that God chose for the sacrifice can be seen in the background.

David Teniers II, *The Prayer of Abraham and Isaac*, 1653. Vienna, Kunsthistorisches Museum.

In this scene the young Rebekah, shown in company with other young women, gives water to Eliezer, Abraham's servant. Sometimes she listens to him or receives precious gifts from him.

Rebekah at the Well

The Place
The city of Haran

The Time
When Isaac is forty years old

The Figures
Eliezer, Rebekah, and other women

The Sources
Genesis 24

Variants
Rebekah and Eliezer at the well; the courting of Rebekah; Isaac meeting Rebekah

Diffusion of the Image
The scene most frequently represented from this story is the meeting of Rebekah and Eliezer at the well. This subject has been interpreted as prefiguring the Annunciation.

As he becomes old, Abraham hopes to find a wife for his son Isaac from among his extended family. He swears his eldest servant, Eliezer, to a solemn oath and sends him to find the woman destined to be his daughter-in-law. Eliezer, in turn, assembles a caravan of ten camels loaded with precious gifts and departs for the city of Haran, where Abraham's brother Nahor lives.

He reaches Haran in the evening, when women gather at the well to draw water. As he arrives, the servant prays to the Lord to point out the chosen girl. The sign that Eliezer asks for is clearly fulfilled: a young woman named Rebekah, Abraham's grandniece, serves water to the foreign guest and his camels with her pitcher. Eliezer offers her gifts—a nose ring and bracelets—and he asks her whose daughter she is. Revealing her identity, Rebekah invites the servant to spend the night at her father's house. At Bethuel's house, Laban, Rebekah's older

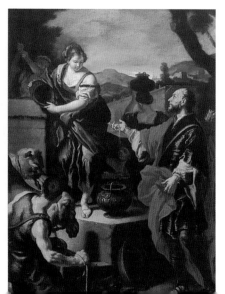

brother, welcomes the guests, and Eliezer immediately reveals his identity, explaining the reason for his visit. Rebekah is given permission to marry Isaac, and the next day she sets out on the return journey with the servant. Reaching the land of Abraham, the young girl is welcomed by Isaac, who takes her inside his mother Sarah's tent.

Eliezer arrives in the city of Haran with a host of camels. These animals are an indication of Abraham's great prosperity and his being blessed by God.

After recognizing the girl destined to become Isaac's wife, Eliezer offers her jewels as a gift. Abraham's old and trusted servant is shown in elegant clothing.

Rebekah is described in the biblical text as a girl who is "very fair to look upon," one who has never known a man. The young woman is shown here in an outfit that favors her youthful bosom. She holds a jug with which she offers water to Eliezer and his camels.

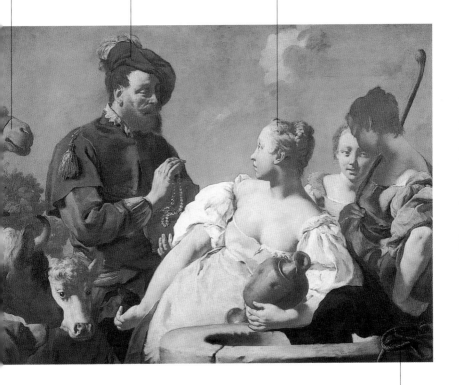

Welcoming a foreign guest is a favorite subject in the East.

◄ Francesco Solimena, *The Meeting of Eliezer and Rebekah at the Well*, ca. 1700. Rouen, Musée des beaux-arts.

▲ Giovanni Battista Piazzetta, *The Meeting of Eliezer and Rebekah at the Well*, 1740. Milan, Brera.

Rebekah at the Well

The buildings of Haran, where
Rebekah's father, Bethuel, lives, make
up the background of this scene.

Eliezer reaches the gates of Haran just as it
is beginning to get dark, the hour when
women go to the well to draw water. In this
canvas, Abraham's servant is shown giving
jewels to Rebekah.

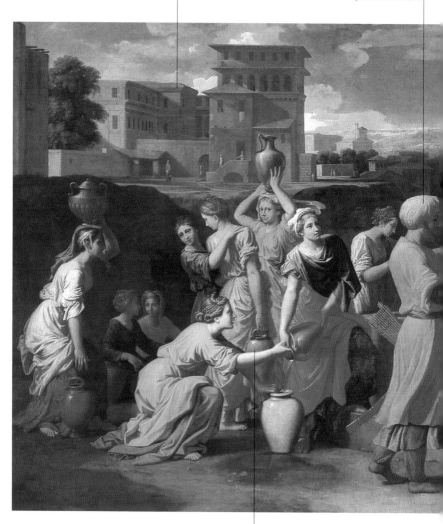

▲ Nicolas Poussin, *The Meeting of
Eliezer and Rebekah at the Well*, 1648.
Paris, Musée du Louvre.

Other women continue to
draw water from the well
and pour it into huge
amphorae that they carry
on their heads.

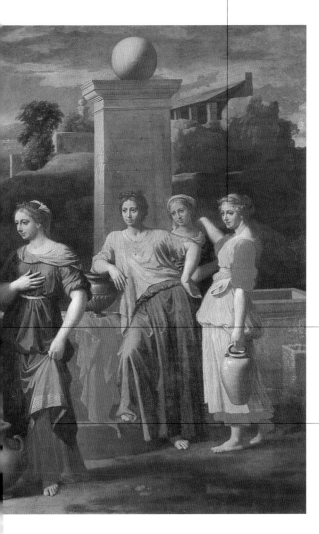

Some of the young women who went to the well with Rebekah stand watching, curious to see what is happening.

The well was a common meeting place in the Eastern world. It is a symbol of fertility and life and as such an ideal place to arrange a marriage.

Rebekah appears amazed to receive such a gift from a foreigner and she invites Eliezer to spend the night at her father Bethuel's house. As soon as he arrives, Abraham's servant explains to Bethuel and Rebekah's brother Laban the reason for his journey: to search for the woman destined to become Isaac's wife.

The amphora that Rebekah used to give Eliezer and his camels water is in the foreground.

Rebekah at the Well

The other women continue to draw water from the well and carry away the full amphorae by balancing them on their heads.

In amazement, the good-looking Rebekah accepts gifts from the foreign guest.

Eliezer hands precious gifts (a nose ring and bracelets) to the beautiful Rebekah. The offering of gifts during a marriage contract was common in the ancient world.

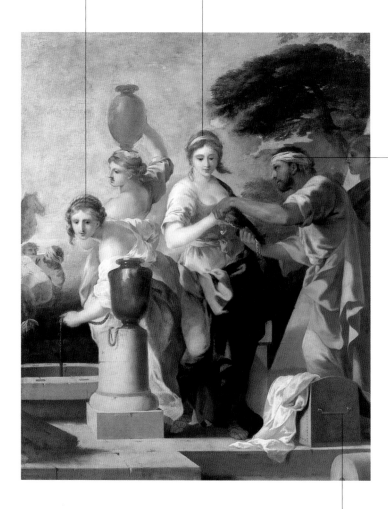

▲ Sébastien Bourdon, *The Meeting of Eliezer and Rebekah at the Well,* ca. 1660. Blois, Musée des beaux-arts.

The jewel box in which Abraham's servant brought the precious gifts for Isaac's future wife lies at his feet.

After having obtained the beau-
tiful Rebekah to be Isaac's wife,
Eliezer returns with the young
girl to Abraham's house.

Upon meeting his future
wife, Isaac embraces her
and leads her into his
mother Sarah's tent.

▲ Marc Chagall, *Isaac Receiving Rebekah
as His Wife*, 1977–78. Stained-glass
window. Magonza, Santo Stefano.

Near a well at the gates of Haran, Eliezer meets
Rebekah, daughter of Bethuel, who proves to be
the woman chosen to become Isaac's wife.

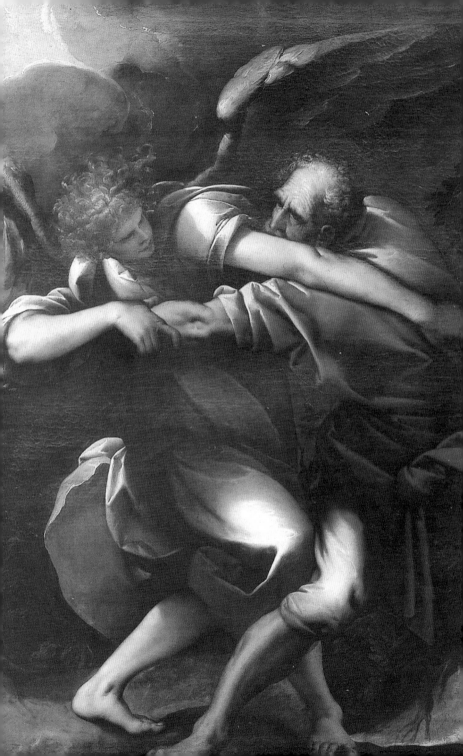

THE STORY
OF JACOB

◄ Morazzone, *Jacob Wrestling the Angel*, ca. 1610. Milan, Quadreria Arcivescovile.

► Bruges School illuminators, *Jacob Sends Joseph in Search of His Brothers*, late fifteenth century. Miniature from the Grimani Breviary. Venice, Biblioteca Marciana.

After Abraham and Isaac, Jacob is the third great patriarch of the Bible. The twelve tribes of the people of Israel originated from his descendants.

Jacob

The Place
Born in the land of Canaan, Jacob then departs for Haran, where he stays for twenty years; he then returns to Canaan. Finally, he goes to Goshen, where he stays until his death.

The Time
Jacob, along with his twin brother Esau, is born when Isaac is sixty years old and dies at the age of 147.

The Sources
Genesis 25, 27–35, 37, 42–50

Diffusion of the Image
The depiction of Jacob's life in art is often linked to his son Joseph's. Scenes relating to the patriarch appear in different eras, both individually and in cycles of works.

▶ Palma il Giovane, *Jacob amidst His Flock* (detail), 1620–24. Vicenza, Palazzo Thiene, Banca Populare Collection.

Jacob, twin brother of Esau, is born immediately after his brother, holding on to his brother's heel as proof that he would supplant him in the future. The two brothers become the founding fathers of two hostile peoples: Israel and the Edomites.

First Jacob acquires his brother's birthright in exchange for a plate of lentils. Then he receives, through deceit planned by his mother Rebekah, the blessing of his father Isaac. He thereafter departs for the land of Haran in search of a wife. He first marries Leah and then Rachel, the two daughters of Laban. Jacob has twelve children, all of whom are born in the land of Haran, except for the youngest, Benjamin, at whose birth Jacob loses his beloved Rachel.

In Haran Jacob becomes rich and receives a promise from God that the covenant would be maintained with him on the banks of the river Jabbok. In that moment he is given the name Israel. After reconciling with Esau, he goes to Shechem, where his sons sell their brother Joseph as a slave.

After sending his sons to Egypt because of famine, Jacob once again finds Joseph, who has become minister of provisions. Thanks to him, Jacob settles in Goshen, where he lives out the rest of his life.

In ancient times, the Church considered Jacob a prefiguration of Christ.

As the weary Esau returns from the hunt, he begs his brother Jacob to give him a bowl of the soup. Shrewdly, Jacob asks him for the privileges of his birthright in exchange.

The Sale of the Birthright

For many years, Isaac and Rebekah are not able to have children. Eventually Rebekah conceives a child, but she has a difficult pregnancy. As she nears the end of her term, the Lord tells her, "Two nations are in your womb, and two peoples, born of you, shall be divided; the one shall be stronger than the other, the elder shall serve the younger."

Although Jacob and Esau spring from a twin birth, Esau, who is reddish like a hairy cloak, is born first and thus acquires the birthright of an eldest son. As the two boys grow to adulthood, Esau becomes a nomadic hunter, Jacob a sedentary shepherd "dwelling in tents." Their father Isaac, who loves to eat game, prefers Esau, while their mother Rebekah favors the peaceful Jacob.

One day, the second-born son prepares some "red pottage" or lentil soup. Esau returns exhausted from hunting and asks his brother for a bowl of it. Jacob asks him for his birthright in exchange.

Weary and famished, Esau answers: "I am about to die; of what use is a birthright to me?" After extracting Esau's promise, Jacob gives his brother soup and bread in exchange for the rights of an eldest son. Esau eats, drinks, and departs. "Thus Esau despised his birthright," notes the biblical text.

The Place
The house of Isaac

The Time
The biblical text states that the episode occurred when Esau and Jacob were grown men.

The Figures
Jacob and Esau

The Sources
Genesis 25:27–34

Variants
Selling the birthright for a bowl of lentils

Diffusion of the Image
Fairly widespread

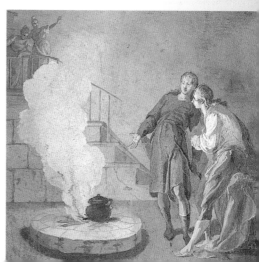

► Mattia Bortoloni, *Esau Selling Jacob His Birthright for a Bowl of Lentils,* 1716. Piombino Dese, Cornaro Villa.

The Sale of the Birthright

In the Bible Esau is also called "Edom," or "red," a name that links him to the red plate of lentils that he receives from Jacob in exchange for his birthright. "Edom" is also the name of a clan that traced its origins back to Esau and became a fierce enemy of the Hebrew people.

Returning exhausted from the hunt, Esau asks Jacob for a bowl of the lentil soup that he has prepared.

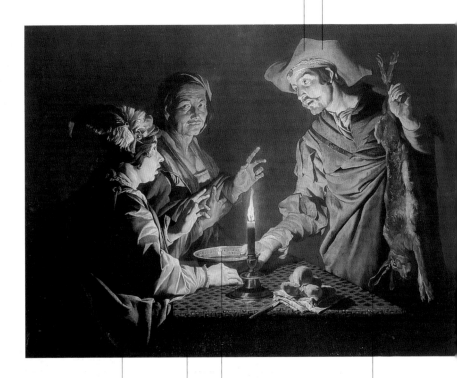

Jacob takes advantage of his brother by asking him on the spot for his birthright in exchange.

In the Bible it says that Jacob prepared a "red pottage," and only later is it explained that this was a soup of red lentils.

On the table, beside the bowl and candle, sits the bread that Jacob offers Esau with the soup.

▲ Matthias Stomer, *Esau Selling Jacob His Birthright for a Bowl of Lentils*, ca. 1640. St. Petersburg, Hermitage.

In a patriarchal family, a birthright had special significance. The eldest son retained a series of privileges: he succeeded his father as head of the family and received a double inheritance. According to the ancient law of the Hurrites, it was possible to transfer a birthright in exchange for a meal.

At his mother's suggestion, Jacob deceives his father, Isaac, in order to obtain the blessing destined for Esau.

The Blessing of Jacob

One day, Isaac, who has become old and almost blind, calls for his eldest and favorite son, Esau. He sends him out to hunt game and to cook it for him, promising to give him his blessing after he has eaten. Hearing Isaac's words, Rebekah calls the son that she favors, the second-born Jacob, and urges him to anticipate his brother so that he will receive the blessing instead. Jacob is scared and fears being recognized by Isaac because of his smooth skin, which contrasts with Esau's hairiness, but his mother convinces him to obey. Taking two goats from the flock, Jacob brings them to Rebekah, who prepares Isaac's favorite dish. Dressing Jacob with Esau's festive garments, Rebekah wraps her son's arms and neck with the skins of kid goats. Then she sends him in to his father with the meat dish and bread.

Feeling Jacob and smelling his clothing, Isaac is tricked by the ploy and, believing that Jacob is Esau, he blesses him. As Jacob exits his father's tent, Esau returns from the hunt and prepares the meat; he, too, brings it to his father. Realizing he has been tricked, Isaac explains to Esau that once given, the blessing cannot be withdrawn. The elder son bursts into tears, swearing that he will kill his brother after his father dies.

The Place
Isaac's tent in Beersheba

The Time
When Esau and Jacob are forty years old

The Figures
Esau, Isaac, Jacob, and Rebekah

The Sources
Genesis 27, 28:1–5

Variants
Jacob deceives Isaac to obtain his blessing. This episode is often followed with the scene of Isaac rejecting Esau.

Diffusion of the Image
This subject, which has been depicted frequently, features Jacob kneeling before Isaac and receiving his blessing. Rebekah often stands behind her favorite son, placing her hand on his shoulder.

◀ Domenico Fetti (attributed), *Isaac Blessing Jacob*. Venice, Gallerie dell'Accademia.

The Blessing of Jacob

The episode of the
blessing of Jacob is set
within Isaac's house.

Isaac, old and almost completely
blind, is shown giving his blessing
to his second-born son, Jacob,
believing that he is Esau.

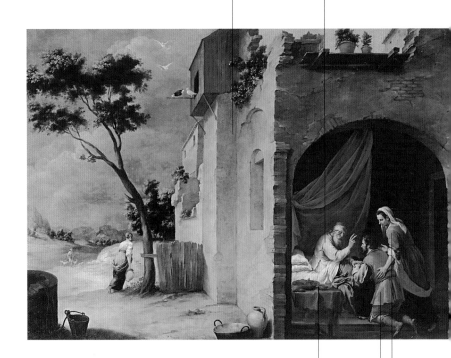

The dish of meat, the bread,
and the wine that Rebekah
prepared for Jacob to bring to
his father are shown on the
table set near Isaac's bed.

▲ Bartolomé Esteban Murillo,
Isaac Blessing Jacob, 1665–70.
St. Petersburg, Hermitage.

Dressed in Esau's clothing with his arms
covered in goatskins, Jacob receives the
blessing that his father intended for his
brother. Setting aside any judgment of
his actions, some interpreters of the
Bible see the blessing of Jacob as a
glorification of Israel's superiority.

Standing behind
her favorite son,
Jacob, Rebekah
supports her son
in deceiving his
father.

Esau goes to Isaac, bringing
him the dish he requested
and believing that he will
receive his father's blessing.

Behind Esau,
Rebekah watches,
pleased that Isaac
refuses to bless him.

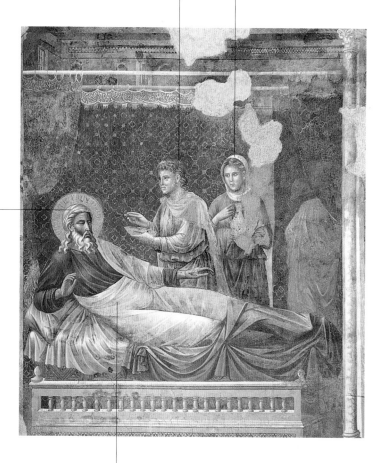

...aac is portrayed
...ing in bed, his
...es shuttered by
...e blindness that
...creasingly
...flicted him.

Isaac Master (probably
...otto), *Isaac Rejecting Esau*,
... 1290. Assisi, Upper
...silica of St. Francis.

After having discovered the deceit
committed by Jacob, the elderly father
explains to Esau that he cannot now
bless him, since he has already blessed
his second-born son. In consequence,
Esau will always serve his brother. In
the East, a blessing was a decisive
transfer of inheritance and could not
be voided or modified.

115

A multitude of meanings have been attributed to the ladder that appears in Jacob's dream. Above all it alludes to God's favor for the entire people of Israel.

Jacob Dreams of a Ladder to Heaven

The Place
In Luz, on the road toward Haran. After his dream, Jacob calls the place Bethel, today the Arab village of Beitin, north of Jerusalem.

The Time
At night, on a stop during the journey toward Haran

The Figures
Jacob, the angels, and God

The Sources
Genesis 28:10–22

Variants
Jacob's Ladder

Diffusion of the Image
This subject has been portrayed represented in Christian art ever since the paleo-christian period.

After Jacob deceives Isaac in order to secure the blessing that was destined for the first-born Esau, Rebekah advises him to flee to Haran, in Mesopotamia, to his uncle Laban. In doing so he distances himself from Esau, who intends to kill him as soon as their father dies.

On the road toward Haran, Jacob stops one night to sleep. He lays his head down, using a rock as his pillow, and there he has a dream. He sees a flight of steps that leads from earth to heaven with two companies of angels climbing and descending in both directions. At the top of the ladder is the Lord, who speaks to Jacob, promising him that the land where he lies will one day belong to his descendants, the people of Israel.

"Surely the Lord is in this place; and I did not know it," says Jacob when he awakes. Realizing that his dream involved God's own house and the gate of Heaven, he is afraid.

In the morning when he rises, he takes the rock where he had laid his head and places it so that it stands like a sacred stele. He pours oil over it and calls the place Bethel, "the house of God."

▶ Jusepe de Ribera, *Jacob's Dream* (detail), 1639. Madrid, Museo del Prado.

The story of Jacob's dream also aims to justify the origins of rituals that were performed in Bethel, where the ark of the covenant was kept for a time in a sanctuary.

The presence of angels represents contact between the human and divine spheres.

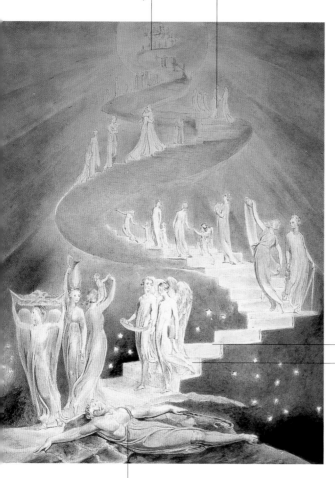

The image of the staircase recalls the stairs of a Babylonian temple, or ziggurat, at the top of which stood the temple of the divinity.

In medieval times, Jacob's ladder was read as a symbol of Mary, in her role as mediator between Heaven and earth. The significance of the ladder has been subject to various interpretations: it also was seen as Jesus—someone who unites Heaven and earth—or the path of humanity, which rises toward its meeting with God.

Jacob is lying on his cloak, a garment that in the East was also used as a blanket.

Jacob is depicted lying on the ground on the road to Haran, dreaming of a staircase that leads from earth to Heaven. The dream and the divine revelation within it have clear symbolic meaning. In antiquity, dreams were believed to be a direct manifestation of divinity.

William Blake, *The Dream Jacob's Ladder*, ca. 1790. London, The British Museum.

Only after many years of work for his father-in-law, Laban, does Jacob obtain his beloved Rachel as his wife. After the birth of Joseph, they depart for the land of Canaan.

Jacob and Rachel

The Place
The meeting at the well takes place in Haran.

The Time
The meeting occurs when Jacob arrives on his journey from Canaan. After about twenty years in Haran with Laban, Jacob and Rachel depart for Canaan.

The Figures
These vary: Jacob, Rachel, and shepherds; Jacob, Rachel, Joseph, Leah, Leah's children, servants, Laban, and his servants

The Sources
Genesis 29:1–14; 31:1–54

Variants
Rachel meeting Jacob at the well; Rachel sitting upon the idols of her father

Diffusion of the Image
Widespread

After wandering for a long time, Jacob arrives in Haran, where he lodges with his mother's brother Laban. There, he meets his cousin Rachel. He single-handedly moves the heavy stone that covers the well, allowing her sheep to drink. Jacob then stays with Laban and works for him as a shepherd. Later the two agree that the young man must stay in Laban's service for seven years before he can marry his beloved Rachel. But at the end of seven years Laban, through trickery, first gives him her ugly older sister Leah as a wife. Jacob wins the beautiful Rachel only after another seven years of work. He has numerous children by his first wife, but only after a long wait is Rachel able to give birth to Joseph, his favorite son.

Jacob then wishes to return to his native country, and he sets out in that direction with his flocks, wives, and children. Without her husband's knowledge, Rachel steals the statues of the domestic gods, which were destined for the legitimate heir, from her father. As soon as Laban realizes his loss, he and his sons catch up to Jacob and accuse him of theft. Maintaining his innocence, Jacob allows his camp to be searched for the statues, with no result. Before they part ways, Laban and Jacob are reconciled.

▶ William Dyce, *Rachel Meeting Jacob at the Well* (detail), ca. 1850–53. Leicester, City Museum.

Laban has been identified as the figure at the left. He moves toward Jacob and welcomes him, saying, "Surely you are my bone and my flesh!"

The episode of meeting Rachel at the well is one of the most frequently depicted of Jacob's life. As soon as he sees his cousin, Jacob is completely taken with her. With superhuman strength, he manages to roll away a huge stone from the well in order to water Laban's animals.

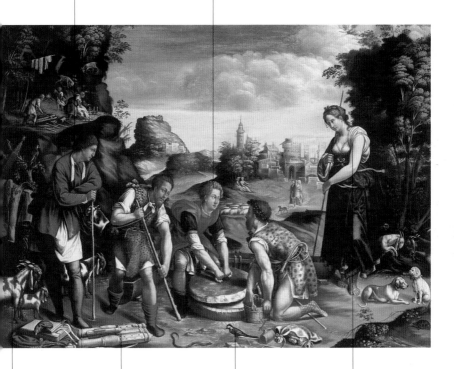

Among the many details inserted in this composition is a set of reed pipes, the typical instrument of shepherds.

The bird that fixes on the snake in front of it could be a commentary on Laban's strategy to make Jacob stay with him for an extra seven years.

Rachel, described in the Bible as being "beautiful and lovely," witnesses the scene.

The spotted goats near Laban could allude to Jacob's reward for the second seven years that he works for his father-in-law.

▲ Master of the Twelve Apostles, *Rachel Meeting Jacob at the Well*, ca. 1525. New York, private collection.

Jacob and Rachel

Jacob makes an agreement with Laban: in reward for his work, he will take those animals from the flock that are spotted or black, while the others will remain Laban's.

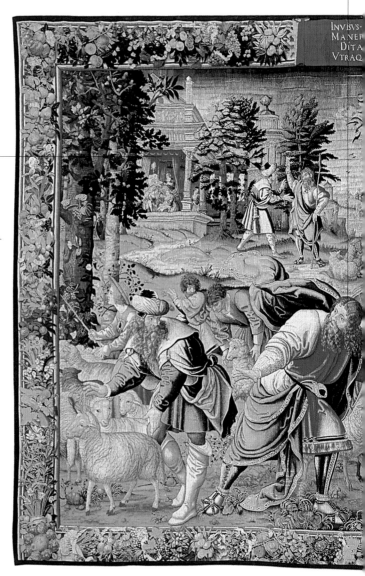

In the building depicted in the background, Rachel, whom Jacob was able to marry only after fourteen years of work for his father-in-law, gives birth to Joseph.

INVISVS·
MANEI
DITA
VTRAQ

▶ Made in Brussels, *Jacob Dividing Laban's Flock*, 1528–34. Tapestry. Brussels, Musées royaux des beaux-arts.

Jacob takes some tree branches and makes strips from their bark, which he places in the drinking troughs of the animals. Through this trick, the majority of the lambs born after the animals mate will be either black or spotted.

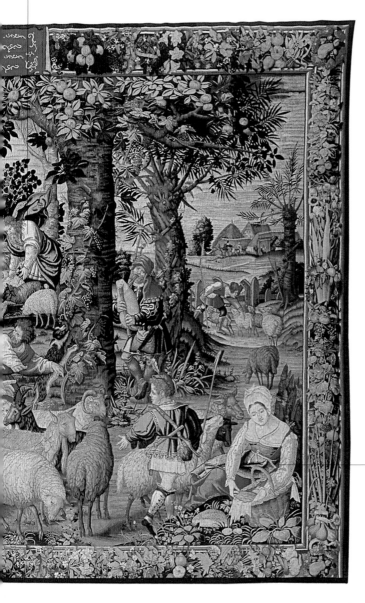

A shepherd girl takes food from a large basket in the right foreground.

Jacob and Rachel

Unaware of his wife's trickery and sure of her innocence, Jacob allows his father-in-law to inspect his camp. Rachel's theft may relate to a custom in the ancient Near East, which decreed that possession of the statues sanctioned the rights of inheritance.

Intent on shepherding, holding a pastoral staff, is Jacob's fourth son, Judah. He is the forefather of what will become the richest tribe in the future, into which David, Solomon, and Jesus himself will be born. Jacob will transfer command over the other tribes to him.

With her back turned toward the mountainous landscape, Rachel's slave Bilhah points toward the central scene with her right hand. Next to her are her two sons, Dan and Naphtali.

This episode is set in the mountains of Gilead, along the road that Jacob and his family use to return to Canaan.

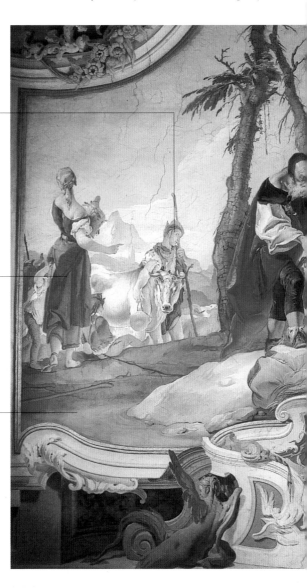

Under the tent holding an amphora is Leah, her slave
Zilpah, and one of Laban's brothers, who all attentively
observe what is happening. Next to the two women are
six brothers and Dinah, the only girl.

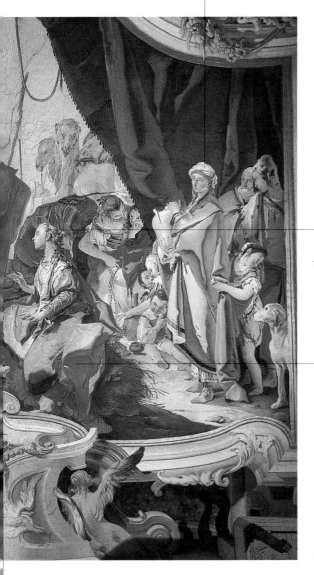

At the request of Laban, who
is searching for his idols, the
woman says, "Let not my
lord be angry that I cannot
rise before you, for the way
of women is upon me."
Because of this ruse, her
father does not find them.

To be able to keep the terafim that
she stole from her father, Rachel
resorts to a clever ruse. She hides
the statues of idols under the
camel saddle she is sitting on and
pretends that she is suffering due
to menstruation.

The Hebrew term terafim, which
means "household gods," has
uncertain significance. Most
likely it indicates the family
divinities and, therefore, tiny
statues. These were endowed
with some sort of divinity or the
ability to predict the future.

◄ Giovanni Battista Tiepolo,
*Rachel Sitting on the Idols of
Her Father*, 1726–28. Udine,
Palazzo Arcivescovile, Galleria
degli Ospiti.

Joseph is portrayed next to Rachel; at this point he is the
youngest of Jacob's children and the first by his beloved wife.

This episode, when Jacob first assumes the national name of "Israel," is widely interpreted as an allusion to allegorical battles, or to the struggle between man and God.

Jacob Wrestles the Angel

During his return trip to the land of Canaan, the country of his ancestors, Jacob fears the retribution of his brother, Esau, and he sends out a scouting party. The party returns and reports that his brother is marching toward them with four hundred men. Jacob then decides to send servants with the best heads from his flocks to meet Esau and to ingratiate themselves, after which he will follow with his family.

The servants, therefore, each with part of the flock, head toward Esau, while Jacob spends the night at the camp. Needing to cross the river Jabbok, Jacob takes his wives, servants, and eleven sons in the middle of the night and crosses at a ford to the other bank. There, as Jacob waits by himself, a man approaches him and wrestles with him until the break of dawn. When the stranger sees that he cannot beat Jacob, he dislocates the joint of Jacob's hip and tells him, "Let me go, for the day is breaking." Jacob responds, "I will not let you go, unless you bless me." The man replies, "Your name shall no more be called Jacob, but Israel, for you have striven with God and with men, and have prevailed." Then he blesses Jacob. Jacob calls the place Peniel, because there he saw God face-to-face and survived.

The Place
Near the river Jabbok, a tributary on the left bank of the river Jordan that crosses the region of Gilead in Jordan.

The Time
During the return trip to Canaan

The Figures
Jacob and a man

The Sources
Genesis 32:23–33

Variants
This episode was interpreted in various ways, depending on the period of Christian art.

Diffusion of the Image
A common scene ever since paleochristian times

▶ Giuseppe Maria Crespi, *Jacob Wrestling the Angel* (detail). Stockholm, The Royal Collection.

At the beginning of Christian art, Jacob is shown wrestling directly with God. Later God is replaced by an angel to symbolize the struggle between the human and divine. In medieval art Jacob often clashes with a demon, to illustrate allegorical combat between virtue and vice.

The scene is set along a ford of the Jabbok, a passageway for caravans of merchants who were en route to Damascus, crossing present-day Jordan on the way to the Red Sea. Rivers quite often signaled the borders between the territories of different tribes. The difficulty of crossing the ford was interpreted as a confrontation with the "river gods."

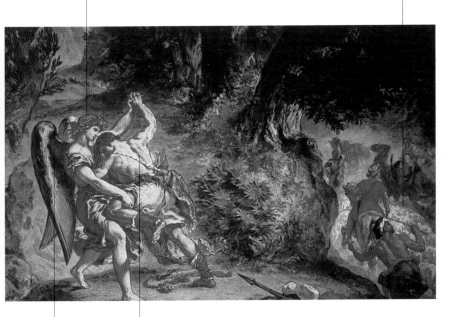

Jacob seeks to beat the angel but is hit on the thigh. (This is reminiscent of the legendary episode of St. Christopher and the angel.)

The mysterious being came to be interpreted as an angel, although he is only called a "man" in the biblical text. He conceals his identity, remaining shrouded in divine secrecy.

▲ Eugène Delacroix, *Jacob Wrestling the Angel*, 1850–61. Paris, Saint-Sulpice.

Jacob Wrestles the Angel

A tree, placed on the diagonal, divides the red meadow, isolating the scene of Jacob wrestling the angel from the Breton women praying.

The decisive significance of this scene concerns the change that takes place in Jacob, who is no longer called by that name but rather by "Israel." His new name illustrates a change in Jacob's calling and destiny: he becomes the founding father of the people of Israel.

This episode has also been read as an example of the conflict between "church" and "synagogue," with Jacob's sick leg symbolizing the Jews, who did not recognize Jesus as the Messiah. The idea that a withered limb is a symbol of disbelief is also found in the tale of the two nurses at the Nativity of Christ.

The being that appears to Jacob and seeks to overcome him symbolizes the divine mystery; after encountering it, Jacob emerges defeated and limping, yet transformed.

A group of Breton women are portrayed kneeling in the foreground, set off by their characteristic white bonnets.

▲ Paul Gauguin, *The Vision after the Sermon; Jacob Wrestling with the Angel*, 1888. Edinburgh, National Gallery of Scotland.

► Francesco Hayez, *The Reconciliation of Esau and Jacob* (detail), 1844. Brescia, Pinacoteca Tosio Martinengo.

Returning to the land of Canaan, Jacob finds himself before his brother Esau and a company of four hundred men. Unexpectedly, the meeting ends with an embrace.

Jacob Reconciles with Esau

After sending his brother the best heads from his flocks, and having spent the night wrestling with an angel, Jacob watches Esau arrive with a company of four hundred armed men. Dividing his wives and children, he places the servants and their children first, then Leah with hers, and finally Rachel and Joseph, so that they can flee if they need to. He places himself in front of them all and, at Esau's arrival, bows seven times to the ground. Counter to Jacob's expectations, as soon as Esau sees his brother, he runs to greet him, embracing and kissing him. Both weep for joy at seeing each other. "Who are these with you?" Esau asks his brother. Jacob has the women draw near with their children, and they bow before Esau.

Amazed at the flocks that preceded his brother's arrival, Esau asks, "What do you mean by all this company which I met?" "To find favor in the sight of my lord," Jacob replies. Esau does not mean to accept such a gift, but his brother insists and eventually convinces him. Esau then proposes that they walk back home together, but Jacob prefers to go slowly, respecting the pace of the children and the suckling animals.

The Place
On the road returning to Canaan

The Time
The day after Jacob wrestles the angel

The Figures
Jacob, Leah, Rachel, the children, servants, Esau, and his warriors

The Sources
Genesis 33:1–17

Variants
Jacob portrayed kneeling before Esau, followed by his family and servants

Diffusion of the Image
Relatively rare

In the Middle Ages, this episode was read as an allusion to Judaism being supplanted by Christianity, and Jacob's crossed arms were seen as a symbol of the cross.

Jacob Blesses the Sons of Joseph

The Place
In Egypt

The Time
A short time before
Jacob's death

The Figures
Jacob, Joseph,
Ephraim, and
Manasseh

The Sources
Genesis 48

Variants
Jacob Blessing
Ephraim and
Manasseh

**Diffusion of
the Image**
It occurs in various
iconographic depictions in medieval and
Renaissance Christian art. Up until the
Renaissance, Jacob
is portrayed generally with his arms
crossed, but this is
seen less often in
later periods.

▶ Rembrandt Harmensz. van
Rijn, *Jacob's Blessing* (detail),
1656. Kassel, Gemäldegalerie.

Jacob's favorite son, Joseph, becomes viceroy of Egypt, and the pharaoh gives him the beautiful Asenath, daughter of an Egyptian priest, to be his wife. Asenath bears him two sons, Ephraim and Manasseh. Joseph welcomes his brothers and Jacob to the pharaoh's court. Then he brings his two sons to be blessed by his father, who is near death, so that they may partake in the promises received from God. Jacob tells Joseph that the two children will become his own sons, while those who are born afterward will remain Joseph's.

Jacob blesses the two children, crossing his hands with his right on Ephraim's head and his left on that of Manasseh, although the latter is the first-born. Joseph thinks his father is mistaken, but Jacob explains, "I know, my son, I know; he also shall become a people, and he also shall be great; nevertheless his younger brother shall be greater than he, and his descendants shall become a multitude of nations." With his blessing, Jacob indicates that, among the tribes of Israel, Ephraim's would be more important than that of Manasseh.

The elderly Jacob, by adopting the two children of Joseph, will make them equal to his sons and therefore to the forefathers of the tribes of Israel. The ritual of adoption includes a series of gestures: the kiss, the embrace, the placing of the adoptee in one's lap "between the knees," the laying of hands, and the blessing.

Joseph seeks to correct his father's blessing with his hands.

Joseph's wife, Asenath, witnesses the scene from the side.

Manasseh's face appears saddened by his grandfather's unexpected choice.

Ephraim will be the head of ten tribes that make up Israel's northern kingdom. The blessing, in fact, implies special wishes for fertility. Ephraim's becomes one of the most powerful and influential tribes in northern Israel.

The patriarch lays his right hand on the second-born Ephraim. In the Bible, the right hand is a symbol of luck and success.

The inversion of the hands has historical and spiritual meaning, indicating the preeminence that the tribe of Ephraim will have over that of Manasseh and the fact that divine choices follow not the ways of inheritance but those of grace.

▲ Rembrandt Harmensz. van Rijn, *Jacob's Blessing*, 1656. Kassel, Gemäldegalerie.

FROM EGYPT TO THE PROMISED LAND

Johann (Pan) Liss, *The
Finding of Moses*, 1626–27.
Lille, Musée des beaux-arts.

Bruges School illuminators,
The Brazen Serpent, late
fifteenth century. Miniature
from the Grimani Breviary.
Venice, Biblioteca Marciana.

The adventurous episodes in the story of Joseph have inspired numerous artists, partly because this character was interpreted as a prefiguration of Christ.

Joseph

The Place
Though born in the land of Canaan, Joseph lives in Egypt after being sold by his brothers. At his death, his remains are brought to his native land near Shechem.

The Time
Around 1650 B.C.

The Sources
Genesis 37–50

Diffusion of the Image
The stories of Joseph's life have been widespread in Christian art since the sixth century, especially within cycles of paintings and in medieval religious art, thanks to the interpretation that the figure of Joseph prefigures that of Christ.

Jacob's eleventh son and the first by his beloved Rachel, Joseph is the favorite of his elderly father. His jealous brothers decide to sell him to some Ishmaelite slave merchants and to blame his disappearance on a wild beast. After being brought into Egypt, Joseph is bought by Potiphar, the captain of the pharaoh's guard, who eventually appoints him to be his overseer. Imprisoned after being falsely accused by Potiphar's wife, Joseph is placed at the head of the other prisoners and favorably interprets the dream of the pharaoh's chief butler there. When the butler returns to his job, he invites the sovereign to have Joseph interpret the disturbing dreams that have assailed him. Joseph tells the pharaoh that his dream foretells seven years of plenty followed by seven years of famine. Winning the pharaoh's trust, the young man is asked to manage a portion of the country's economy. As predicted, a great famine strikes many of the bordering regions, and soon a number of people pour into Egypt to buy grain. Among these are Joseph's brothers. After recognizing them and making them repent of their past actions, Joseph helps them settle in Egypt with their father's entire tribe.

◀ Antonio Castillo y Saavedra, *Joseph Explaining the Pharaoh's Dream*. Madrid, Museo del Prado.

This is the first episode in the stories of Joseph. It is often depicted along with the scene of Joseph in the well, or with his brothers showing their father his bloody garment.

Joseph Is Sold by His Brothers

Favored by his father because he is the child of Jacob's beloved Rachel, Joseph is resented by his brothers because he does not work in the fields and is able to interpret dreams. Their envy increases when their father gives their younger brother an elegant garment for his seventeenth birthday. Making things even worse, one night Joseph dreams that his brothers' sheaves of grain bow before his, and even the sun, moon, and stars prostrate themselves before him.

As a result, when Joseph's father sends him to join his brothers in a remote pasture, they throw him into a dry well, intending to kill him. They decide, however, to sell him to some slave merchants who are journeying to Egypt. They soil the boy's coat with animal blood and bring it to Jacob, leading him to believe that a ferocious beast has killed his son. The aged father falls into inconsolable mourning.

The scene of Joseph being lowered into the well and the subsequent one, when he is pulled out, have been seen as prefiguring the Entombment of Christ and his Resurrection.

The Place
In Dothan, near Shechem, in a pasture far from Jacob's house

The Time
When Joseph is about seventeen years old

The Figures
Joseph, his brothers, and Ishmaelite merchants

The Sources
Genesis 37:1–36

Variants
The scene of Joseph being lowered into the well often precedes this episode. Sometimes it is followed by the episode in which his brothers show their father Joseph's bloody robe.

Diffusion of the Image
Quite widespread

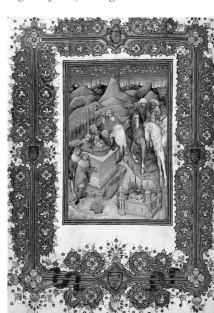

Luchino Belbello, *Joseph Being Pulled from the Well and Sold by His Brothers*, ca. 1415. Miniature from the Visconti Hours. Florence, Biblioteca Nazionale.

Joseph Is Sold by His Brothers

Joseph, kneeling, weeps at
his impending fate. He is
about to be taken into
Egypt and sold as a slave.

► Gioacchino Assereto,
*Joseph Being Sold by His
Brothers*, ca. 1625. Private
collection.

The Ishmaelite slave merchant is shown buying Joseph from his brothers.

The brothers are distinguishable from the merchants by their shepherds' clothing. Reuben, the eleventh brother, did not agree with those who wanted to kill Joseph.

The bargaining takes place in Dothan, twelve miles from Shechem, in a pasture that is far from Jacob's house and near the well into which Joseph's brothers lowered him.

Joseph Is Sold by His Brothers

Joseph's brothers wear the short, sleeveless tunics typical of shepherds.

The brothers carrying the robe watch their father to see if he believes their lie.

The "robe with long sleeves" that Jacob gave to Joseph was a symbol of distinction and dignity: full-length garments such as this one, reaching down to the feet, were meant for princes, not those dedicated to work. The brothers have stained it with animal blood.

▶ Diego Rodriguez de Silva y Velázquez, *Jacob Receiving Joseph's Bloody Tunic*, 1630. El Escorial, San Lorenzo Monastery.

The expression of the man in the hat seems to betray a smile, while the young man in front of him appears to reflect on what is happening.

When Jacob receives news of his son's slaughter, he opens his arms as a sign of his enormous pain. The father, shown barefoot on a carpet, remains inconsolable in his sorrow until he sees his son again in Egypt.

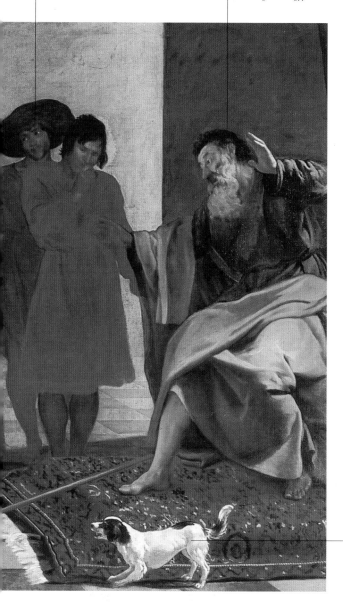

Only the dog, thanks to its keen sense of smell, realizes that the robe is stained with animal blood rather than Joseph's. No one, however, pays any attention to its barking.

Potiphar's wife, who falls in love with Joseph, represents the shrewd, seductive foreign woman. This episode faithfully follows a recurrent motif in popular tales of its time.

Joseph and Potiphar's Wife

The Place
The bedroom of Potiphar's wife, in Egypt

The Time
When Joseph serves the pharaoh's minister Potiphar

The Figures
Joseph and Potiphar's wife, and sometimes Potiphar in the scene when the minister's wife accuses Joseph

The Sources
Genesis 39:7–20

Variants
Potiphar's wife; Joseph being accused by her

Diffusion of the Image
Somewhat widespread

After being brought into Egypt, Joseph is sold to Potiphar, one of the pharaoh's ministers. Joseph is immediately successful with his master, so much so that he is appointed overseer of his palace and his goods. Potiphar's wife falls in love with him and tries to convince Joseph to lie with her. The young man refuses decisively, saying, "Lo, having me my master has no concern about anything in the house, and he has put everything that he has in my hand; he is not greater in this house than I am; nor has he kept back anything from me except yourself, because you are his wife; how then can I do this great wickedness, and sin against God?"

One day, when the two are alone, the woman seizes him by his cloak, seeking to hold him. Joseph, instead, flees headlong, leaving his garment behind in her hands. The disappointed woman decides to take her revenge: she accuses Joseph of having tried to seduce her. Potiphar believes her, and the young man, falsely accused by his master, is thrown into prison. But there, too, he manages to distinguish himself, and the warden charges him with overseeing the inmates.

▶ Jacopo Tintoretto, *Joseph and Potiphar's Wife* (detail), 1555. Madrid, Museo del Prado.

When the young Joseph refuses to lie with her, Potiphar's wife seeks to stop him by holding on to his cloak.

This animated scene is set within Potiphar's bedroom, where a matrimonial bed can dimly be seen.

The annoyed expression on Joseph's face contrasts with the disappointed look of the woman, who has failed in her attempt to win over her husband's young manager.

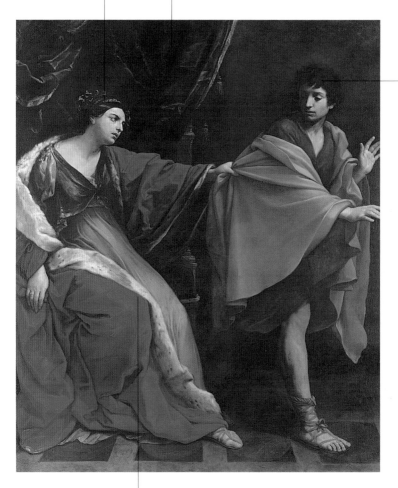

As is often the case with foreign women in the Bible, the wife of the Egyptian minister symbolizes feminine guile.

▲ Guido Reni, *Joseph and Potiphar's Wife*, ca. 1620. Holkham, Viscount Coke Collection.

139

Joseph and Potiphar's Wife

Young Joseph, identifiable by his sad and disconsolate gaze, knows that he cannot defend himself against the false testimony of Potiphar's wife.

The scene is set in the bedroom of Potiphar and his wife.

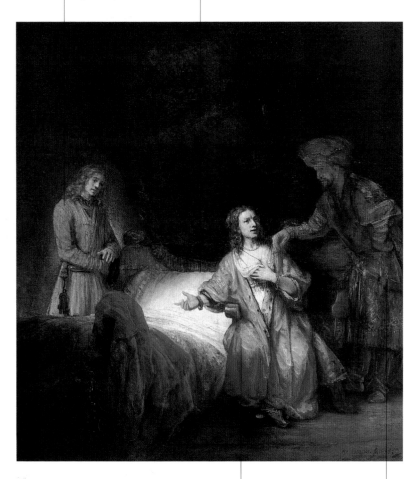

Potiphar's wife tells her husband how Joseph tried to entice her, using the young man's cloak as proof. Rembrandt has depicted the woman with great realism: she is attractive, but no longer young.

Incredulous and upset, Potiphar listens to his wife's accusations. They erode his complete trust in Joseph, whom he had appointed manager of his property.

▲ Rembrandt Harmensz. van Rijn,
Joseph Accused by Potiphar's Wife, 1655.
Washington, D.C., National Gallery of Art.

Numerous episodes of Joseph's life demonstrate his ability to interpret dreams: at his father's house when he is seventeen; when he is in prison in Egypt; and with the pharaoh.

Joseph Interprets Dreams

As a child, Joseph often tells his father, Jacob, and his family of his dreams: one in which his brothers' sheaves of grain bow before his, and another in which the sun, the moon, and the stars prostrate themselves before him. Both dreams symbolize his future status.

His ability with dreams provokes his brothers' envy, and they sell him to slave merchants who are on their way to Egypt. Later, when he is thrown in jail after being accused falsely by Potiphar's wife, Joseph interprets the dreams of two of his fellow prisoners. One is the pharaoh's chief butler, who Joseph predicts will be reinstated in his position, and the other is the chief baker, who instead will be hanged. Finally, Joseph is summoned by the chief butler to interpret the pharaoh's incomprehensible riddle of a dream:

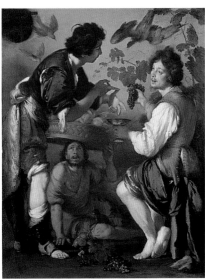

thin cows devour fat ones and thin ears of grain devour plump ones. Joseph realizes the dream's significance: it announces seven years of good harvests followed by another seven of famine. He advises the pharaoh that in order to meet this challenge he must find a wise manager. The sovereign, convinced of Joseph's managerial talents, decides to name him viceroy and carries out a solemn ceremony of installation.

The Place
In the house of Jacob in the land of Canaan; in an Egyptian prison; and in the pharaoh's palace, also in Egypt

The Time
At different moments in Joseph's life

The Figures
These vary: Joseph, Jacob, and the brothers; Joseph, the pharaoh's butler and baker; and Joseph, the pharaoh, and Egyptian priests

The Sources
Genesis 37:1–11, 40, 41:1–46

Variants
Joseph telling his dreams; Joseph explaining the prisoners' dreams; and Joseph explaining the pharaoh's dreams

Diffusion of the Image
Very widespread

◀ Bernardo Strozzi, *Joseph Interpreting Dreams*, ca. 1625. Genoa, private collection.

Joseph Interprets Dreams

This painting depicts the moment in which the boy tells his family his dreams: in one his brothers' sheaves of grain bow before his, and in another the sun, the moon, and the stars kneel before him.

Joseph is seventeen years old and has already gained the ability to interpret dreams.

One of his brothers, worried about the future, listens attentively to his younger brother's predictions.

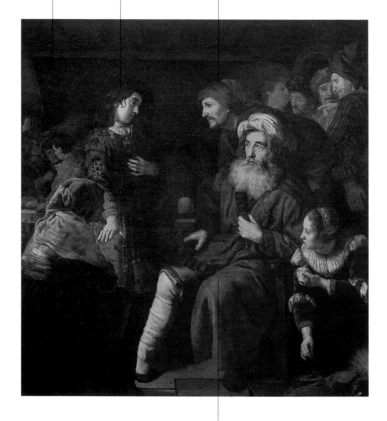

Jacob, who has grown old, also listens carefully to the son chosen by God.

▲ Jan Victors, *Joseph Telling His Dreams to His Family*, 1651. Düsseldorf, Kunstmuseum.

This scene is set in a jail cell, where Joseph has been imprisoned after being falsely accused by Potiphar's wife.

The chief baker tells how, in his dream, he has three baskets on his head, and on the highest there are many kinds of foods for the pharaoh, yet birds eat them. Joseph predicts that he will be hung from a pole in three days' time, and birds will eat his corpse.

The elegantly dressed Joseph interprets the dreams of the pharaoh's chief butler and baker.

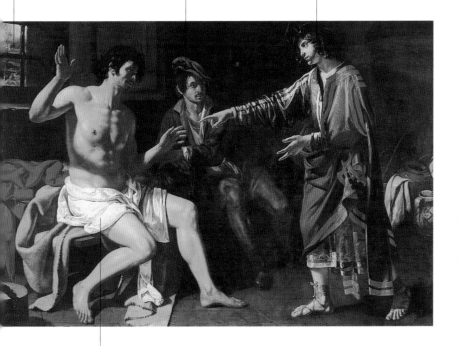

The chief butler dreams of having before him a vine with three branches, which begin to bud, blossom, and bring forth ripened grapes. He takes one of the pharaoh's cups, squeezes the grapes, and places it in the sovereign's hand. Joseph predicts that he will be reinstated in his position in three days' time.

Giovanni Francesco Guerrieri, *Joseph Explaining the Prisoners' Dreams*, ca. 1620. Rome, Galleria Borghese.

Joseph Interprets Dreams

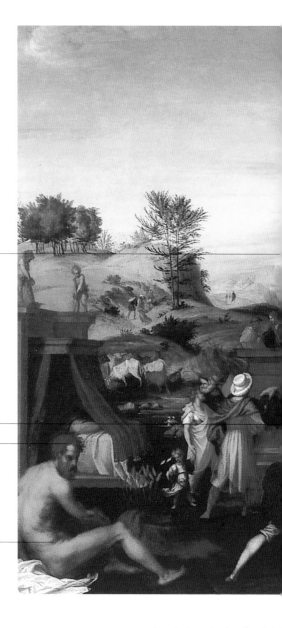

Thanks to the suggestion of the pharaoh's chief butler, Joseph is freed from prison so that he can interpret the sovereign's mysterious dreams.

Joseph is able to interpret the pharaoh's dreams with divine help, which the Egyptian priests cannot. In contrast to Egyptian and Babylonian ways of thinking, the Bible says that those who are wise submit to God and evaluate everything in light of faith.

In antiquity the dreams of the king had special significance, since the sovereign was often considered a son of God, particularly in Egypt. His dreams were therefore seen as revelations of the divine will.

The sovereign is upset as he ponders the significance of his dream: he is on the bank of the Nile when seven fat cows emerge from the river. Seven thin cows follow them and devour the first group. He then sees seven fat ears of grain fall from the sky and just as many thin ears, which devour them.

Joseph advises the pharaoh to find a wise manager. He must store up enough grain during the years of prosperity to face the years of famine.

This crowded scene
includes more than
ne episode.

This panel is part of a series
painted for the nuptial chamber of
Pierfrancesco Borgherini, on which
del Sarto, Pontormo, Granacci,
and Bacchiacca collaborated.

▲ Andrea del Sarto, *Life of Joseph
the Hebrew*, ca. 1520. Florence,
Galleria Palatina.

Joseph Interprets Dreams

After Joseph interprets his mysterious dream, the pharaoh decides to appoint him viceroy and he carries out solemn rites of installation. In this episode, the sovereign places a gold necklace with the royal seal around Joseph's neck.

The installation ceremony calls for the rituals of investiture: the bestowal of the ring with the royal seal, ceremonial garments, a gold necklace, and finally a procession.

Another servant holds the ceremonial cloak that Joseph is to wear.

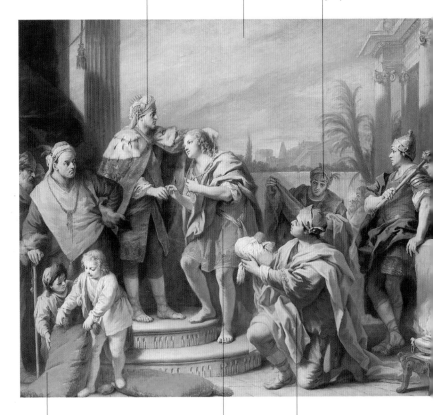

Joseph humbly accepts the investiture and the esteemed commission.

A brazier containing incense is lit to consecrate the ceremony of investiture.

Two children lay two stuffed cushions at the foot of the stairs where Joseph is to descend.

A kneeling servant passes Joseph an Eastern-style headdress.

▲ Jacopo Amigoni, *Josep in the Palace of the Pharaoh*, ca. 1750. Mad Museo del Prado.

The reconciliation of Joseph with his brothers, and his meeting with his aged father, Jacob, who thought he was dead, are among the most moving scenes of the Old Testament.

Joseph Is Reconciled with His Brothers

As Joseph foretold, the famine arrives after seven years of abundance and spreads beyond Egypt's borders, striking a number of neighboring countries. Thanks to the reserves of grain accumulated in the good years, Joseph is able to sell the surplus to the neighboring peoples. Among those who arrive in Egypt to buy grain are Joseph's brothers, who have been sent by their father, Jacob. Without letting himself be recognized, Joseph asks them news of their father and of Benjamin, the only brother who had remained at home. Joseph keeps one of them hostage, promising to let him go only when they agree to bring back their younger brother. Jacob does not want Benjamin to leave because he is the last remaining son of his beloved Rachel, but he is forced to agree when the foodstuffs run out again. Joseph welcomes his brothers to Egypt, and, after filling their sacks with grain, he places a silver cup in Benjamin's sack and sends soldiers after his brothers to bring them back to the palace. Testing the brothers' affection for Benjamin, Joseph pretends to seize their young sibling. He then reveals his identity. Later Jacob and his children are welcomed in Egypt, where the pharaoh hires Joseph's brothers to supervise his cattle.

The Place
In Egypt, in the palace of the pharaoh

The Time
After seven years of abundance, just as many years of famine follow.

The Figures
Joseph, his brothers, and Jacob

The Sources
Genesis 42–45

Variants
Frequently associated with other moments in his life: Joseph selling grain to his brothers; the discovery of the silver cup in Benjamin's sack; the meeting of Joseph with his father, Jacob; and the presentation of Joseph's brothers and father to the pharaoh

Diffusion of the Image
Somewhat widespread

◀ Francesco Granacci, *Joseph Presenting His Father and Brothers to the Pharaoh*, 1515. Florence, Galleria degli Uffizi.

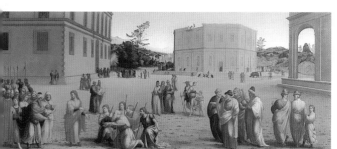

Joseph Is Reconciled with His Brothers

The soldier points to Benjamin as
the guilty party. Benjamin's face
expresses his distress, since he
knows he did not commit the
theft of which he is accused.

The soldier and Joseph's steward
overtake the brothers, who had
only just departed from the
pharaoh's palace, and find the
silver cup in Benjamin's sack.

The man on horseback
wearing a turban represents
the steward, whom Joseph
had sent to accomplish this
mission.

Joseph's silver cup may be linked to
the ancient practice of looking into a
bowl of water tinctured with a few
drops of oil in order to discern the
will of the gods. The cup is a symbol
of abundance and immortality, and
it was used as an instrument of
communion with God.

Joseph orders that a silver cup be
placed in Benjamin's sack in order
to make his brothers return to the
palace and to test their affection
for their younger brother.

▶ Claes Cornelisz Moeyaert, The
Finding of the Cup in Benjamin's Sack,
1627. Budapest, Szépmüvészeti
Múzeum.

One of Joseph's eleven brothers looks desperately toward the sky and tears open his clothing. The gesture of rending one's garments is generally a sign of indignation or struggle. Because the cup was considered a sacred object, its theft was punishable by death.

Opening their sacks, the other brothers demonstrate that they have not stolen anything from the pharaoh's palace.

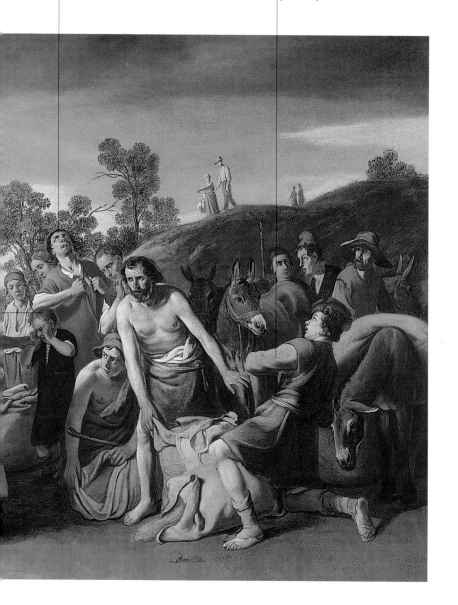

Joseph Is Reconciled with His Brothers

Several of Joseph's brothers appear in the scene.

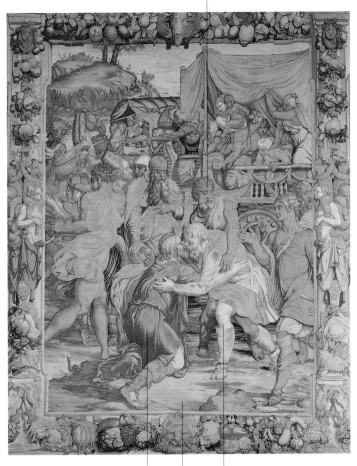

Joseph throws himself on his knees before his father.

The elderly Jacob, supported by one of his sons, seems almost to bow before his beloved Rachel's favorite son, whom he had believed was long dead.

▲ Nicolas Karcher, *Joseph Meeting His Father*, 1549. Tapestry. Florence, Palazzo Vecchio.

Joseph's meeting in Egypt with his adored father represents a moment of particular emotional intensity.

Influences from northern European painting have been cited in describing this landscape, which is populated with tiny figures. Art criticism has particularly noted its similarity to a motif taken from a print by Lucas van Leyden.

This is the last panel from the nuptial chamber of Pierfrancesco Borgherini, which features multiple and complex references to the most important representatives of Florentine painting, such as Giotto, Masaccio, Botticelli, and Michelangelo.

In the foreground, the scene of the presentation of Jacob to the pharaoh appears. The stature and monumentality of the figures recall works by Raphael and Michelangelo in Rome.

Along the central diagonal of the composition, Joseph stands on a cart and distributes food to the people of Egypt.

Inside a room covered by a large canopy of green fabric, the episode of the elderly Jacob blessing Joseph's sons, Ephraim and Manasseh, is shown.

Jacopo Pontormo, *Joseph with Jacob in Egypt*, probably 1518. London, National Gallery.

Guide and legislator of the Hebrew people and bearer of the tablets of the Law, Moses frees the people of Israel from Egyptian slavery and leads them through the desert toward the Promised Land.

Moses

The Place
The life of Moses takes place between Egypt, Midian, Mount Horeb, Mount Sinai, the plateau east of the Jordan, and Mount Nebo.

The Time
Moses lived in the thirteenth century B.C. The Exodus and life in the desert under his leadership took place between 1290 and 1265 B.C.

The Sources
Exodus, Leviticus, Numbers, and Deuteronomy

Attributes
The tablets of the Law, the staff, the bronze serpent, and sometimes two horns on his head

Diffusion of the Image
The episodes of Moses' life are quite common in art because he is one of the most direct prefigurements of Christ in the Old Testament.

▶ Michelangelo Buonarroti, *Moses*, ca. 1515. From the funerary monument of Pope Julius II. Rome, San Pietro in Vincoli.

Son of the Levite Amram and his wife Jochebed, Moses is the younger brother of Miriam and Aaron. As a child he is adopted by the pharaoh's daughter and raised as an Egyptian prince. As an adult he sees an Egyptian slave guard striking an Israelite and kills the guard. He flees to Midian, where he marries Zipporah, daughter of Jethro. On Mount Horeb he has a vision of a burning bush and receives the divine command to return to Egypt to free the people of Israel. After numerous attempts to convince the pharaoh to let his people go, Moses leads Israel toward Canaan and Mount Sinai, where he receives the Ten Commandments. In old age, Moses dies on Mount Nebo without being able to enter the Promised Land.

Moses is generally depicted with a white beard and long hair, not as a young, beardless man. Rays of light come from his head, and sometimes horns. This representation originates from an erroneous translation of the Latin term *cornuto* as "horned" in the Vulgate to describe Moses' face when he descended from Mount Sinai after receiving the tablets of the Law. *Cornuto* also signified "shining from rays of light" in the Latin of that period.

Here the tablets of the Law do not
have the usual rounded tops but
appear instead as blocks of stone
with rectilinear edges.

Because of an erroneous translation of the Bible in the
Vulgate, the patriarch is often represented with two horns
on his head. Here, in contrast, his face is shown "radi-
ant" with light. That is how the Bible describes Moses
after he has received the second tablets of the Law.

Moses is shown in half-length, leaning on a
balustrade as he holds the tablets of the Law
with his right hand and a staff with his left.

The legislator is
portrayed in elegant
clothes, probably a
ceremonial robe.

Phillippe de Champaigne, *Moses with
the Tablets of the Law*, ca. 1650. St.
Petersburg, Hermitage.

Moses

Moses stands before the burning
bush and receives from God the
task of leading the Israelites out of
Egypt to the land of Canaan.

Moses takes off his san-
dals before approaching
the burning bush, since
it is in a sacred place.

This fresco forms a
parallel with another
portraying the temp-
tations of Christ,
which also appears
on the walls of the
Sistine Chapel.
Among the figures of
the Old Testament,
Moses is one of
the most direct
prefigurements of
Christ. There are
numerous concor-
dances between
episodes of the
two figures' lives.

▲ Botticelli (Alessandro di Mariano Filipepi),
Moses and the Daughters of Jethro, 1482.
Vatican City, lateral wall of the Sistine Chapel.

Generally this episode is
interpreted as Moses leading
the Israelites out of Egypt.

Moses drives away the shepherds, who keep the daughters of Jethro from watering their animals.

After murdering the Egyptian guard, Moses flees to the land of Midian.

This Israelite, compelled to forced labor, is aided by a woman.

At the well of Midian, Moses waters the animals of the daughters of Jethro, a local priest. After becoming a shepherd for Jethro, he marries one of his daughters, Zipporah.

Although he was not raised in the Hebrew religion, Moses kills an Egyptian guard for wounding an Israelite.

Representations of this episode often depict the basket on the Nile, or else the scene of Moses' rescue with maidservants crowding around the child.

The Finding of Moses along the Nile

The Place
On the banks of the Nile

The Time
When Moses is three months old

The Figures
The pharaoh's daughter, her maidservants, Moses in a basket, and sometimes his sister, Miriam, hidden behind the reeds of the Nile

The Sources
Exodus 2:1–10

Variants
Moses being entrusted to the waters

Diffusion of the Image
This episode is quite widespread in the iconography of Christian art as prefiguring the Flight into Egypt.

► Orazio Gentileschi, *Moses Being Saved from the Waters of the Nile* (detail), ca. 1630. Madrid, Museo del Prado.

Thanks to Joseph, the descendants of the people of Israel settle in Egypt and become numerous. A new pharaoh, however, fearing their increasing numbers, enslaves them and then decides to kill all their male children. The Israelite Amram and his wife Jochebed, already possessed of a daughter named Miriam, have a son named Moses. At first the mother tries to hide him at home but then she decides to place him in a basket spread with pitch, which she puts into the Nile. The pharaoh's daughter, who has come to the riverbank with her maidservants to bathe, finds the baby and decides to keep him. Miriam, who is hidden nearby, offers to seek out a Hebrew woman to nurse the child. As a result, Moses is entrusted to his own mother, Jochebed. After weaning the child, Jochebed brings him to the pharaoh's daughter, who raises him as her own son in the Egyptian court.

The legendary origins of Moses are similar to those of a powerful Mesopotamian sovereign, King Sargon. He too was placed inside a reed basket by his mother and floated on a river. Rescued by a farm worker, Sargon went on to become a great king and the founder of an important dynasty.

This scene is set along the banks of the Nile, a few miles upriver from the pharaoh's palace, which has been depicted with the features of Castel Sant'Angelo. A variety of details from the city of Rome are recognizable in the background landscape.

Moses' sister, Miriam, points to the pharaoh's palace. The family hopes that the child in the basket will end up there.

The figure lying near a sphinx on the riverbank represents a river god and has allegorical meaning. His attributes are a quiver of arrows and the musical instrument hanging from the tree behind him.

The basket in which the baby is placed seems to be flat and made of wicker.

Moses' father, the Israelite Amram, departs, sad and disheartened at the child's uncertain fate.

Moses' older brother, Aaron, is depicted naked as he follows his father and turns to look at his little brother.

Moses' mother, Jochebed, places the child in the basket and then into the water. The woman's face reveals the desperation behind her action.

▲ Nicolas Poussin, *Moses Being Placed in the Waters*, 1654. Oxford, Ashmolean Museum.

The Finding of Moses along the Nile

The maidservants of the pharaoh's daughter are amazed at the beauty of the tiny Moses, who has been rescued from the waters. The little one resembles a figure of the Christ child.

This episode is set along the Nile River, where the princess has gone to bathe.

The princess can be distinguished from the other young women of her company by her crown and her elegant clothes, which are decorated with precious stones.

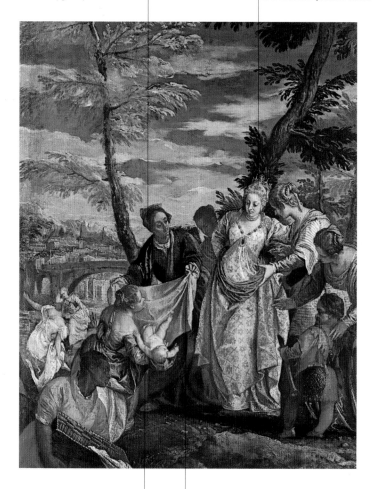

The name "Moses" can be explained according to popular tradition as meaning "rescued from the waters"; but in reality it is of Egyptian origin and means "son." In the New Testament his name denotes the Law of God, and Jesus is presented as the new Moses.

Little Moses is presented to the pharaoh's daughter by her maidservants.

▲ Paolo Veronese, *The Finding of Moses*, ca. 1570–75. Washington, D.C., National Gallery of Art.

It has been theorized that this episode from Hebrew tradition, which has no counterpart in the biblical text, is aimed at furnishing an explanation for Moses' speech defect.

Moses and the Crown of the Pharaoh

According to the Jewish historian Flavius Josephus, who lived in the first century A.D., Moses sits at the pharaoh's table with his adopted mother when he is three years old. As a game, the pharaoh takes his crown and places it on the child's head. Suddenly the boy throws it to the floor and tramples upon it. Troubled, the pharaoh asks his advisers how he should understand such a gesture, which is punishable by death. An angel, taking the shape of one of the wise men of the court, advises that precious stones and hot coals be brought for the child to choose between. By doing so, they will be able to judge if he had acted on purpose. Guided by the angel, Moses takes the coal and brings it to his mouth, wounding his lips and tongue. From that moment on, his speech is less fluent.

The Place
In the house
of the pharaoh

The Time
When Moses is
three years old

The Figures
Moses, the pharaoh,
his advisers, an
angel, and the
pharaoh's daughter

The Sources
*Antiquities of the
Jews* 2.9.7, by the
Jewish historian
Flavius Josephus

Variants
The trial of Moses

**Diffusion of
the Image**
This iconography is
not very widespread
in art history and
takes its origins from
a text by the Jewish
historian Flavius
Josephus.

◀ Giovanni Battista Ruggieri,
*Moses and the Crown of
the Pharaoh*, 1632–33.
Private collection.

Moses and the Crown of the Pharaoh

The stunned pharaoh cannot understand the significance of Moses' gesture.

The pharaoh's daughter, recognizable thanks to the crown that adorns her head, turns toward the child, sword in hand. He has just committed an act punishable by death.

Moses is portrayed holding the pharaoh's crown.

▲ Orazio Ferraro, *Moses and the Crown of the Pharaoh*, 1640. Private collection.

► Giorgione (Giorgio da Castelfranco), *The Trial of Moses*, 1500–1501. Florence, Galleria degli Uffizi.

The pharaoh, seated on a marble throne, witnesses the trial of Moses. He seeks to comprehend why the boy trod upon the crown.

Giorgione put great effort into depicting the background landscape. It is composed of broad surfaces, drenched in light, that are characteristic of his tonal painting.

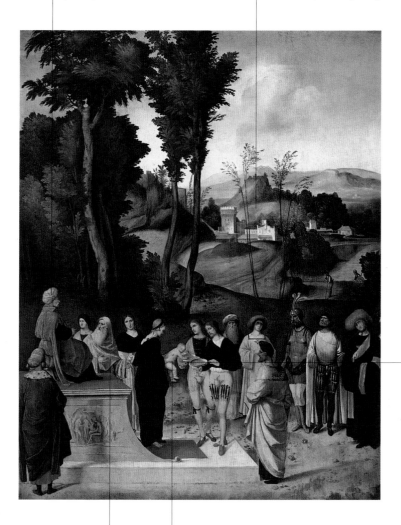

Flanking the sovereign are several wise men of the court. Concealing his angelic nature, one courtier has advised the pharaoh to put Moses to this test.

Moses is depicted as a naked infant just a few months old, carried by the pharaoh's daughter. The text of the Jewish historian Flavius Josephus tells how an angel guides the child's hand to take the burning coal and bring it to his mouth, burning his tongue.

The two bowls that Moses can draw from contain precious stones and hot coals.

This episode, whose iconography is quite widespread in Christian art, represents one of the many Old Testament meeting scenes that take place at a well.

Moses and the Daughters of Jethro

The Place
In Midian, with the clan of Midianites, who were traditionally located east of the Gulf of Aqaba-Elat on the Red Sea, although in this episode they are presented as a tribe of Sinai

The Time
After fleeing to Midian because he killed an Egyptian guard

The Figures
Moses, the daughters of Jethro, and shepherds

The Sources
Exodus 2:16–22

Variants
Moses and the well of Midian

Diffusion of the Image
Fairly widespread

▶ Rosso Fiorentino, *Moses and the Daughters of Jethro*, 1523. Florence, Galleria degli Uffizi.

One day, Moses, now a grown man, sees the Israelites at forced labor. Witnessing an Egyptian guard beating an Israelite, Moses kills the guard. Despite being educated in the pharaoh's court, Moses has not lost his Hebrew roots, and he is filled with indignation at the drama of his oppressed people. Forced to flee after the Hebrews spread the news of the murder, Moses goes into the wilderness. Reaching a well in Midian, he encounters seven girls who want to water their flocks but have been chased away by shepherds. After witnessing the scene, Moses drives the men away and waters the girls' animals. As a result, the girls' father, Jethro, a priest of Midian, welcomes him. Moses stays with Jethro and marries one of his daughters, Zipporah, with whom he has two sons.

Among the daughters of Jethro is Zipporah, who will become Moses' wife. In marrying her, he becomes related to the Midianites, a tribe that will eventually be hostile to Israel. In fact, Moses names the first son born of this marriage Gershom, which means "foreigner" or "guest."

Moses meets the seven girls, daughters of Jethro, at the well of Midian.

The choice of the well is not random: frequently, the well in the Old Testament acts as a meeting place that leads to a marriage, as, for example, when Abraham's servant Eliezer meets Rebekah, and when Jacob meets Rachel.

Pervaded by a longing for justice, Moses drives away the shepherds, who do not want to let Jethro's animals drink.

Carlo Saraceni, *Moses Defending the Daughters of Jethro*, 1609–10. London, National Gallery.

Moses, taking off his shoes, stands before a flaming bush that i[s] not consumed. This episode has been interpreted as prefiguring the dogma of the Virgin Mary.

The Burning Bush

After his flight, Moses lives in the desert for many years, working as a shepherd for his father-in-law, Jethro. One day he takes his flock to the mountain of God, Horeb, where an angel appears to him within a bush, surrounded by fire. As the flames do not consume the bush, Moses approaches. But God orders him to take off his sandals, since the place where he stands is "holy ground." At the Lord's appearance, Moses covers his eyes and listens to God's message: "I have seen the affliction of my people who are in Egypt, and have heard their cry because of their taskmasters; I know their sufferings, and I have come down to deliver them out of the hand of the Egyptians." God then sends Moses to the pharaoh so that he can take his people out of Egypt and lead them to the land of Canaan. Moses, frightened, does not believe he is up to the task, but God reassures him, telling him that he will always be by his side.

Still uneasy, Moses asks God what name he should use when he speaks about the Lord to the sons of Israel. God responds, "I am who I am." In fact, Jews never pronounce the name of God, Yahweh, even when they read from the biblical text.

The Place
On Mount Horeb, which in Hebrew means "arid," sometimes identified as Mount Sinai

The Time
When Moses lives with Jethro, the priest of Midian

The Figures
Moses, the angel, God, and sometimes the Virgin Mary

The Sources
Exodus 3:1–20

Diffusion of the Image
In medieval times the image of the burning bush, which burns without being consumed, was interpreted as a symbol of Mary's virginity. According to iconography that was originally Byzantine, she can appear seated on a throne inside the flame.

▶ Made in Lorraine, *The Burning Bush*, ca. 1200. Detail from the Trivulzio Candelabra. Milan, cathedral.

The Virgin and Child are seen within the shrub that burns without being consumed. Their presence in this Old Testament scene derives from the idea that the burning bush prefigured the Immaculate Conception and the dogma of Mary's virginity.

The Christ child, in turn, holds a mirror that shows a reflection of himself and his mother, symbolizing the Immaculate Conception of Mary.

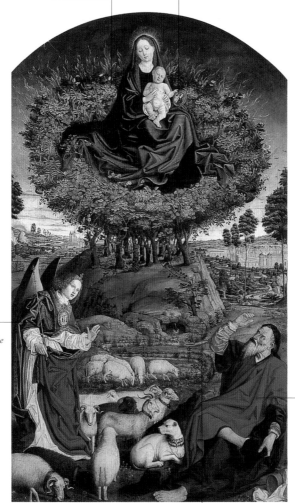

Moses is portrayed taking off his shoes in respect for the holy place, where one is meant to walk barefoot. He is compelled to cover his face with his hands, since the power and brilliance of God are more than humans can bear. Moses clearly demonstrates his human weakness.

...s in many other ...iblical passages, the ...ngel represents ...od's messenger.

This episode is set on Mount Horeb, which can be identified with Mount Sinai. Beginning in the sixth century, Christian tradition knew it as Gebel Musa, or "mountain of Moses." The Hebrew term saneh ("to hate") could be at the origins of the word "Sinai." The type of bush described here, which is native to the Sinai Peninsula region, could catch fire under the scorching desert sun.

▲ Nicolas Froment, *The Burning Bush*, 1475–76. Aix-en-Provence, Cathedral of Saint-Sauveur.

The Burning Bush

When he appears within the bush, God is accompanied by three angels and many putti. He is recognizable by his long, white hair.

On many occasions when God shows himself, he appears amid flames and shining light. The Lord announces to Moses that he will have to lead his people out of Egypt to the land of Canaan.

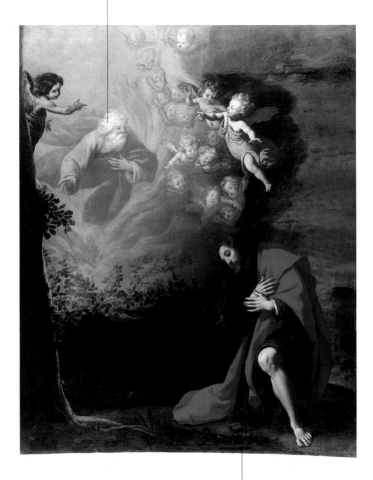

Moses asks God what to call him when his people ask. The Lord reveals himself with a verb-name, the Hebrew word for "I am" (hjh). The four sacred, unpronounceable letters "YHWH" derive from this word.

His eyes cast downward, Moses is shown kneeling before the burning bush in a humble pose as he listens to the Lord's words.

▲ Matteo Rosselli, *The Burning Bush*, before 1623. From a cycle of paintings in the Cathedral Tribune. Pisa, cathedral.

These rarely portrayed episodes illustrate the violence and the wide range of plagues inflicted on the Egyptians and their sovereign for having opposed God's will.

The Plagues of Egypt

God has charged Moses with freeing his people from slavery. As soon as he returns to Egypt, Moses, along with his brother, Aaron, goes to the pharaoh to ask permission for Israel to depart. The sovereign refuses repeatedly and increases the Israelites' sufferings. Moses predicts each of the punishments that God then inflicts on Egypt: the waters of the country become like blood; enormous quantities of frogs crawl from the Nile; lice torture man and beast; ferocious flies fill the Egyptians' houses; an epidemic kills the cattle; painful ulcers afflict both humans and animals; damaging hail falls; locusts invade the land; and darkness covers the earth for three days. Despite seeing all Moses' predictions come true, the pharaoh still refuses to grant the Israelites' their freedom.

Among the "plagues" of Egypt—the punishments with which God smites the country for its king refusing to let the Israelites go—one of the most frequently shown is the first: the transformation of the waters of the Nile into blood. The river becomes red, causing all the fish to die. This plague comes to affect all flowing water in Egypt, until finally there is no longer any water fit to drink.

The Place
Egypt

The Time
The days before the pharaoh allows the Israelites to leave Egypt

The Figures
Moses, Aaron, and the Egyptians

The Sources
Exodus 7–11

Variants
At times only a specific plague is depicted.

Diffusion of the Image
These iconographic subjects are not common. Among the ten plagues of Egypt, one of the most frequently depicted is the transformation of the Nile waters into blood.

◄ Bartholomeus Breenbergh, *Moses and Aaron Changing the Rivers of Egypt to Blood*, 1631. Los Angeles, J. Paul Getty Museum.

The Hebrews construct a building for the pharaoh.

The Hebrews are shown under forced labor as they gather plant stubble to make bricks.

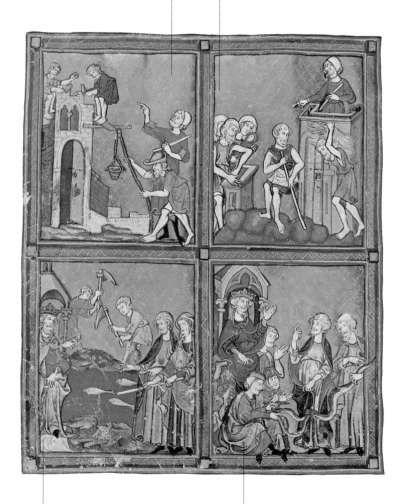

Moses and Aaron transform water into blood, carrying out one of the plagues inflicted on the Egyptians.

Standing before the pharaoh, Moses and Aaron change their rod into a serpent.

▲ English-Hebrew illuminator, *Four Stories of Moses*, ca. 1300. London, The British Museum.

▶ Jacopo Tintoretto, *The Passover of the Hebrews*, 1577. Venice, Scuola di San Rocco, Sala Grande.

After the final plague comes to pass, the pharaoh allows the Israelites to depart. They are portrayed eating lamb's meat and unleavened bread, ready to begin the journey toward the Promised Land.

Passover

Despite the occurrence of the first nine plagues, the pharaoh continues to deny the Hebrews their freedom from slavery. As the final plague, Moses predicts the death of all first-born Egyptian children, including the pharaoh's own. Moses orders the head of each Hebrew family to slaughter a year-old lamb, take a bunch of grass and immerse it in the lamb's blood, and with it mark the two door jambs and the threshold of the house. The blood protects them from the massacre that takes place that night in Egypt. In addition, Moses orders the families to prepare a meal with the lamb's meat and unleavened bread and to eat it with haste, and then to dress in traveling clothes and sturdy shoes. The Israelites do what Moses orders, and that night God kills all the Egyptians' first-born sons together with the first-born animals. That very night the pharaoh summons Moses and Aaron and lets the Hebrews depart.

The Place
Egypt

The Time
In the month of Abib, the first month of the Jewish calendar, the night before the departure for the Promised Land. Scholars maintain that the episode can be placed between 1290 and 1260 B.C.

The Figures
The Israelites

The Sources
Exodus 12:1–36

Variants
The Passover of the Hebrews, the night of Passah. Sometimes it is associated with the episode showing preparations for the Hebrews' departure.

Diffusion of the Image
Besides being one of the main Jewish holidays, Passover is quite common as a subject in Christian iconography because it is read as prefiguring the Last Supper.

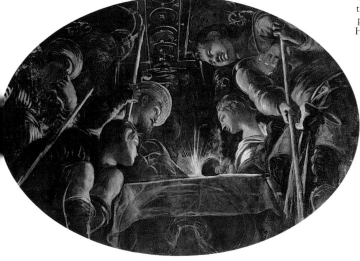

Passover

This fresco depicts the Israelites, who are ready to depart for the land of Canaan. They are quickly consuming their final meal in Egypt.

The Israelites are shown with traveling clothes and pilgrims' walking staffs.

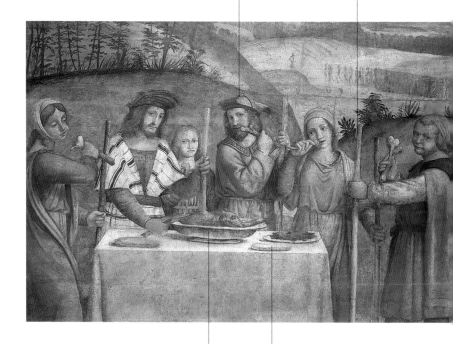

The table has been laid with lamb. The Israelites used its blood to mark their houses so that they could be passed over by the exterminating angel, who slays the first-born sons of the Egyptians.

Alongside the meat is the flat bread that the Lord ordered them to eat.

▲ Bernardino Luini, *The Celebration of Passover*, 1510–20. Milan, Brera.

This episode shows the pharaoh's army being swept away by the waters of the Red Sea. As the Egyptians struggle in vain to save themselves, the Hebrews reach the far shore unscathed.

The Passage of the Red Sea

The route the Israelites followed during the Exodus is not the most direct one. Instead, God urges them to enter the Sinai Peninsula, crossing the Reed Sea (or the Red Sea) in the Bitter Lakes area. The Egyptian troops do not control this road as effectively, making it safer for the Israelites.

In order to show them the way toward the Promised Land, God marks the road with a column of clouds by day and a column of fire by night. As soon as the pharaoh learns of their departure, he regrets letting them go and orders his chariots of war to pursue them. The Egyptians reach the Israelites as they near a strait. God orders Moses to extend his staff over the sea. In that instant the waters separate, creating a dry area for the Israelites to pass through. When Moses once again extends his hand over the sea, the waters flow back, sweeping away the Egyptian army.

Safely reaching the opposite shore, Moses' sister, Miriam, and the other Israelite women intone songs of thanksgiving to God.

The Place
Probably in the Bitter Lakes area rather than near the actual Red Sea

The Time
Just after the Israelites depart from Egypt

The Figures
The Israelites, led by Moses; the pharaoh; and the Egyptian army

The Sources
Exodus 14:15–31

Variants
The Egyptian army submerged in the Red Sea. Sometimes the triumphal song of the Hebrews is included.

Diffusion of the Image
The early Church interpreted this iconography as a symbol of baptism, since the water of the Red Sea is associated with the purifying water of the sacrament.

◄ Lucas Cranach the Elder, *The Passage of the Red Sea*, 1540. Munich, Alte Pinakothek.

171

The Passage of the Red Sea

Storm clouds mass at the
horizon between sea and sky
in the background.

Chariot wheels float
upon the sea, torn off
the vehicles by God.

The waves crowd in on the pursuers,
closing off any means of escape.

An elephant sinks as the
men it carries on its back
seek safety in vain.

▲ Bernardino Luini, *The
Passage of the Red Sea*,
1510–20. Milan, Brera.

The name "Reed Sea," mistranslated as "Red Sea" in a Greek version of the Bible called the Septuagint, indicates the marshy area of the Bitter Lakes near the Egyptian city of Sile.

Moses' gesture of raising his hand to make the waters flow back over the enemy army corresponds to a liturgical act carried out by a priest.

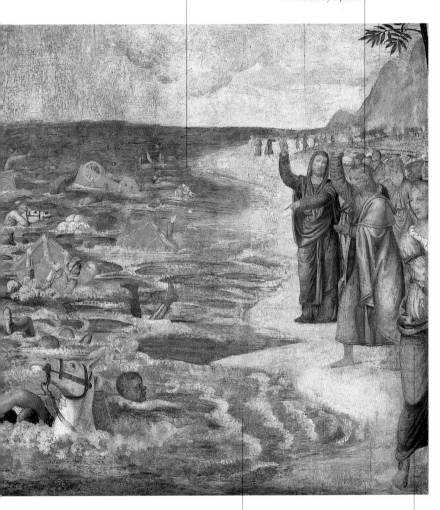

A clear contrast is drawn between the Egyptian army, its chariots and knights swept away by the waters, and the Israelites on dry land, witnessing the massacre of their enemies.

The young woman near Moses may represent his sister, Miriam, who later intones a song of thanksgiving to God together with other Israelite women.

173

Following peasant custom, the Israelites carry their goods on their heads.

The Egyptians and their horses are swept away by the red waters of the sea.

Moses is portrayed with a staff and hornlike rays of light above his head. Seated on the shore, he orders the waters to flow back over the enemy army.

Gathered in safety around Moses, the Israelites watch the massacre of the Egyptian army.

In the foreground are various nude male figures. The artist's preparatory studies for these figures have been found.

◀ Agnolo Bronzino, *The Passage of the Red Sea*, 1540–45. Florence, Palazzo Vecchio, Eleonora da Toledo Chapel.

Manna is "the food of angels" given by God that prefigures the Eucharist. The Hebrews are shown gathering manna on the ground and carrying away filled baskets.

The Gathering of Manna

The Place
In the wilderness of Sin, in the south of the Sinai Peninsula

The Time
During the march in the desert, two and a half months after the exodus from Egypt

The Figures
The Israelites

The Sources
Exodus 16:1–36, Numbers 11:7–9

Variants
The fall of manna

Diffusion of the Image
This scene has been seen as prefiguring the multiplication of loaves and fishes and the Eucharist.

After marching through the wilderness for many weeks, the Israelites run out of provisions. They fear they will die of hunger and raise strong complaints against Moses and Aaron. Hearing their plea, God tells Moses to announce that he will provide for his people. In the evening a great flock of quails stops at their camp, falling easy prey to the Israelites. Then, in the morning, they find spread around their camp tiny ears of grain, which taste like honey bread. This is manna. Moses orders his people to collect the manna in jugs, each family according to its needs for a single day. Nothing is to be left over, since each day they are to find enough to nourish themselves. Only on the sixth day do they gather a double quantity, since they rest on the feast day. Those who are afraid that they won't receive what was promised gather more food than they need for a day, only to find worms inside in the grain.

► Guido Reni, *The Fall of Manna*, 1615. Ravenna, cathedral, Santissimo Sacramento Chapel.

► Jacopo Tintoretto, *The Fall of Manna*, ca. 1577. Venice, Scuola di San Rocco, Sala Grande.

The episode of the gathering of manna is set in the wilderness of Sin, in the southern part of the Sinai Peninsula.

The figure of God the Father appears in the bright sky.

In biblical tradition, manna is seen as an extraordinary type of food, defined as "the food of angels" given by God. In the New Testament it becomes a symbol of the Eucharist, as shown in Jesus' discourse in the synagogue of Capernaum (John 6).

The Israelites are shown amazed as they watch manna fall from Heaven and gather it in wicker baskets.

The curtain in the foreground has been considered an allusion to the curtain of the temple of Jerusalem and the tablecloth from the Last Supper.

This scene has been seen as prefiguring the multiplication of loaves and fishes, and the Eucharist. Here, in fact, manna is represented in the shape of pure eucharistic hosts.

With his back to the viewer, Moses reaches his arm into the center of the composition.

The Gathering of Manna

In the Bible manna is described as "a fine, flake-like thing, fine as hoarfrost on the ground." In reality it is a resinous substance that drips from the bark of the tamarisk tree, commonly found on the west coast of the Sinai Peninsula.

The figures are holding tiny jars, which, once filled, are poured into larger containers. In this painting the collection vessels for the manna are quite large.

Moses gives instructions to the Israelites on how to gather manna and in what quantity.

There are numerous animals roaming among the Israelites, of a variety of species: a giraffe, a rabbit, a goat, and something that appears to be a cross between a cat and a civet.

Manna becomes a symbol of divine love. It continues to fall during the forty years of Israel's journey in the desert and ceases at the threshold of the Promised Land. Along with the water that was made potable and the quails that allowed themselves to be caught, manna represents a symbolic contrast with the plagues inflicted on the Egyptians.

In this episode, which is portrayed frequently in Christian art, the Israelites are depicted either in the act of giving thanks or as they fill their amphorae with water.

Water Springs from the Rock

As the march through the desert continues, once again the Israelite people complain to Moses, this time because of the thirst that afflicts them and their animals, saying, "Why did you bring us up out of Egypt, to kill us and our children and our cattle with thirst?" A worried Moses turns to God and asks what to do. The Lord answers that Moses must go up a mountain and strike a rock with his staff. With this, all the water needed to nourish the people and animals will flow from the rocky mass. The iconographic representation of this episode is quite simple and provides for the depiction of Moses. He touches a cliff with his staff and a rich stream of water gushes immediately forth.

Sometimes this episode is linked with one in which Moses builds an altar to the Lord after the victory against Esau's grandson Amalek.

The Place
In the wilderness of Sin, in the Rephidim area

The Time
During the march in the desert

The Figures
Moses and the Israelites

The Sources
Exodus 17:1–7, Numbers 20:1–13

Variants
Moses striking water from the rock

Diffusion of the Image
Widespread in Christian art of all periods

Bacchiacca, *The Gathering of Manna*, 1540–55. Washington, D.C., National Gallery of Art.

Jacob Jordaens, *Moses Striking Water from the Rock*, ca. 1645–50. Los Angeles, Paul Getty Museum.

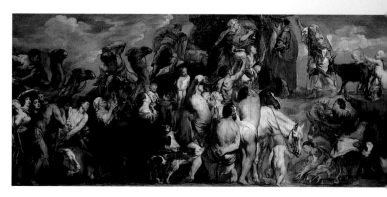

Water Springs from the Rock

Touching the rock with his staff, the patriarch makes a spring of water run from the stone.

Moses' gesture of raising the staff has a specific symbolic value: like a flag for warriors, it is a sign of calling and mobilization.

The Israelites watch breathlessly and wait for the much-desired miracle. Their reserves of water have been exhausted for some time, and strong resentment toward Moses has arisen among them.

Even the animals risk dying of thirst. The dog in the foreground, which drinks immediately from the spring that pours from the rock, illustrates the animals' terrible thirst.

A child stands ready to collect the water in an amphora.

A landscape of trees forms the background of this scene. The episode is set in the wilderness of Sin, in the Rephidim area.

The Israelites, who have been painted here with great attention to the pictorial rendering of human types, are arrayed in a semicircle around the patriarch.

Some figures are walking away with amphorae filled to the brim with water.

Mothers give water to their children.

His staff in hand, Moses makes water pour from the rock.

Paolo Guidotti (Cavaliere Borghese), oses Making Water Spring from a Rock, 15. From a cycle of paintings from the athedral Tribune. Pisa, cathedral.

▲ Lucas van Leyden, *Moses and the Israelites after the Miracle of Water from the Rock*, 1527. Boston, Museum of Fine Arts.

A group of Israelite men and women witness the scene.

The sacrificial lamb is shown upon the stone altar.

Wrapped in a large white cloak, Moses is about to carry out a sacrifice of thanksgiving to the Lord.

▲ Massimo Stanzione, *The Sacrifice of Moses*, 1628–30. Naples, Capodimonte.

After their victory against Esau's grandson Amalek, Moses raises a sacrifice of thanksgiving to the Lord.

▶ Jusepe de Ribera, *Moses with the Tablets of the Law* (detail), ca. 163. Naples, Church of the Carthusia. Monastery of San Martin

The Book of Exodus states that God reveals only his voice to Moses. Nevertheless, the personified image of God often appears in depictions of Moses receiving the tablets of the Law.

The Tablets of the Law and the Golden Calf

Moses leads the Israelites through the desert to Mount Sinai. Ascending Sinai, Moses speaks with God for forty days and forty nights, and God gives the patriarch two stone tablets bearing the Ten Commandments. While Moses' servant Joshua waits for him halfway up the path, Aaron remains with the people below. The Israelites, however, grow tired of waiting. They ask Moses' brother to continue without him and to build them an image of God to carry as a trophy on the journey. Aaron then takes all the gold they have among them and makes a calf, before which the Israelites offer sacrifices and dance. Descending from Mount Sinai to take up once again with the "unfaithful" peo-ple, Moses sees the Hebrews dancing round the calf. Enraged, he flings the tablets down at the foot of Mount Sinai. He destroys the golden calf and later receives the order from God to make two new tablets and ascend Mount Sinai alone. After once again staying forty days and forty nights on the mountain with God, Moses descends with the new tablets of the Law and his face radiant from the magnificence of the Lord. Aaron and the other Israelites are struck by his brilliance.

The Place
The presentation of the tablets of the Law takes place on Mount Sinai, while the adoration of the golden calf occurs at the foot of the mountain.

The Time
During the march in the desert

The Figures
Moses and God; the Israelites and Aaron

The Sources
Exodus 19, 20, 32:1–24, 37

Variants
Moses receives the tablets of the Law, the Hebrews adore the golden calf, Moses with the new tablets of the Law

Diffusion of the Image
These episodes are widely repre-sented in Chris-tian art, both individually and together as a single scene.

The Tablets of the Law and the Golden Calf

With an accentuated plastic effect, Moses is shown on Mount Sinai as he receives the tablets of the Law.

The tablets of the Law are shown as a scroll and are written "by the hand of God." The reference to God's hand accentuates the importance and the dignity of the legislation given to Moses.

Moses' servant Joshua waits for him halfway up the path.

God the Father is manifested by the hand that emerges from the firmament. He personally entrusts the Law to the patriarch.

▲ French illuminator, *Moses Receives the Tablets of the Law*, ninth century. Miniature from the Montier-Grandval Bible. London, The British Museum.

The trees in the background seem to recall the "concise" style handed down from classical antiquity.

The Israelite men and women eat and drink during the absence of Moses, who remains on Mount Sinai for forty days speaking with the Lord. They lose faith and ask Aaron to build a golden calf for them to worship.

The golden calf has been placed on a pedestal, around which the Hebrews dance festively. Aaron made the calf by melting down all the gold found in the camp.

Moses and Joshua can be seen running down Mount Sinai. The patriarch carries the tablets of the Law, but when he sees the Israelites' act of idolatry, he throws them to the ground, destroying them.

Eventually Moses realizes that the Hebrews need a material object of worship for their religion. He orders them to build the ark of the covenant, guarded by two cherubs, into which he places the tablets of the Law.

▲ Lucas van Leyden, *The Adoration of the Golden Calf*, 1528. Amsterdam, Rijksmuseum.

The Tablets of the Law and the Golden Calf

The golden calf is placed on a huge altar decorated with garlands. The idol resembles a real animal. Calves and bulls were considered symbols of strength and fertility in the ancient Near East and as a result were associated with God.

The Hebrew people's request that Aaron build them "gods who shall go before us" refers to the custom of Eastern armies to carry a statue or emblem of a god before their ranks. Even the tribes of Israel had insignia that distinguished them.

Aaron is dressed in a white tunic and invites the Israelites to acknowledge the God of Israel in the golden calf.

The Israelites dance in a circle around the trophy. Among the ancients, in fact, dance always accompanied holy feasts and celebrations.

Some figures turn toward the golden calf, praying to it and saluting it.

▲ Nicolas Poussin, *The Adoration of the Golden Calf*, 1634. London, National Gallery.

▶ Rembrandt Harmensz. van Rijn, *Moses Breaking the Tablets of the Law*, 1659. Berlin, Gemäldegalerie.

Two women notice Moses' arrival from Mount Sinai. As soon as he sees the golden calf, he throws the tablets of the Law to the ground, burns the idol in the fire, and, mixing its ashes with water, makes the Israelites drink it.

The tablets of the Law are placed in the ark of the covenant (Exodus 25:16). They are called the "testimony" because they remind Israel of the covenant sanctioned at Sinai based on the Ten Commandments.

The tablets of the Law written in Hebrew and with rounded tops are a common feature in seventeenth-century Dutch painting. The first five commandments are written on the tablet at the rear, the other five on the one in front.

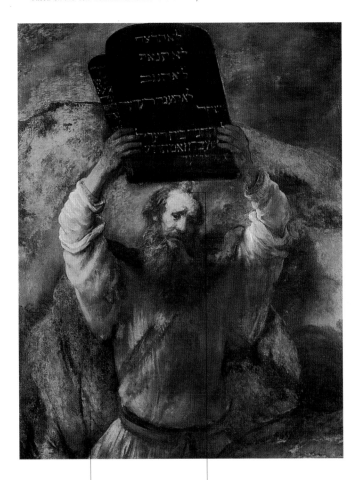

Despite different interpretations, it is probable that this painting represents the patriarch in the act of breaking the tablets after seeing the Israelites worshiping the golden calf. The expression on Moses' face reveals great sorrow.

To describe the rays of light that emanate from Moses' face after his meeting with the Lord on Sinai, the Hebrew Bible uses the term queren, which can also mean "horn." In his Latin translation of the sacred text, St. Jerome favored that meaning, which led to representations of Moses with two horns on his forehead in the works of numerous artists.

This episode shows the followers of Korah being swallowed up by the earth, which has opened beneath their feet. Among them all, only Aaron remains undisturbed.

The Punishment of Fire from Heaven

The Place
In the desert

The Time
During the march
in the desert

The Figures
Moses, Aaron,
Korah, Dathan,
Abiram, and another
two hundred men

The Sources
Numbers 16:1–35

Variants
The punishment of
Korah; the destruc-
tion of the group
supporting Korah

**Diffusion of
the Image**
This iconography is
uncommon.

While the Israelites are in the desert, two hundred important men, led by Dathan, Abiram, and the Levite Korah, rise up against Moses and Aaron, accusing them of placing themselves above the other members of the community. They are especially opposed to Aaron's right to hold the position of high priest, since they maintain that "all the congregation are holy." To resolve the situation, Moses orders these men to present themselves with their incense burners before the meeting tent.

When they are assembled, Moses challenges them to offer incense to the Lord, a ritual act reserved for Aaron and his sons. He tells them, "Be present, you and all your company, before the Lord...and let every one of you take his censer, and put incense upon it, and...bring before the Lord his censer." The next day they do as Moses asked. The earth opens up, swallowing all the men who supported Korah. Flames burn the two hundred men and their censers.

► Domenico Beccafumi, *The Punishment of Korah* (detail), 1537–38. From a cycle of paintings in the Cathedral Tribune. Pisa, cathedral.

The supernatural event forms the basis for the stylistic choices of Beccafumi, whose painting features fiery colors and unexpected backlighting.

The Bible maintains that priesthood is a hereditary role. It is entrusted to the tribe of Levi during the sojourn in the desert, when the episode of the golden calf takes place. The priestly ministry is reserved for Aaron and his sons. In fact, they are mentioned together with Moses and the seventy elders admitted to the vision of God on Mount Sinai.

In addition to holes suddenly opening up in the earth, the divine punishment takes the form of a rain of fire and glassy fragments of lava.

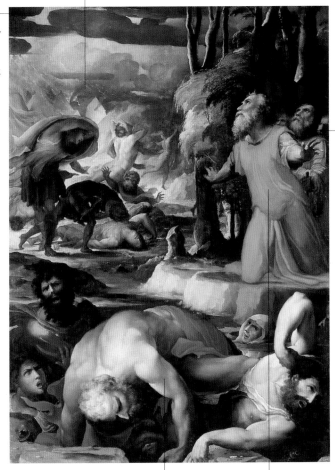

The followers of Korah are shown being swallowed up by the earth. They are portrayed in exaggerated poses and with intense expressions.

As the divine punishment manifests itself, Moses is depicted on his knees with his arms spread wide.

▲ Domenico Beccafumi, *The Punishment of Korah*, 1537–38. From a cycle of paintings in the Cathedral Tribune. Pisa, cathedral.

This episode, which is widespread in the history of art, portrays the Israelites writhing on the ground amid the coils of snakes. Moses saves them by raising up a bronze serpent.

The Brazen Serpent

The Place
In the desert

The Time
During the march in
the desert

The Figures
Moses, the Israelites,
and sometimes
Aaron

The Sources
Numbers 21:4–9

Variants
Moses raising the
brazen serpent

**Diffusion of
the Image**
In medieval artistic
representations, this
subject is placed in
contrast with the ser-
pent in the Garden of
Eden. The serpent
and the tree, in fact,
are seen as symbols
of male and female
fertility.

The Israelites push on through the desert, tired and weary. In this difficult situation, as has occurred many times in the past, the people blame God and Moses. To punish them, the Lord sends poisonous, fiery serpents to invade the camp. Many people die after being bitten by these creatures.

The Israelites then repent and confess their sins before Moses. Their leader, as he usually does, intervenes with God on their behalf. The Lord orders Moses to "Make a fiery serpent, and set it on a pole; and if a serpent bite any man, he would look at the bronze serpent and live."

Moses then does what God tells him: he constructs a bronze serpent and attaches it to a T-shaped pole. Gazing upon this image saves those who have been struck with the serpents' otherwise lethal bite.

▶ Anthony van Dyck, *Moses Raising
the Brazen Serpent*, 1620. Madrid,
Museo del Prado.

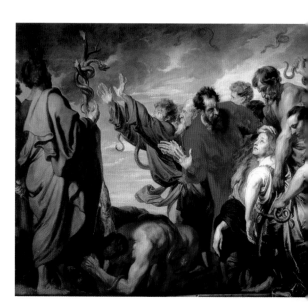

Moses pleads for his people, asking the Lord for some way to remedy the punishment of the poisonous snakes. God tells him to have a bronze serpent cast and to attach it to a T-shaped pole. With his staff in hand, the patriarch calls on the Israelites to look at the effigy in order to be saved.

The brazen serpent was destroyed by King Hezekiah (about 728 B.C.). By that time the Hebrews had ceased to adore it.

Bronze was a material commonly used for making utensils and other objects. In the Bible it is used figuratively to signify strength and hardness.

A number of snakes are shown falling from the sky to signify divine punishment.

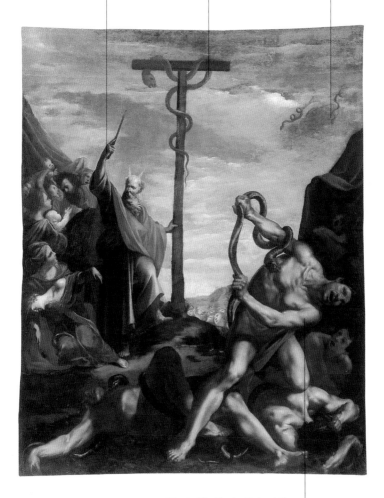

▲ Orazio Riminaldi, *Moses Raising the Brazen Serpent*, 1625. From a cycle of paintings in the Cathedral Tribune. Pisa, cathedral.

Chastised for blaming God and Moses, the Israelites are shown clutched in the coils of fiery and poisonous snakes.

The Brazen Serpent

God the Father, from the highest heavens, tells Moses the remedy for the pain he has inflicted on the Hebrews.

Several men are shown paralyzed in the coils of poisonous snakes.

Moses carries out the divine instructions and raises a staff with a bronze serpent to save the Israelites.

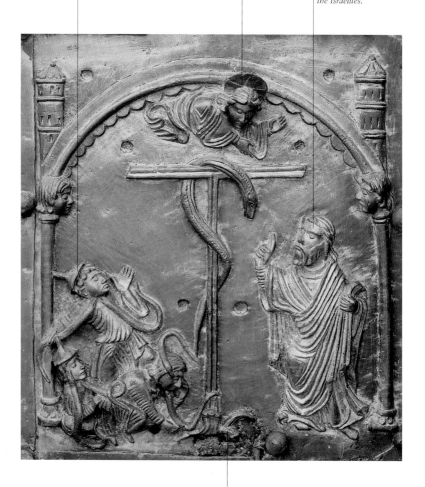

In the New Testament, the evangelist John recalls this episode when he writes, "And as Moses lifted up the serpent in the wilderness, so must the Son of Man be lifted up" (John 3:14).

▲ Master of S. Zeno, II, *The Miracle of the Brazen Serpent*, ca. 1150. Bronze door panel Verona, Basilica of San Zeno.

The conversion of Balaam by an angel is seen as prefiguring the Apostle Thomas's conversion after seeing an apparition of Christ.

Balaam and the Ass

The Israelites find themselves marching through the territories east of the Jordan. They hope by this route to reach the land of Canaan. Moses asks the local kings to give them safe passage, but they refuse. The people of Israel then conquer the entire territory. Balak, the king of Moab, is alarmed at the Hebrews' arrival and sends messengers to summon Balaam, the soothsayer, to curse the people of Israel. Balaam prepares his ass and sets out, but three times during the journey he encounters an angel with his sword drawn. The ass tries to evade the angel, while Balaam, who cannot see him, tries to bring the animal back on track by whipping him. Just then God gives the ass the ability to speak, and the animal asks its master why, despite his being ever faithful, Balaam is beating him. The Lord then reveals the angel, who stands with sword unsheathed, to Balaam and says, "Why have you struck your ass these three times?" Realizing his error, Balaam goes to Balak, who sends him to the Israelites' camp to curse them. Instead, the soothsayer blesses them three times and predicts to the king of Moab the kingly future of that people.

The Place
In the territory of Moab

The Time
During the march in the desert

The Figures
God, Balaam, the ass, the angel, and sometimes Balak, the king of Moab

The Sources
Numbers 22–24

Diffusion of the Image
This subject is common in various pictorial depictions, but especially in decorative elements of Romanesque and Gothic churches.

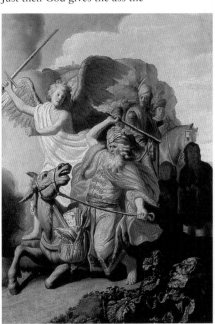

◀ Rembrandt Harmensz. van Rijn, *Balaam and the Ass*, 1626. Paris, Musée Cognacq-Jay.

Balaam and the Ass

The soothsayer Balaam, traveling with
his ass to reach the territory of Moab, is
shown as he is about to strike the animal
for deviating from the right road.

The angel is shown in the fore-
ground, wearing a voluminous
white garment as he prevents
the ass from passing.

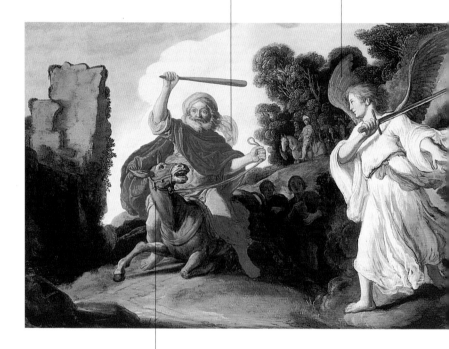

Seeing an angel with a drawn sword
in front of him, the ass swerves three
times from the path that his master
seeks to follow.

▲ Pieter Lastman, *Balaam and the Ass*,
1622. New York, private collection.

Not even Balaam's two servants understand why the ass has stopped, and, with questioning expressions, they discuss the incident between themselves.

Balaam's ass, which sees the angel before its master does, falls to its knees and does not want to continue the journey.

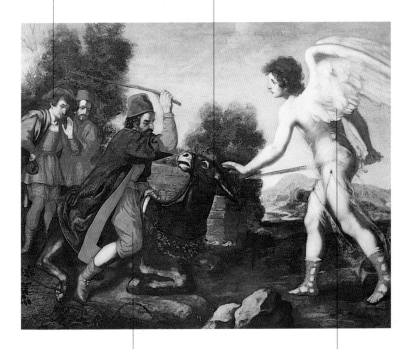

Balaam the diviner, who has not yet seen the angelic figure, insists on flogging his faithful animal, which seems to be inexplicably disobedient on this occasion.

Depicted with clear, evanescent chromatics, the angel intends to remind the soothsayer of the divine prohibition against cursing the army of Israel. Balaam had been ordered to do so by the king of Moab.

Jacopo Vignali, *Balaam and the Ass*, a. 1640. Prato, Cassa di Risparmio Collection (on loan to the Museo Diocesano).

Balaam and the Ass

Balaam the soothsayer is shown riding his ass. Balak, the king of Moab, alarmed at the arrival of the Hebrews, has sent for him, asking that he use his powers to curse the Israelite army.

Balaam looks toward the sky, almost as if he himself were receiving a divine communication.

The animal, which noticed the presence of the angelic being before its master, is shown with its head turned toward the viewer.

▲ Master of S. Zeno, II,
Balaam and the Ass, ca. 1150.
Bronze door panel. Verona,
Basilica of San Zeno.

► *Moses Sending Messengers Canaan*, fifth century. Mosaic.
Rome, Santa Maria Maggiore

Moses has sent messengers ahead to scout out the Promised Land. On their return, they carry a cluster of grapes so large that it takes two men to carry it.

The Return of the Messengers from Canaan

After crossing Mount Sinai, the Israelites head north to the southern edge of the Promised Land. Moses sends twelve messengers, one from each tribe, into the new country so they can look over the land of Canaan, the peoples who live there, and their cities. Joshua and Caleb are among the scouts.

For their return to Moses, the messengers gather a cluster of grapes so big that it takes two men to carry it, suspended from a stick. They also find other fruit, such as pomegranates and figs. Returning to the Israelite camp, they tell Moses and the others: "It does indeed flow with milk and honey, and here is its fruit. However, the people who are living in the land are fierce, and the towns are fortified and very strong." In addition, some of the messengers declare: "The land that we explored is a country that consumes its inhabitants. And all the people we saw there are huge men, veritable giants."

This news foretells numerous difficulties to be overcome before they can conquer the Promised Land. The Israelites become discouraged and rebel once again against God and Moses. For their punishment, they are to continue wandering in the wilderness for another forty years. Only the next generation will be able to enter into the Promised Land.

The Place
The messengers reach the land of Zin, Rehob, and Hebron. They go to the valley of Eschol, where they gather the branch of grapes, and then return to Moses at Kadesh, in the wilderness of Paran.

The Time
The messengers' journey lasts forty days.

The Figures
Moses, the messengers, and the other Israelites

The Sources
Numbers 13–14

Diffusion of the Image
Not very common

The Return of the Messengers from Canaan

The twelve messengers, one from each tribe, make their way back to Moses at Kadesh in the wilderness of Paran, bringing samples of the wonderful fruit that grows in that land: grapes, pomegranates, and figs.

Behind Moses, the Israelites anxiously await the news that the messengers report from the new land.

Two men carry an enormous cluster of grapes hanging from a stick.

With his staff in hand, Moses witnesses the return of the messengers he sent to the land of Canaan.

▲ Giovanni Lanfranco, *Moses and the Messengers from Canaan*, 1621–24. Los Angeles, J. Paul Getty Museum.

Moses lies dying on the ground, surrounded by his people. After thirty days of mourning, Joshua is charged with leading the people of Israel.

The Death of Moses

When Moses feels death approaching, he urges the people to have faith in the Lord even during the difficulties they will encounter with their enemies: "Be strong and of good courage, do not fear or be in dread of them: for it is the Lord your God who goes with you; he will not fail you or forsake you." He then transfers his authority to Joshua by laying his hands upon him. Gathering the entire assembly, he delivers a long canticle and blesses the sons of Israel.

From the camp, which is located on the eastern plain of the Jordan, Moses ascends to Mount Nebo. From there, God shows him the Promised Land, which he will never reach. Then the old man lies down on the ground and waits for death to arrive. One medieval tradition, sometimes illustrated, tells how Satan tries to steal Moses' body, but the archangel Michael prevents him.

The Place
On Mount Nebo

The Time
When Moses is
120 years old

The Figures
Moses, an angel, and
some of the Israelites

The Sources
Deuteronomy 31–34

Variants
The farewell of
Moses and his death

**Diffusion of
the Image**
Generally the episode
of Moses' death
appears within the
last scenes of his life.

◄ Luca Signorelli, *The Testament of Moses* (detail), 1482. Vatican City, lateral wall of the Sistine Chapel.

199

The Death of Moses

The patriarch is shown lying on the
ground, waiting for death, surrounded
by several Israelites. The passage in
Deuteronomy says that after his death
he was mourned for thirty days.

Moses transfers his authority to
Joshua, giving him his staff and
laying hands upon him.

Moses descends alone
from Mount Nebo.

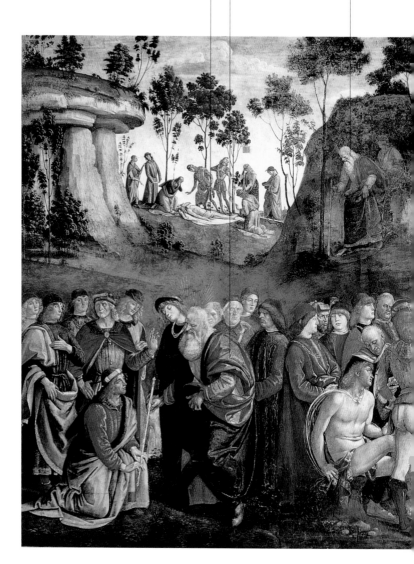

An angel leads Moses to Mount Nebo to show him the Promised Land, which the patriarch will never enter.

The land of Canaan appears in the background. Only the next generation of Israelites will be able to enter it.

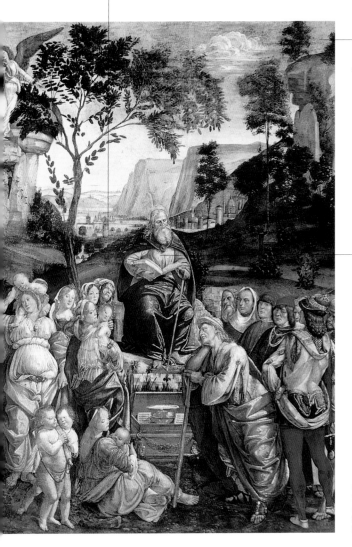

This fresco by Luca Signorelli summarizes the historical events of the final part of Moses' life.

The prophet, seated on a throne, explains the Law to the Israelites. His face is radiant, although it is obvious that Moses, who is by now very old, is at the end of his days.

◄ Luca Signorelli, *The Testament of Moses*, 1482. Vatican City, lateral wall of the Sistine Chapel.

DAVID AND SOLOMON

Saul
The Tree of Jesse
David
David and Music
David and Goliath
Abigail before David
David and Bathsheba
Solomon
The Judgment of Solomon
The Visit of the Queen of Sheba
The Idolatry of Solomon

Michelangelo Buonarroti,
David (detail), 1501–4.
Florence, Galleria
dell'Accademia.

Bruges School illuminators,
*The Queen of Sheba before
Solomon*, late fifteenth
century. Miniature from the
Grimani Breviary. Venice,
Biblioteca Marciana.

The first king of Israel, Saul, is often portrayed seeking to alleviate his pervasive sorrow by listening to the young David play music.

Saul

The Place
In the kingdom of Israel

The Time
During the eleventh century B.C.

The Sources
1 Samuel

Attributes
He is often portrayed with a dour expression, or holding a javelin.

Diffusion of the Image
The figure of Saul appears in various episodes related to his life and David's: Samuel rejects Saul; David plays the lyre before Saul; Saul throws a javelin at David; Saul and the Witch of Endor; and the death of Saul in battle.

▶ Made at Castelli d'Abruzzo, *David Mourning the Death of Saul*, 1673. Decorative plate. Milan, Castello Sforzesco, Civiche Raccolte d'Arte Applicata.

Saul, the son of Kish from the tribe of Benjamin, is anointed the first king of Israel by the prophet Samuel, the last of Israel's judges. A young man endowed with extraordinary physical abilities, he is not accepted enthusiastically by the entire people and has numerous disagreements with Samuel himself. During his first important battle with the Philistines, Saul performs a sacrifice himself rather than waiting for the priest Samuel to do it. Samuel later pronounces that none of Saul's offspring will reign after him because of his actions.

Saul disobeys Samuel again when he spares the Amalekite king and tribal leaders, whom he is supposed to execute. As a result, Samuel anoints David in Bethlehem to replace Saul. This greatly upsets the king, who becomes melancholic and hostile to David. Although the young shepherd had been chosen as royal cantor to cheer him up, Saul can no longer bear his presence. Before a crucial battle against the Philistines, Saul consults the Witch of Endor, who at his request summons the spirit of the deceased Samuel. As Samuel predicted, Jonathan and Saul's other sons die fighting, while the king, who is seriously wounded, takes his own life.

204

Sadness pervades Saul's soul, even before an "evil spirit" is sent to afflict him. The spirit is punishment for Saul committing the sin of divination, or not believing in the Lord's intervention and resorting to magic.

The elegantly dressed Saul holds a staff, a symbol of royalty, in his right hand.

The young David is depicted playing the harp for the sovereign.

Rembrandt Harmensz. van Rijn and workshop, *David Playing the Harp before Saul*, 1656. The Hague, Mauritshuis.

Saul

The lance's trajectory highlights
the failure of Saul's attempt on
David's life.

Saul's house is rendered quite
simply by means of an arch
supported by two columns.

Kneeling, David manages to
avoid being hit.

Saul is shown seated on a throne
holding a lance, with which he
tries to strike David.

▲ *Saul Hurling a Lance at David*, twelfth
or thirteenth century. Ivory casket. Sens,
cathedral treasury.

King of Israel in the second half of
the eleventh century B.C., Saul is
convinced that God prefers the
young David to him, and he tries a
number of times to kill him.

David holds a stringed musical instrument
similar to a lute, with which he was trying to
cheer the unhappy Saul. He moves in order
to not be struck by the lance.

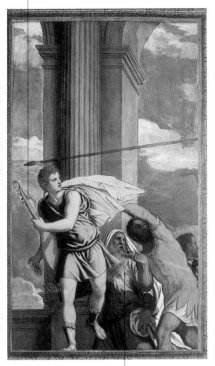

Several people from
Saul's court witness
the scene.

A dog, symbol of domestic fidelity,
watches the scene in the foreground.

Giuseppe Porta, *Saul Hurling a
Lance at David*, 1555. Venice,
Santa Maria della Salute.

Saul

This scene is set within a domestic interior that represents the home of a necromancer in Endor, where Saul and his servants have come by night.

The spirit of Samuel tells the king that Jonathan and his other sons will die in the battle that is about to occur. The Lord, in fact, has abandoned Saul.

At Saul's wishes, the Witch of Endor makes the spirit of the deceased Samuel appear just before a battle against the Philistines.

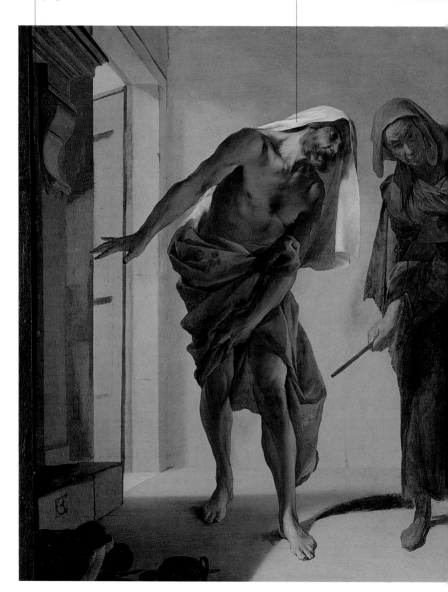

Although prohibited by law as an idolatrous practice, consulting the dead was quite common in the Middle East.

Saul kneels before the apparition of Samuel's spirit. By resorting to a forbidden practice, the sovereign is committing a grave act of disobedience. He turns to the soothsayer because the Lord has not responded to him through prophets or dreams.

The sovereign is shown wrapped in a large cloak: he has disguised himself before coming to the soothsayer in order not to be recognized. Nevertheless, when he reaches the woman, she recognizes him and fears for her fate. Saul assures her, however, that nothing will happen to her.

◀ Bernardo Cavallino, *The Shade of Samuel Invoked by Saul*, 1650–56. Los Angeles, J. Paul Getty Museum.

Saul is shown lying disfigured upon the ground. A sword has pierced his throat and his mouth is open. The Philistines later behead him and his sons and hang their heads and corpses from the wall of Beth-shan. During the night the men of Jabesh-gilead take down the bodies and give them an honorable burial.

This episode is narrated in the biblical book of Samuel. It concerned a battle between the Philistines and the Israelite troops that occurred on Mount Gilboa, between the plain of Jezreel and the Jordan River. The scene here is set in a majestic mountainous landscape.

The enemy patrol that is about to reach Saul is set apart from the enormous swarm of the other soldiers.

In this painting, Brueghel seems to have been inspired by the Battle of Issus, which had been painted about thirty years before by the German artist Albrecht Altdorfer.

Saul's shield bearer, seeing the king's fate, takes his own life on the rocky promontory.

The painting's main subject has been depicted in a marginal space on the left side. Having been defeated in battle with the Philistines and wounded by an arrow, Saul asks his shield bearer to run him through with his sword. When the man refuses, the sovereign throws himself on his sword in order not to fall into the hands of the enemy.

▲ Pieter Brueghel the Elder, *The Suicide of Saul*, 1562. Vienna, Kunsthistorisches Museum.

This family tree visually traces the lineage that begins with Jesse and culminates in the birth of Christ. It is one of the most widespread and suggestive subjects of Western sacred art.

The Tree of Jesse

"There shall come forth a shoot from the stump of Jesse" (egredietur virga de radice Jesse), predicts a passage in Isaiah. Taking this passage for reference, the iconography of a genealogical tree diffused, illustrating Jesus' lineage from Jesse, the father of David. The message is reaffirmed in Jeremiah: "Behold, the days are coming, says the Lord, when I will raise up for David a righteous Branch, and he shall reign as king."

Beginning in the Middle Ages, this prophecy has been depicted as a genealogical tree displaying Jesus' origins. Generally the trunk of the tree springs from Jesse's side as he lies on the ground. The tree bears many branches, upon which Jesus' ancestors are arrayed.

At its top are Mary and Jesus. The genealogy, in fact, concludes not with Joseph, following the Hebrew custom of descent along the paternal line, but rather with Mary, who is also a descendant of Jesse and his son David.

In the New Testament, Matthew inserts Jesus in a genealogy that descends from Abraham. This places him within the sphere of the chosen people and focuses especially on the figure of David. Luke, on the other hand, follows an inverted method that goes back to Adam, in order to show Christ's brotherhood with all humanity.

The Place
Palestine and Jerusalem

The Time
Beginning in 5228 B.C.

The Figures
Jesse or Adam, David, Christ, the Virgin Mary, the patriarchs, kings, and other ancestors of Christ

The Sources
Isaiah 11:1-3, Jeremiah 23:5, Matthew 1:1-17, Luke 3:23-38

Variants
The tree can originate with Jesse or Adam. Usually the central sequence includes Jesse, David, Solomon, the Virgin Mary, and Christ.

Diffusion of the Image
Particularly in stained-glass windows of Gothic cathedrals and in Flemish art, also as an image of the Church

◀ Master of S. Zeno, II, *The Tree of Jesse*, ca. 1150. Bronze door panel. Verona, Basilica of San Zeno.

The Tree of Jesse

Along the central axis of the tree are King David, Solomon, the Virgin Mary, and the blessing Christ. The succession of the various figures follows the way Gothic windows are read: from the bottom up.

Other figures fro the Old Testame are shown along t sides. They a identifiable thanks scrolls bearing the name

The tree of life characterized interwoven gre leaves that crea golden ton arrayed in thr parallel column

Jesse is portray sleeping peacefully the grass, with t tree of life rising fr his cloak. Jesse Bethlehem, or Is which in Hebre means "man God," is Davi fath

In many religious cultures, the tree is a symbol of growth toward heaven and continual regeneration. It is an image of life overcoming death, from which it is reborn.

▲ Emilian illuminator, *The Tree of Jesse*, fourteenth century. Parma, Biblioteca Palatina.

The artist has lavished special attention on the costumes of the individual figures; these reflect the Flemish magnificence of the period.

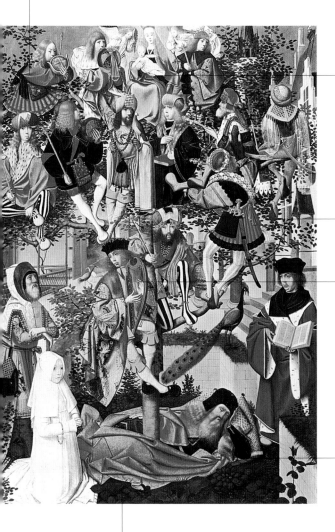

The Virgin and Child point to Jesus' descent from the line of David.

The flow of lateral branches and vines symbolizes the exuberant life that distinguishes the tree of life.

The figure of David, son of Jesse, is easily recognizable thanks to his lyre, one of his attributes.

At the foot of the tree, the sleeping Jesse lies on a large pink cloak with his head resting on two pillows.

Genealogies are a literary genre found quite often in the Old Testament. They serve to attest to an individual's membership in the collectivity of Israel, the people of God, and their corresponding image is often a genealogical tree.

▲ Geertgen tot Sint Jans, *The Tree of Jesse*, ca. 1490. Amsterdam, Rijksmuseum.

David, the second king of Israel, is one of the most widely represented figures in the history of art. Besides founding an important kingdom, he was a musician and a poet.

David

The Place
In the Bethlehem area, Hebron, and Jerusalem

The Time
He lived between about 1040 and 980 B.C. and died at the age of seventy years.

The Sources
1 Samuel 15–31, 2 Samuel, 1 Kings 1–2

Attributes
The shepherd's staff, the sling and stone, stringed instruments (generally a lyre), the head and sword of Goliath, and a crown

Diffusion of the Image
Quite widespread, both as prefiguring Christ and, according to Matthew, as Christ's direct ancestor

▶ Pedro Berruguete, *David*, ca. 1482. Paredes de Nava, Museo Parroquial de Santa Eulalia.

Samuel anoints David, the youngest son of Jesse of Judaea, as second king of Israel. Summoned to court, the boy is named shield bearer to King Saul and distinguishes himself for his courage during his fight with Goliath. Saul, however, becomes melancholic and hostile to David. He tries to kill him by throwing a javelin at him, but David evades it. When Saul and his sons, including Jonathan, are killed in the battle against the Philistines at Gilboa, David mourns them and ascends to the throne, becoming the first king of Judaea and, eventually, king of Israel as well.

During his reign, David fights numerous battles with the

Philistines, the Edomites, the Moabites and the Ammonites. Conquering the city of Jerusalem, he makes it the capital of his great kingdom. He falls in love with Bathsheba, the wife of Uriah, one of his commanders, and then has Uriah stationed in a dangerous position in battle so that he is killed. As punishment, David's first child with Bathsheba does not ascend to the throne. Their second-born son, Solomon, succeeds David.

David is frequently shown absorbed in playing a stringed musical instrument, generally a lyre, which is one of his most significant iconographic attributes.

David and Music

David is portrayed devoting himself to music at various times in his life and on different occasions. Sometimes he is presented as a shepherd playing his lyre as he watches over his flocks. This subject recalls Orpheus enchanting the animals with his music.

More often, David plays before Saul to comfort him in his gloom. After carrying out acts that the prophet Samuel did not approve, Saul is forsaken by the spirit of God and becomes even more melancholic. David is called to the court because of his reputation as a musician. He plays so well that, whenever the king is unhappy, David cheers him up with his music.

Even when he becomes king of Israel, David still takes up the lyre on occasion. He plays it again in the episode when he dances before the ark of the covenant, and in some scenes he plays it to stir up his soldiers. A number of paintings depict him as an old man, still delighting in playing.

The musical instrument shown varies according to the period and the artist. Generally it is a stringed instrument, most often a lyre, a harp, or a viola. He is also often portrayed with a psalter.

The Place
In the Bethlehem area, Hebron, and Jerusalem

The Time
At different points in David's life: as a young shepherd, as king, and as an old man

The Figures
David and his flock; David and Saul; David and a group of Israelites; and David and his soldiers

The Sources
1 Samuel 16:23, 2 Samuel 6

Variants
David plays the lyre before Saul; David dances before the ark of the covenant. The instrument portrayed varies according to the period.

Diffusion of the Image
Quite widespread

◀ *David*, ca. 1120. Exterior relief. Santiago di Compostela, cathedral.

David and Music

The frown on the face of the
king reveals his uneasy mood.

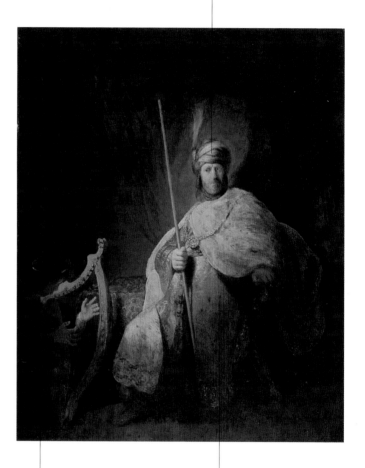

Saul is shown holding a
long staff and wearing a
large cloak.

The instrument played by David
varies according to the period in
which the painting was executed. In
this canvas by Rembrandt, the young
shepherd is playing the harp.

▲ Rembrandt Harmensz. van Rijn, *David
Playing the Harp before Saul*, 1629–30.
Frankfurt, Städelsches Kunstinstitut.

The Philistines take possession of the ark of the covenant, where the tablets of the Law are kept. But the ark causes them so many misfortunes that they return it.

The ark is a visible sign of the presence of God in the midst of his people. It accompanies Israel during the pilgrimage in the desert, the people's entrance into the Promised Land, and the battles that follow to conquer the cities there.

David's wife, Michal, witnesses the scene from a window and mocks her husband. Her reaction should probably be understood in light of the fact that the wives of the king and the maidens of the court, as opposed to common women, could not participate in feasts.

Joined by a group of Israelite men, David brings the ark to Jerusalem to the sounds of horns and joyous songs.

Brimming with enthusiasm, David plays and dances before the ark wearing only a linen garment.

▲ Jan de Bray, *David Dancing before the Ark of the Covenant*, 1670. Evansville (Ind.), Museum of Arts and Sciences.

David and Music

With his poetry, David seeks to create a model in which prayer joins with the human experience.

This scene is set in an interior. It opens onto a partial view of imaginary architecture, which is visible through the window.

In this work, Solario seems to show traces of influence from northern European art, especially Dürer's graphics.

About seventy psalms have been attributed with certainty to David.

David is shown kneeling as he plays the harp. His vermilion cloak stands out from the painting's brown and gray background.

▲ Andrea Solario, *David Playing the Harp*, ca. 1490. Bergamo, private collection.

The sad expression on David's face
expresses his mood after he has caused
Uriah's death and taken the officer's wife,
Bathsheba, to be his own.

The crown in the lower
left corner identifies the
figure as a king.

Now advanced in age,
David is still absorbed
in playing the violin.

▲ Giovanni Francesco Guercino, *David
Playing the Violin*, 1617–18. Rouen,
Musée des beaux-arts.

David and Music

Sacred dance was quite common in the East as an expression of faith. Wearing an ephod, dancing, offering sacrifices, and giving blessings were holy acts reserved for priests, but in the early period of the monarchy, the king also had priestly privileges.

*David's wife Mich[a]
watches him from
balcony of the palac[e]
and reproaches hi[m]
for behaving in suc[h]
a way in front of h[er]
servant[s]*

*King David, wit[h]
musicians befor[e]
him, dances as h[e]
leads the ark int[o]
Jerusalem*

*Music and liturgical acclamations signal
important moments in the history of Israel.
The figure of David seems to have contributed
greatly to the importance of music in worship.*

▲ Fiammenghino (Giovanni Mauro della
Rovere), *David Playing before the Ark of
the Covenant*, 1623. Peglio, Church of Sts.
Eusebius and Victor.

*David wears a linen ephod,
an apronlike vestment worn
during ancient rites. It does
not cover him adequately as
he dances.*

One of the most widespread iconographic subjects in the history of art is David holding the head of the giant Goliath, whom he killed with skill and daring.

David and Goliath

During Saul's battle against the Philistines, a man from the enemy army named Goliath approaches the sovereign, saying that he wants to fight single combat, with the winner enslaving his opponents. The giant Philistine wears a bronze helmet and armor, and the point of his javelin is made of iron. No one dares to accept his challenge. Young David, however, has come to the camp to bring his brothers some provisions. He asks Saul's permission to fight Goliath. The king accepts and offers David his armor, but David refuses, feeling that it would hinder his movements. Procuring five stones from the valley floor, he takes up his sling and heads toward the giant. He strikes Goliath's forehead with a stone and, quickly seizing the giant's sword, beheads him. At that very moment the Israelites attack the Philistines, chasing them to the gates of their city.

After David's victory over Goliath, the young shepherd returns carrying the giant's head like a trophy. The women of Israel greet him with music, singing, and dancing, until Saul is filled with envy. From then on, in fact, the sovereign begins to suspect that the young man wants to take his crown.

The Place
Between Socoh and the valley of Terebinth

The Time
When David is still young

The Figures
David, Goliath, Jonathan, Saul, and the Israelite women

The Sources
1 Samuel 17:38–51, 18:6–7

Variants
David with the head of Goliath; the triumph of David

Diffusion of the Image
Quite widespread, especially in seventeenth-century painting, when the decapitated head of Goliath became an opportunity to portray the giant's face realistically. The episode of the triumph of David was interpreted as prefiguring Christ's entry into Jerusalem.

◀ Gian Lorenzo Bernini, *David*, 1623–34. Rome, Galleria Borghese.

David and Goliath

The hero David became the symbol of the republic of Florence.

Portrayed naked, just befor
hurling the stone, Davi
expresses strong psycholog
cal tension. He stands wii
the sling draped over his le
shoulder, and his right arr
holding the fatal ston
extended along his sid

The statuary of antiquity
constituted a fundamental
reference point for this mas-
terpiece by Michelangelo.

▲ Michelangelo Buonarroti, *David*, 1501–4.
Florence, Gallerie dell'Accademia.

Saul and his ministers receive David beneath a canopy in the great council hall. The king orders a page to bring weapons for David, who has volunteered to face Goliath.

As David shepherds his father's flock, he must face a bear and a lion that attack the sheep.

David heads toward Jerusalem holding Goliath's head and sword. Exultant young women from the city come out to meet him as he enters in triumph.

A messenger of the king speaks with David, asking him to enter into Saul's service.

David hits Goliath and cuts off his head.

A captain seems to offer to take David's place.

▲ Lorenzo Lotto, *David and Goliath*, ca. 1526. Marquetry from the choir. Bergamo, Santa Maria Maggiore.

David sets down the king's weapons and faces the giant with only his sling and a stone that he takes from his bag. The hero is marked by his shepherd's clothing, staff, shoulder bag, and the flask in his belt.

The young David holds the giant Goliath by the hair after striking him with the stone. He prepares to cut off Goliath's head with a sword.

Goliath is shown stretched out with his eyes closed. His body is outfitted with heavy metal armor.

▲ *David and Goliath*, ca. 1123. Fresco from the Church of Santa Maria di Tahull. Barcelona, Museu d'Art de Cataluña.

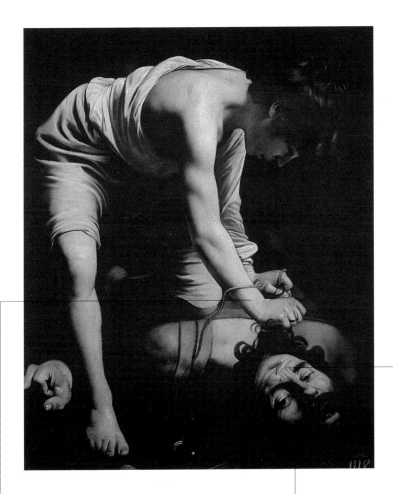

The defeated Goliath lies on the ground while David, kneeling above him, places a rope around his neck.

The head of the giant is depicted with meticulous care in the foreground. Goliath's face contrasts clearly with that of the young adolescent.

The severed head, which reappears in the iconography of the martyrdom of John the Baptist and the slaying of Holofernes, was a popular subject beginning in the fifteenth century.

The wound on the giant's forehead from the stone hurled with the sling is a violent one. His eyes and mouth, opened toward the viewer, are also disturbing.

Michelangelo Merisi da Caravaggio, *David and Goliath*, 599. Madrid, Museo del Prado.

David and Goliath

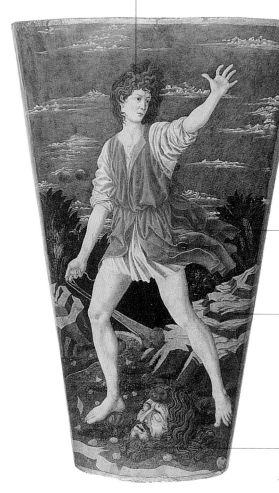

Young David is portrayed after he has struck the giant with his sling.

David wears a sho[?] shepherd's tunic, havi[?] refused the heavy arm[?] that Saul offered h[?] before the batt[?]

The scene is a rocky landscape, with a wide sky as background.

Goliath was struck on the forehead by the rock that David hurled with his sling. His head now lies at the hero's feet, its eyes closed.

▲ Andrea del Castagno, *The Youthful David*, ca. 1450. Painted shield. Washington, D.C., National Gallery of Art.

After David's victory over Goliath, Jonathan forms a deep friendship with the young shepherd.

Jonathan is Saul's eldest son. He first appears in the story as a warrior fighting alongside Saul, and later as David's friend.

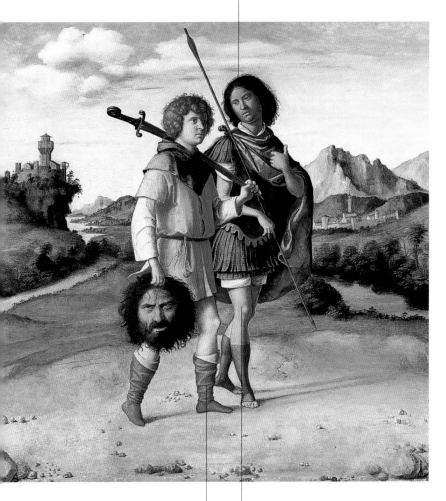

David is depicted here with the giant's sword on his shoulder, casually carrying Goliath's head in his right hand. The young shepherd's face displays anxiety and uncertainty.

Elegantly dressed, Jonathan seems older than David by several years.

▲ Giovanni Battista Cima da Conegliano, *David and Jonathan*, ca. 1505–10. London, National Gallery.

David and Goliath

Here David is portrayed as a young man in a short garment typical of a shepherd's iconography. He is carried on a typically Roman triumphal wagon toward the city of Jerusalem.

The young man holds Goliath's severed head and the sling with which he struck the giant.

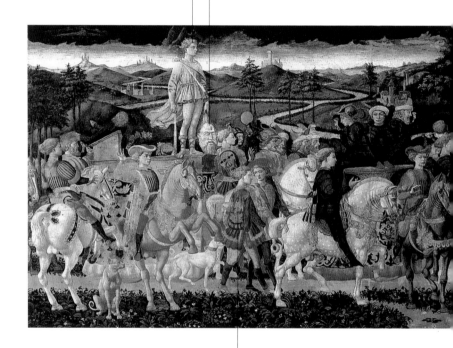

The triumphal procession approaches Jerusalem, where young girls welcome David, dancing and playing music in his honor.

▲ Francesco Pesellino (Francesco di Stefano), *The Triumph of David and Saul* (detail), ca. 1450. London, National Gallery.

The songs were accompa-
nied by musical instruments
and dance movements.

The walls of Jerusalem
make up the background.

In the Bible, women
often sing of the feats
of Israel's heroes or
conquering armies.

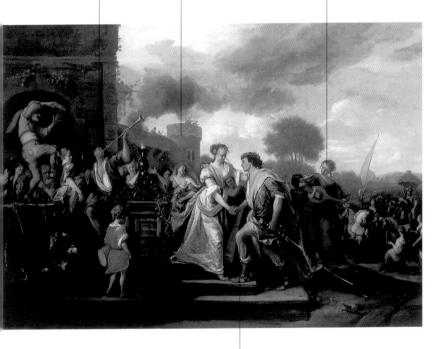

The victorious David returns to Jerusalem and
is welcomed by the Israelite women, who sing
and dance for him. He carries Goliath's long
sword with him.

Jan Steen, *The Triumph of
David*, 1640. Copenhagen,
Statens Museum for Kunst.

David and Goliath

An angel is about to place a crown of laurels on the hero's head.

This allegorical depiction presents all the typical elements of David's iconography.

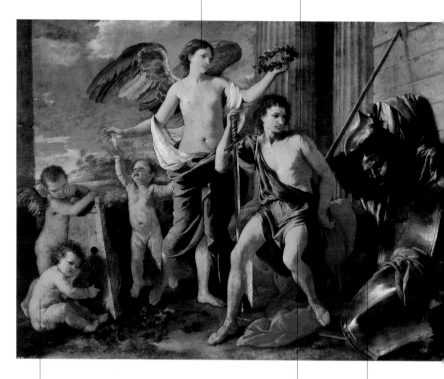

Some putti are shown near a psaltery, another musical instrument associated with David.

The huge head of the giant hangs like a trophy.

David is shown seated, wearing a short garment. His hand rests on Goliath's long sword.

▲ Nicolas Poussin, *The Triumph of David*, ca. 1627. Madrid, Museo del Prado.

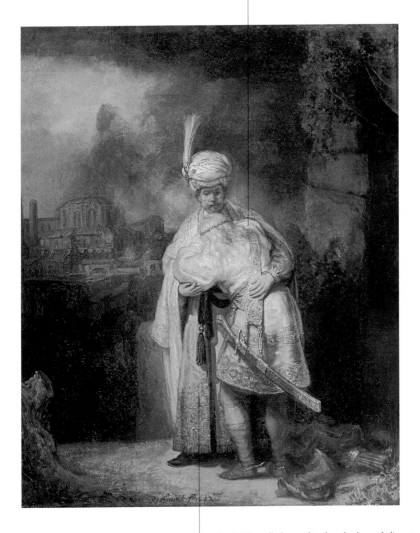

Rembrandt Harmensz. van Rijn, *The Farewell of David and Jonathan*, 1642. St. Petersburg, Hermitage.

As they bid farewell, the two friends make the symbolic gesture of exchanging clothing. For the ancient peoples of the East, an alliance was typically sealed by inserting a strip of clothing into a clay plaque, upon which the terms and conditions of the pact were written. By giving his clothing and weapons to David, Jonathan seeks to conclude an alliance with him.

David and Goliath

When David asks for arms, the priest proposes that the young man take Goliath's sword.

After bidding farewell to Jonathan, David goes to Nob to Ahimelech the priest.

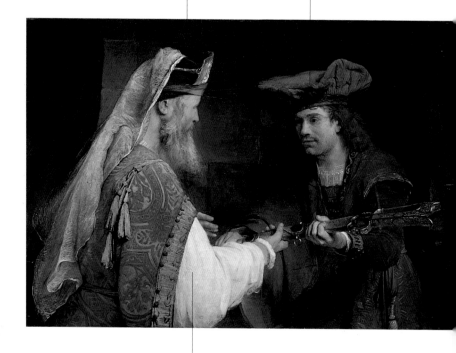

This episode shows the priest Ahimelech dressed in rich, elegant vestments. He offers David the sword of the giant, whom he killed in the valley of Terebinth.

▲ Aert de Gelder, *Ahimelech Giving the Sword of Goliath to David*, ca. 1680s. Los Angeles, J. Paul Getty Museum.

▶ Workshop of Peter Paul Rubens, *David Meeting Abigail*, 1620s. Los Angeles, J. Paul Getty Museum.

This episode shows the beautiful Abigail kneeling and offering gifts to David so that he will pardon the offense that her husband has committed against him.

Abigail before David

Fleeing from Saul, who seeks to kill him, David retreats to the wilderness of Judea, where he gathers a band of outlaw warriors. Nabal, a rich breeder of sheep, lives in the region. Some of David's men ask him for provisions, but Nabal refuses to give them any, and the young warrior decides to punish him. Nabal's wife Abigail, an intelligent woman, comprehends the error that her husband has committed, and she brings David food and wine as a gift, begging him not to kill Nabal. The offering is welcomed benevolently, and David, won over by Abigail, forgives her husband's offense. David blesses her and swears his forgiveness. In exchange for her gifts, he offers her serenity and peace.

Abigail returns home and finds Nabal drunk. The next day the woman tells her husband what happened, and he is struck by how nearly he escaped danger. Nabal dies a short while later, and David takes the young Abigail to be his wife.

The Place
In the wilderness of Judea

The Time
During the exile after David flees from Saul

The Figures
Abigail, David, and his soldiers

The Sources
1 Samuel 25

Variants
Abigail's offering

Diffusion of the Image
Fairly widespread

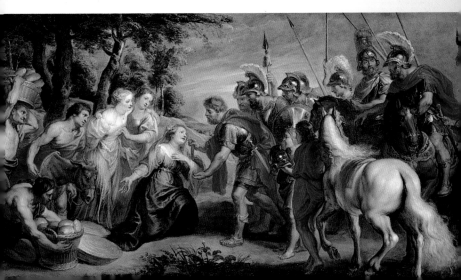

Abigail before David

Abigail is the wife of Nabal, and she is described in the biblical text as a wise and clever woman. After her husband's death, David "sent to speak with Abigail," or, rather, began negotiating to obtain her as his wife.

After her husband's offense against David, Abigail brings the warrior gifts, begging him to forgive Nabal.

Impressed by the young woman, David benevolently accepts her offerings.

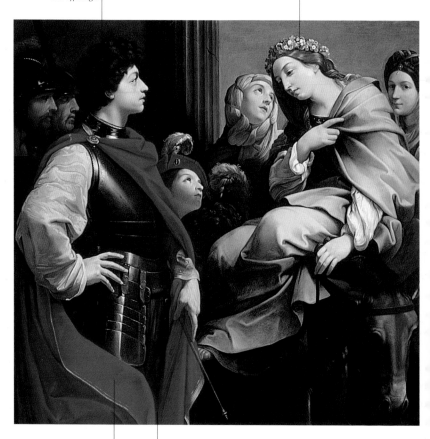

Like all kings and great princes, David has a number of wives. The first is Michal, Saul's daughter. Abigail, Ahinoam, and Bathsheba are others.

In the ancient Near East, polygamy and the keeping of concubines were common practices, since a large family was considered a sign of God's blessing. This custom was later condemned in the New Testament.

▲ Guido Reni, *David and Abigail*, 1615. Budapest, Szépmüvészeti Múzeum.

The episode of Bathsheba bathing is quite widespread in the sacred art of all periods, since it allowed artists to portray a young woman's nude body.

David and Bathsheba

While his army besieges the enemy city of Rabbah, David stays behind in Jerusalem. One evening, strolling along the balcony of his palace, he sees a very beautiful woman bathing. He learns that she is Bathsheba, the wife of Uriah, one of his officers who at that moment is away serving in his army. Taking advantage of his power, David has her brought to his palace and lies with her. The woman becomes pregnant and tells the king.

David then recalls Uriah to Jerusalem and tries to make him sleep with his wife, so that Bathsheba's child will be acknowledged as Uriah's. But the officer, respecting the sexual abstinence prescribed in times of war, does not lie with her.

David then sends Uriah back to the front, ordering the commander of his army to place him on the front lines and desert him there. In the course of events, Bathsheba's husband is slain and David takes her as his wife. Despite the king's repentance, his first child with Bathsheba dies.

The Place
In Jerusalem, in David's palace

The Time
When David is king, during the siege of the city of Rabbah

The Figures
Bathsheba, her maid-servants, David, and sometimes Uriah

The Sources
2 Samuel 11–12

Variants
Bathsheba bathing; the letter from David; the adultery of David and Bathsheba; the repentance of David

Diffusion of the Image
Quite widespread, especially the scene of Bathsheba bathing. Despite David's conduct, the episode of David's adultery with Bathsheba has been seen as prefiguring Christ and the Church.

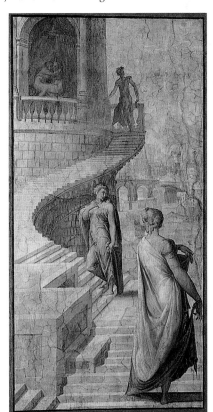

◀ Francesco Salviati, *Bathsheba Goes to King David*, 1555. Rome, Palazzo Ricci Sacchetti.

David and Bathsheba

The magnificent setting and hairstyles illustrate the cultural climate between the Renaissance and Mannerism.

David appears at a window of his palace and admires the beautiful Bathsheba for the first time.

The artist inserts this scene into a rich and studied architectural setting, which features strong foreshortening of perspective relative to the landscape portrayed in the background.

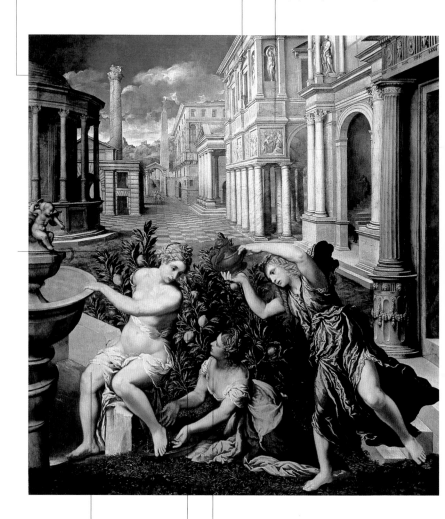

The beautiful Bathsheba is shown nude as she bathes in water from a fountain.

A lemon bush separates the principal scene of Bathsheba bathing from the architectural setting behind her.

A maidservant attends to washing her mistress's feet.

▲ Paris Bordone, *Bathsheba Bathing*, 1545. Cologne, Wallraf-Richartz-Museum.

David is shown in the background speaking with a man on a balcony.

A maidservant helps the young woman by covering her back with a sheet so she can bathe.

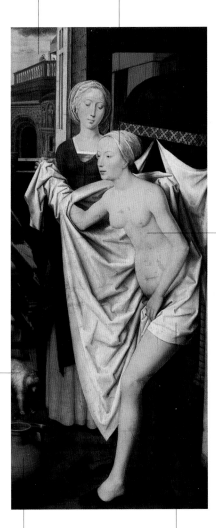

Bathsheba is portrayed in a noblewoman's bedroom, where she rises from her alcove after resting.

The dog, ironically, symbolizes Bathsheba's nuptial fidelity.

Hans Memling, *Bathsheba Bathing*, 1485. Stuttgart, Staatsgalerie.

The careful study of secondary details, such as the amphora and the slippers on the pavement in the foreground, is typical of Flemish tastes.

The woman's body is depicted with plain, chaste features and classical balance. Her long-limbed figure, with slightly protruding abdomen, reflects the standards of feminine beauty in the fifteenth century.

David and Bathsheba

Recognizable by the crown on his head, King David looks out from his balcony to see Bathsheba intent on her bathing and being attended by her maidservants.

A woman o color holds a oval mirro before Bathsheb so she can admir hersel

Another helper brings a tray of ointments.

Having just stepped out of her bath, Bathsheba is attended by numerous maidservants. One of them dries her legs.

▶ Sebastiano Ricci, *Bathsheba Bathing*, 1720. Budapest, Szépmüvészeti Múzeum.

The Book of Samuel says that
Uriah's wife was taking a ritual
bath to cleanse herself after
menstruating: "Now she was
purifying herself from her
uncleanness."

The scene is set
out in the open
under a portico.

A girl combs
Bathsheba's long,
curly hair.

David and Bathsheba

In this episode, which is not mentioned in the biblical text, Bathsheba receives David's letter from a messenger. The sovereign invites the girl to come to him at the palace.

A maidservant busy caring for Bathsheba's body. A fountain stands nearby.

Details in the foreground show the special attention Steen gave to realistic elements, which allow the scene to be placed in context. These details include Bathsheba's clog; the dog, a symbol of nuptial fidelity that in this case is betrayed; and a pitcher containing water.

▲ Jan Steen, *Bathsheba after the Bath*, ca. 1665–70. Los Angeles, J. Paul Getty Museum.

olomon represents the wise king and embodies the ideal of the erfect sovereign. Like David before him, Solomon was seen as refiguring Christ.

Solomon

he younger son of David and Bathsheba, Solomon
ucceeds his father as leader of Israel. After Solomon
 anointed king by David at the spring of Gihon,
 uth of Jerusalem, God appears to Solomon, asking him what
 e would like to receive. The king asks for the ability to under-
 and what is just and what is cruel so that he can administer
 his people with rectitude.

Praised for his wisdom, Solomon resolves a dispute that had
risen between two prostitutes after the death of one of their
hildren. He orders the temple of Jerusalem to be erected,
 ulfilling David's desire to build a house for the ark of the
 ovenant. Solomon's court is renowned for its magnificence
 nd pomp, which impresses the Queen of Sheba when
 he visits.

Solomon is surrounded by
umerous foreign wives and
oncubines, who persuade
im to perform sacrifices to
agan gods. Because of this
ansgression, God predicts
 at his kingdom will be
ivided in two after his death.

Solomon receives a visit
 om his mother, Bathsheba,
 ho comes to ask him for a
 vor. He seats her on a
 rone at his right. This
 pisode is considered a
 refiguration of the Corona-
 on of the Virgin Mary.

The Place
Israel

The Time
Reigns over Israel
from about 970
to 930 B.C.

The Sources
1 Kings

Attributes
A royal crown and
an ivory and gold
throne with six steps
and two lions

**Diffusion of
the Image**
Quite widespread
since Solomon, like
David, was seen as
prefiguring Christ

◄ Pedro Berruguete,
Solomon, ca. 1482.
Paredes de Nava,
Museo Parroquial de
Santa Eulalia.

241

One of the most frequently portrayed episodes of Solomon's life is his judging the dispute between two women, one of whom has stolen the other's son.

The Judgment of Solomon

The Place
In the court of
King Solomon

The Time
During the reign of
Solomon, between
970 and 930 B.C.

The Figures
Solomon, his
courtiers, two prosti-
tutes, a living and a
dead child, and the
executioner

The Sources
1 Kings 3:16–28

**Diffusion of
the Image**
Quite widespread.
This episode has
been interpreted as
prefiguring the Last
Judgment or as a
symbol of justice.

Two prostitutes appear before Solomon, who as king also play the role of judge. Both women gave birth to sons a few days apart and both live in the same house. One night, one mother, realizing that she had crushed her own son in her sleep and killed him, substituted her child for the other's. As a result both women claim the living child. They appeal to the judgment of the king. In order to discover the truth, Solomon has a sword brought out. He says, "Divide the living child in two and give half to the one, and half to the other." At this point the true mother renounces her son so that he will not be killed, while the other wants it to be cut in two. Thus Solomon, identifying which woman is the real mother, entrusts her with the child. The biblical passage comments, "And all Israel heard of the judgment which the king had rendered; and they stood in awe of the king, because they perceived that the wisdom of God was in him, to render justice."

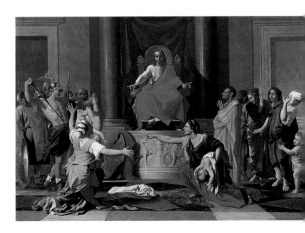

▶ Nicolas Poussin, *The
Judgment of Solomon*, 1649.
Paris, Musée du Louvre.

The landscape that unfolds in the background has been painstakingly created.

Solomon is depicted on the throne surrounded by his courtiers.

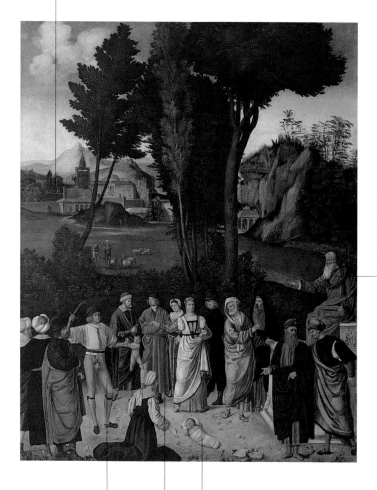

A warrior holds the living child with his left hand, ready to slice it in two.

The dead child lies on the ground, wrapped in swaddling.

Giorgione (Giorgio da Castelfranco), *he Judgment of Solomon*, 1505. Florence, Galleria degli Uffizi.

A group of dignitaries and the two women waiting for Solomon's judgment are assembled before the sovereign.

The Judgment of Solomon

A soldier holds the living child by the legs, ready to cut it in two with his sword.

The Lord grants Solomon the gift of wisdom and the episode of the Judgment of Solomon is proof of it. The subject was widely treated throughout the history of Christian art.

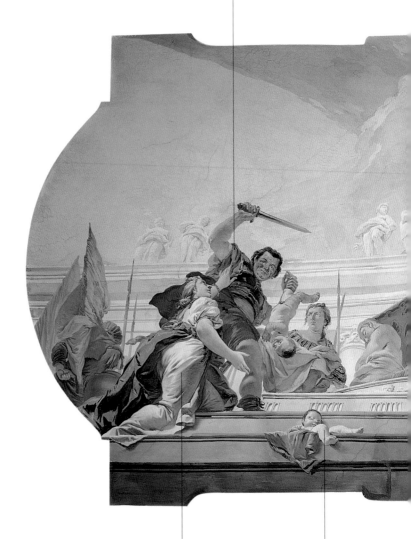

One of the two women stops the soldier, renouncing the child so that it may live.

The dead child is show illusionistic steps create foot of the sovereign's

▲ Giovanni Battista Tiepolo, *The Judgment of Solomon*, 1729. Udine, Palazzo Arcivescovile, Sala Rossa.

Members of the court encircle Solomon on his throne. The figure of Solomon embodies the ideal of a sovereign and the perfect wise man. He knows how to arbitrate justly and to find a solution to even the most complex problem.

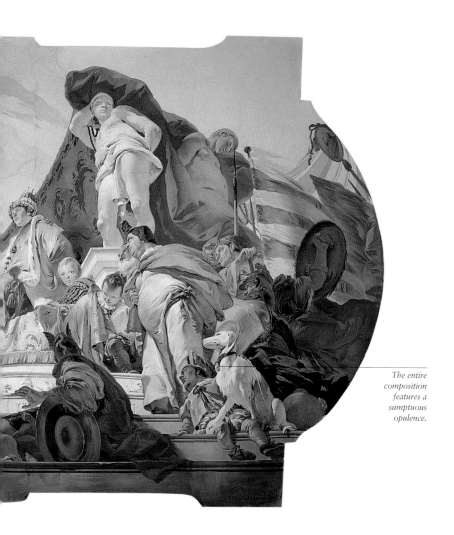

The entire composition features a sumptuous opulence.

n various passages of the Old Testament, the king seems to be he supreme administrator of justice. In other cultures of the Near East, the king also pronounces judgments and sentences. n the tradition of Israel, leaders such as Moses, Joshua, and 'amuel act as administrators of justice.

This episode, which is quite widespread in iconography, has been interpreted variously. Some saw it as prefiguring the meeting between Christ and the churches of pagan converts.

The Visit of the Queen of Sheba

The Place
At the court of King
Solomon

The Time
During the reign of
Solomon, between
970 and 930 B.C.

The Figures
Solomon, the Queen
of Sheba, and at times
her retinue

The Sources
1 Kings 10:1–13

Variants
Solomon and the
Queen of Sheba; the
Queen of Sheba visits
Solomon

**Diffusion of
the Image**
Quite widespread and
often interpreted as a
meeting between the
faithful king and the
pagan queen, as high-
lighted in the Gospels
of Luke and Matthew,
or between Christ and
the churches made up
of pagan converts. The
scene was also seen as
prefiguring the Adora-
tion of the Magi.

As Solomon is building the splendid temple of Jerusalem to house the ark of the covenant, the Queen of Sheba, who has heard news of the king's riches and wisdom, decides to go and observe these qualities in person. Accompanied by a great retinue of men and camels carrying spices, gold, and precious stones, the queen expresses her admiration for Solomon's wisdom and governance. The Book of Kings reports the queen's greeting to the people of Israel and her divine alliance with King Solomon. In exchange, the king offers her rich gifts before she departs.

Many believe the Queen of Sheba's visit to Solomon to be a legend conceived by priests in order to demonstrate Solomon's greatness. Indeed, at that time, Sheba was a richer land than Israel, and it is quite unlikely that its queen would have been impressed by what she saw at Solomon's court. It is more probable that the Queen of Sheba's visit was motivated by commercial objectives, since the roads from Arabia ran through the kingdom of Israel.

The queen is portrayed with her retinue before Solomon's ivory throne. She gives the sovereign an urn containing precious gifts.

Solomon's wealth comes from commerce. Thanks to Israel's location in Palestine, an obligatory trade route between Egypt, Mesopotamia, Syria, and Asia Minor, Solomon could exercise control over commercial exchanges between these countries.

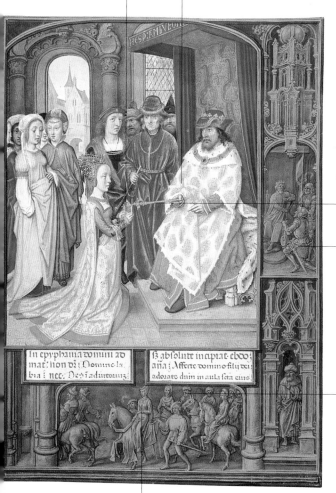

Solomon extends his scepter toward the urn that the queen offers him, indicating his acceptance of the gift. This episode is centered on exalting the splendor and magnificence of Solomon's court and his wisdom.

A messenger announces to Solomon the arrival of the Queen of Sheba.

In Christian tradition the Queen of Sheba has been linked with the Magi, the wise men that go to visit the newborn Messiah.

The Queen of Sheba is shown on the road to Jerusalem.

Konrad Witz, *King Solomon and the Queen of Sheba* (detail), a. 1435. Berlin, Gemäldegalerie.

▲ Bruges School illuminators, *The Queen of Sheba before Solomon*, late fifteenth century. Miniature from the Grimani Breviary. Venice, Biblioteca Marciana.

The Visit of the Queen of Sheba

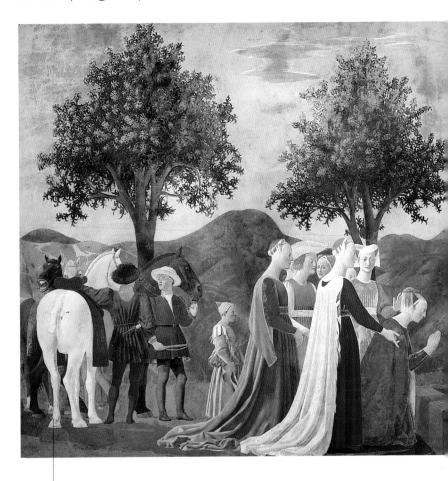

The shield bearers and horses
allude to the long journey
from what is present-day
Yemen to Israel. The kingdom
of Sheba, in fact, was located
in the southwestern part of
the Arabian Peninsula and
had Mareb as its capital.

The apocryphal Gospel of Nicodemus reports that
during her visit to Solomon, the Queen of Sheba
steps on a beam taken from the tree of knowledge
which the king used in his Jerusalem palace as a
bridge over a watercourse. Just then she has a vision
of the role that the wood will later play in redeeming
humanity, when it will be used for the cross of
Christ. She kneels and venerates it

▲ Piero della Francesca, *The Adoration of the Sacred Wood
and the Queen of Sheba before Solomon*, ca. 1455–56. From
the *Stories of the True Cross* cycle. Arezzo, San Francesco.

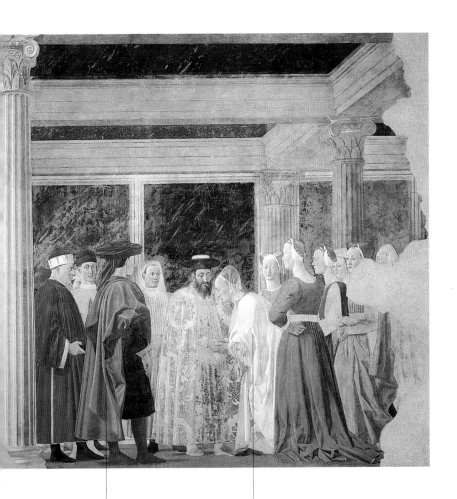

These figures appear excessively tall because of the painting's low point of view. They have been inserted within majestic architecture whose perspective has been rendered somewhat carelessly.

Received by Solomon in his palace, the Queen of Sheba reveals to him the meaning of her vision: the death of Jesus will cause the kingdom of Israel to vanish.

The Visit of the Queen of Sheba

Dressed in a rich cloak, the sovereign wears a crown and holds a scepter.

Solomon welcomes the Queen of Sheba from his majestic ivory throne.

Members of the court are at Solomon's side.

The biblical passage dedicates considerable space to describing Solomon's throne: a great throne of ivory covered with fine gold, rams' heads on its back, two lions on each side, with six steps flanked by twelve more lions. This profusion of detail was a way of celebrating the magnificence of Solomon's kingdom.

▲ Nikolaus Knüpfer, *The Queen of Sheba before Solomon.* St. Petersburg, Hermitage

*ince Solomon is forced to protect the religions of the women
f his harem, many of whom are foreigners, idolatry infiltrates
rusalem. The sovereign himself is affected.*

The Idolatry of Solomon

*any foreign wives and concubines surround Solomon in his
ld age. Under their influence, he begins to build altars and
ffer sacrifices to pagan gods such as Ashtoreth, the goddess of
e Sidonians, and Milcom, god of the Ammonites.

The Lord, warning Solomon of the error he is committing,
redicts that after his death his kingdom will divide, and that
nly Judaea and Jerusalem will remain with his successors.

Generally Solomon is depicted before an altar offering a
acrifice. Pagan statues stand before him, or a golden calf. The
iblical text refers to seven hundred primary wives and three
undred concubines, underscoring the enormous quantity of
omen in Solomon's harem.

The judgment expressed by the Bible regarding Solomon's
dolatry is severe. In other passages of the biblical text, foreign
ives are associated with idolatry, and for this reason such
arriages are forbidden.

The Place
At the court of
King Solomon

The Time
During Solomon's
old age

The Figures
Solomon and the
numerous women of
his harem

The Sources
1 Kings 11:1–8

Variants
Solomon adores
the idols

**Diffusion of
the Image**
Widespread. In
northern European
art from the six-
teenth and seven-
teenth centuries, this
subject reflected
Protestant criticism
of the Catholic use of
sacred images, which
were held by the
Reformation to be a
form of idolatry.

◄ Frans Francken II,
The Idolatry of Solomon,
1622. Los Angeles,
J. Paul Getty Museum.

The Idolatry of Solomon

Solomon's many foreign women can be explained by the fact that a populous harem was a sign of greatness and power, and a necessity in establishing good relations with neighboring kingdoms. Marriages to foreign women, in fact, were often used to cement alliances.

The scene is set within an arcade that opens onto a garden.

Many of the women who are part of his harem are foreigners, and Solomon is diverted from the austerity of faith in Yahweh to dedicate himself to pagan religions.

Solomon, together with numerous women, kneels to worship the pagan idols.

One of Solomon's concubines offers him incense with which to adore the pagan statue.

▲ Marc Antonio Franceschini, *The Idolatry of Solomon*, 1706. Genoa, Palazzo Spinola, Galleria Nazionale della Liguria.

A statue of a pagan divinity forms the background of this painting.

The composition is set under an arcade supported by large spiral columns that are decorated with plant motifs.

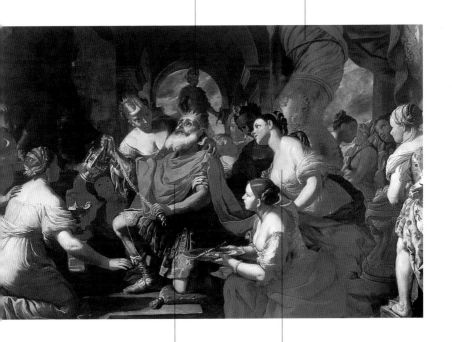

Elderly by now, Solomon offers incense to the pagan gods. The old ruler seems completely absorbed in the religions passed on to him by his foreign wives.

The sovereign is surrounded by a number of wives and concubines who are gorgeously and scantily dressed. They convince him to offer incense to the pagan idols.

Mattia Preti, *Solomon Burns Incense to Pagan Gods*, ca. 1675. Private collection.

STORIES AND HEROES
OF THE ISRAELITES

Lucas Cranach the Elder,
...dith, ca. 1530. Vienna,
...nsthistorisches Museum.

Bruges School illuminators,
...isodes from the Life of
...vid, late fifteenth century.
...iniature from the Grimani
...eviary. Venice, Biblioteca
...arciana.

Samson

As a heroic figure of the Old Testament, Samson stimulated the imagination of both artists and authors. He was a judge for close to twenty years and fought to defeat Israel's traditional enemies, the Philistines.

The Place
The kingdom of Israel

The Time
Eleventh century B.C. He held his judgeship for about twenty years.

The Sources
Judges 13–16; legendary oral traditions

Attributes
The door of a great gate, a broken column, a lion, and the jawbone of an ass

Diffusion of the Image
Quite widespread, especially because of his affinity with the figures of Hercules and David, and as a prefigurement of Christ, a linkage highlighted by the medieval Church

Samson is the most renowned of Israel's judges. Born of the tribe of Dan, he is consecrated at birth as a Nazirite, that is, one dedicated to the service of God. According to tradition, the angel Gabriel appears to his mother and announces that her son will free the Israelite people from the Philistines.

The Philistine threat emerges during Samson's life. Settling along the coast of Palestine, these warrior people begin to subjugate the Israelites. The tribes of Judah and Dan are particularly isolated from the others, and their enemies take advantage of the fact. Samson becomes one of the first heroes to clash with the Philistines.

The sources for his character are not only biblical but also legendary, and they often transmit conflicting information. The biblical text describes him as an adventurer with great physical strength who allows himself to be enticed by female charms.

Despite the fact that he holds the position of judge for twenty years, none of his laws has been handed down.

▶ Salomon de Bray, *Samson with the Jawbone*, 1636. Los Angeles, J. Paul Getty Museum.

Captivatingly narrated in the biblical text, the feats of Samson are only possible because the "spirit of the Lord" descends upon him.

The Exploits of Samson

The feats accomplished by this singular judge of Israel are numerous. Tales of Samson's exploits in the Bible are full of wonderful details that are sometimes imaginary, all with the purpose of celebrating the hero. His first adventure on record concerns the judge and a lion. Despite his parents' hesitation, Samson wishes to marry a Philistine woman from the city of Timnah. As he journeys with them to negotiate the marriage, the young man manages with his bare hands to slay a lion that was crossing the road, a feat reminiscent of those of Hercules.

After being handed over to the Philistines by men from the tribe of Judah, Samson frees himself from his bonds in Lehi and, with the jawbone of an ass, massacres his enemies. Following this prodigious deed, the Lord makes water spring from the jawbone to quench the hero's thirst.

Continuing his adventures, the hero meets a prostitute in the city of Gaza. The citizens there, believing they have captured him, lock the city gates. At midnight, Samson leaves the woman and reaches the gate. Finding it locked, he tears the gate from its hinges and carries it to the summit of a tall mountain that is close to forty miles away.

The Place
Various locations: on the road to Timnah, Lehi, and Gaza

The Time
Various times in his life

The Figures
Samson, his parents, and the lion; Samson and the Philistines; Samson

The Sources
Judges 14–16, and oral traditions

Variants
Samson kills the lion; Samson wipes out the Philistines with the jawbone of an ass; Samson and the gates of Gaza

Diffusion of the Image
Quite widespread, especially the episode of Samson with the lion, which recalls the figures of Hercules and David and was seen as prefiguring Christ's struggle with the devil

◀ Louis Dorigny, *Samson Battles the Philistines*, 1675. Padua, Palazzo Conti.

257

The Exploits of Samson

The scene is set within a spacious landscape

Samson is shown straddling the lion as he pulls apart its jaws with his bare hands.

In addition to Samson, David and Hercules are among the heroic figures who fight with lions.

▲ North German painter, *Samson Slaying the Lion*, 1683. Basedow, parish church.

The lion, a symbol of courage, also frequently alludes to strength.

▶ Bruges School illuminators, *Samson Carrying Off the Gates of Gaza*, late fifteenth century. Miniature from the Grimani Breviary. Venice, Biblioteca Marciana.

Behind him, the citizens of Gaza, who had locked the gates of the city and believed that they had imprisoned Samson, realize that the hero has escaped.

Samson is shown with the gates that he tore off the city walls. He heads away from Gaza, hurling them onto a high mountain.

Jonah is swallowed by the whale.

Both the tale of Jonah inscribed in the frame and the episode of Samson allude to the Resurrection of Christ.

The crew of Jonah's ship cast him into the sea.

The head adorned with a laurel crown portrays Caesar and has been drawn from an ancient medallion.

The Exploits of Samson

The city from which the
hero departs, eluding
capture, is portrayed
behind him.

Samson carries a huge gate from
the city of Gaza in his arms.

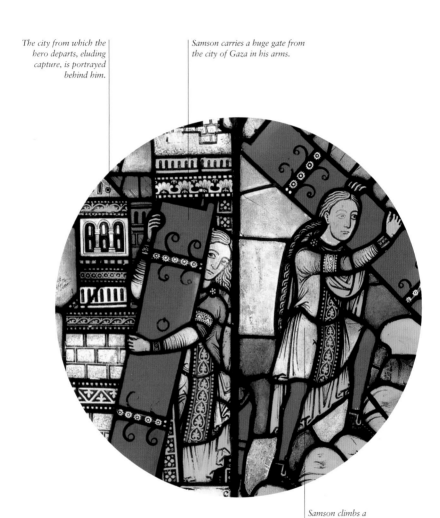

Samson climbs a
tall mountain, from
which he hurls
down the gate.

▲ *Samson and the Gates of Gaza*,
1180–1200. A window from the abbey at
Alpirsbach. Stuttgart, Württembergisches
Landesmuseum.

▶ Guido Reni, *The Victorious
Samson*, 1611–12. Bologna,
Pinacoteca Nazionale.

The episode of the Lord making water flow from the jawbone of an ass seems to derive from an erroneous translation of the Hebrew text, where it is written that Samson drinks from the spring of Lehi, whose name means "jawbone."

The victorious Samson is depicted drinking from the jawbone of an ass. The animal's jawbone is the same weapon that Cain uses to kill Abel.

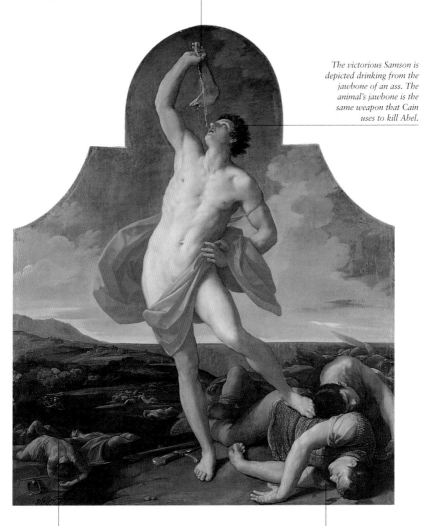

The Philistines occupied the plains of the land of Canaan on the coast of the Mediterranean Sea. Like the Israelites, they were not native to that region but probably had migrated there from the Aegean Sea. According to a tradition reported in the Old Testament, they originated from the island of Crete.

The bodies of the Philistines that Samson massacred with the jawbone are scattered on the ground.

This rarely represented episode tells how Samson, after posing a riddle to the Philistines, reveals the answer to his wife. She passes it on to the Philistines, thus provoking a series of blood feuds.

The Marriage of Samson

The Place
In Timnah

The Time
After the second visit
to his future wife

The Figures
Samson, his wife,
and the invited
guests; Samson and
his father-in-law;
Samson and the foxes

The Sources
Judges 14:10–15:3

Variants
Samson's riddle at
the wedding table;
Samson threatening
his father-in-law; the
foxes with fiery tails;
the foxes in the wheat

**Diffusion of
the Image**
Uncommon

After Samson kills the lion, he travels once again to visit his future wife in Timnah, and on the way he discovers a honeycomb in the animal's carcass.

During the grand, week-long wedding banquet organized by the bride's parents, Samson poses a riddle to his guests about the lion ("the eater," "the strong") and the honeycomb ("something to eat," "something sweet"). He offers thirty festive garments and thirty linen garments to anyone who solves it.

Samson's wife, egged on by her fellow Philistines, persuades Samson to reveal the puzzle's solution. On the seventh day of the feast, the inhabitants of Timnah are able to give the judge the exact answer: "the strong" is a lion, while "the sweet" is honey. Furious, the hero goes to another Philistine city and kills thirty people to obtain the garments he needs to pay the promised prize. Then he deserts his wife.

He later hopes to reconcile, but she has already married a countryman. Samson reacts to this news with violence: he ties three hundred foxes together by their tails and attaches lit torches to them, setting fire to the sheaves of grain on the plain of Sephela, where the Philistines live.

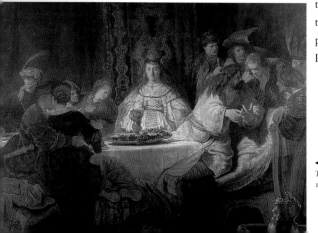

◀ Rembrandt Harmensz. van Rijn, *Samson Telling His Wedding Guests a Riddle* (detail), 1638. Dresden, Gemäldegalerie.

After a period of days, Samson returns to the woman he deserted for revealing his riddle's solution to her countrymen. Samson brings her a gift, but his father-in-law, who has already given her away to another man, does not let him in.

Samson threatens his father-in-law, saying, "This time I shall be blameless in regard to the Philistines, when I do them mischief."

Rembrandt renders Samson's enraged expression with great efficacy.

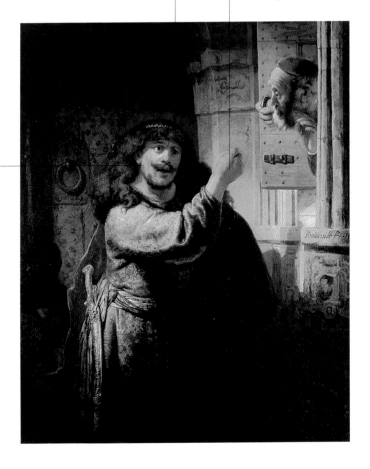

Rembrandt Harmensz. van Rijn, *Samson Threatening His Father-in-Law*, 1635. Berlin, Gemäldegalerie.

The Marriage of Samson

In retaliation for the gruesome destruction carried out by Samson, the Philistines burn the hero's wife and her father alive.

Prevented from seeing his wife, Samson reacts in his accustomed manner, with force and vengefulness. He ties three hundred foxes together by their tails and lights them with torches. Then he sets fire to the sheaves of grain on the plain of Sephela.

This episode of foxes, in which Samson sets the grain on fire with their burning tails, is marked by his thirst for revenge.

The series of retaliatory acts that follows from the indiscretion of Samson's wife seems all out of proportion with her offense. Nevertheless, the biblical text supplies a religious interpretation: it was a means of freeing Israel from its enemies.

▲ Southern Italian illuminators, *Samson Tying Torches to the Foxes' Tails*, tenth century. Montecassino, abbey archive.

Delilah represents the foreign temptress. She manages to endanger Samson and challenge his Nazirite vow, the consecration to God to which he had been bound since birth.

Delilah

Although not referred to as such in the biblical text, Delilah was evidently a Philistine woman, a native of Sorek. Her name contains the Hebrew term that means "night," as opposed to that of the "sun" found in Samson's name.

Bribed by the Philistines to deceive the feared Samson, the beautiful Delilah makes him fall in love with her. After a number of failed attempts, she manages, under the guise of obtaining proof of his love, to make the hero reveal the source of his superhuman strength: his hair, which has never been cut. Armed with this information, which she obtained through deception, she cuts off his hair. Samson immediately loses his strength, and the Philistines are easily able to capture and blind him.

The Place
In the valley of Sorek

The Time
In the time of Samson (eleventh century B.C.)

The Sources
Judges 16:4

Attribute
A knife

Diffusion of the Image
Quite widespread, particularly the episode in which Delilah cuts Samson's hair

▲ Gustave Moreau, *Delilah*, ca. 1890. Paris, Musée Gustave Moreau.

Like many other foreign women in the Old Testament, Delilah is a figure who, thanks to her seductive abilities, threatens Judaism by spreading idolatry.

This episode, which is widely represented in the history of art, tells of Delilah, who enables the Philistines to capture Samson by cutting the hero's hair, from which he draws his strength.

Samson and Delilah

The Place
In the house of Delilah, in the valley of Sorek

The Time
After Samson's exploit with the gates of Gaza

The Figures
Samson; Delilah; her handmaid; sometimes a Philistine, who cuts Samson's hair; and the Philistines who capture him

The Sources
Judges 16:4–22

Variants
Delilah's betrayal

Diffusion of the Image
Quite widespread, often as a symbol of a woman's control over man

Samson is besotted with a Philistine woman, and his enemies see it as a chance to rid themselves of him. They bribe Delilah to persuade the hero to reveal the source of his strength. Three times Samson gives the woman a false answer, but in the end she manages to make him confess: "A razor has never come upon my head; for I have been a Nazirite to God from my mother's womb. If I be shaved, then my strength will leave me, and I shall become weak, and be like any other man."

After learning his secret, Delilah serves wine to Samson, and he falls asleep. She then calls another Philistine to come in and cut Samson's hair.

The hero awakes to find himself in the hands of his enemies. The Philistines blind him and throw him in prison in Gaza.

In iconographic representations of this subject, it is often Delilah herself who cuts Samson's hair. She often wears contemporary clothing, while in other instances she is shown nude. A pitcher or some other container of wine is often near the figures, indicating that Samson became drowsy from intoxication.

▶ Peter Paul Rubens, *Samson and Delilah* (detail), ca. 1609. London, National Gallery.

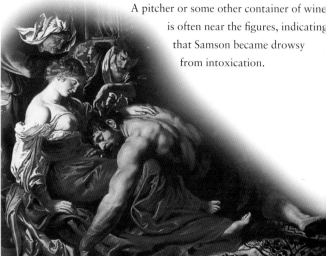

Richly dressed and bejeweled, Delilah cuts Samson's hair. The belief that man's strength lay in his hair was quite common in many societies.

The subject of misfortune caused by foreign women appears frequently in the Bible; Samson is seduced and ruined by Delilah.

The figure of Delilah's elderly servant is quite important. With raised finger and animated gaze, she seems to direct the entire scene.

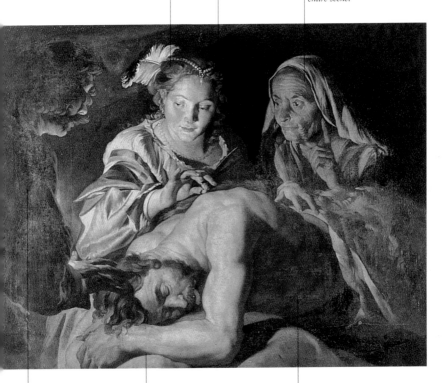

The male figure at the left represents the Philistine soldier whom Delilah calls to capture Samson.

The vow with which Samson was consecrated since birth, as a Nazirite in the service of God, prohibits him from cutting his hair. This episode's story revolves around this symbol.

The naked, defenseless body of the sleeping hero dominates the lower part of the painting.

Matthias Stomer, *Samson and Delilah*, ca. 1630. Rome, Palazzo Barberini.

Samson and Delilah

The scene is set inside Delilah's tent in the valley of Sorek, where the Philistine soldiers stage a raid.

In the background, Delilah flees with the scissors and a huge lock of cut hair.

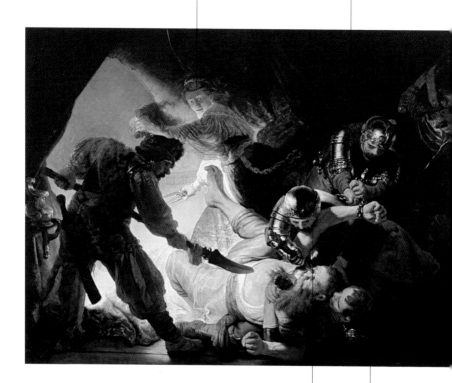

A soldier blinds Samson, who is brought as a prisoner to Gaza.

Thanks to the young woman's betrayal, the Philistines easily capture and blind Samson.

▲ Rembrandt Harmensz. van Rijn, *The Blinding of Samson*, 1636. Frankfurt, Städelsches Kunstinstitut.

The vertical structure to the left of the hero, which resembles a column, could indicate the columns of the Philistine temple that Samson is to destroy.

Just as Samson owes his extraordinary strength to the presence of God's spirit, his weakness means that the Lord has abandoned him. The cutting of his hair marked the end of his status as a Nazirite and, as such, someone consecrated to God.

The blind Samson, his eyes covered with a bandage and his hands chained, is depicted in a moment of intense pain and torment.

A door can be discerned to the right of the chained Samson.

Lovis Corinth, *Samson Blinded*, 1912. Berlin, Gemäldegalerie.

In this painting, Samson seems to suffer from a debilitating malady, as did the artist. The rough and strongly expressive style of the work is indicative of the suffering he endured.

*With the cutting of his hair, which indicated his status as a
Nazirite, Samson is abandoned by the Lord. When called upon,
however, God allows him to defeat his enemies one last time.*

Samson's Last Feat

The Place
In Gaza

The Time
At the end of
Samson's life

The Figures
Samson, the Philis-
tine princes, and the
Philistines invited to
the feast

The Sources
Judges 16:21–31

Variants
The revenge of
Samson; the death
of the blind Samson
in Gaza

**Diffusion of
the Image**
Widespread as
a prototype of
strength; often a
broken column is
depicted. This was
interpreted by the
Church as prefigur-
ing the Mocking of
Christ.

▶ After Giuseppe
Arcimboldi, *Samson
Pulls Down the Philistine
Temple*, ca. 1550.
Stained-glass window.
Milan, cathedral.

Thanks to Delilah's betrayal, the Philistines capture Samson,
gouge out his eyes, and imprison him in Gaza, forcing him to
turn a millstone. In the meantime, however, the hero's hair
begins to grow back.

During a celebration honoring the god Dagon, a divinity
from the ancient Near East and an expression of the cult of fer-
tility, the Philistine princes send to the prison for Samson in
order to amuse themselves at his expense. Led into the temple
where three thousand men and women have gathered, Samson
asks the boy accompanying him to untie his hands so that he
can lean against the building to rest.

Suddenly, he clings to the
columns and, praying to God to
give him strength, clenches the two
central columns that support the
roof with such force that he shat-
ters them. The temple collapses on
the princes, the guests, and Samson
himself. The biblical text observes
that the hero is able to kill more
Philistines in death than he had
in life.

Indeed, as Samson seizes the
two columns with arms that have
regained their original strength,
he shouts, "Let me die with the
Philistines." Any invocations the
priests made to the idol of the god
Dagon were in vain.

...th is an ancestor of David's, named in the genealogical tree ...Jesus at the beginning of the Gospel of Matthew. She is often ...own in Christian art.

Ruth

...native of Moab, Ruth is the widow of a Hebrew immigrant
...o died when she was still young. Deciding to return to her
...sband's homeland with Naomi, her Jewish mother-in-law,
...th goes to glean in the grain fields of Boaz, a rich landowner
...Bethlehem, who is related to her mother-in-law. At the
...vice of the latter, one night Ruth lies at the feet of Boaz, who
...leeping out in the country, and falls in love with him. He
...ognizes her virtue and decides to take responsibility for her
...her kinsman.

...The law of the levirate required that if a man die childless,
...next-of-kin must contract a marriage with the widow.
...hen the nearest kinsman renounces his claim, the law's bind-
...; force is overcome, and Boaz marries Ruth.

...Naomi welcomes the marriage. In the end the happy grand-
mother embraces the baby Obed, who is
born from the union of her
daughter-in-law and Boaz.
Obed becomes the
father of Jesse, who
in Bethlehem
fathers the future
King David.
As the great-
grandmother
of David,
Ruth was
considered an
ancestor of
Christ's.

The Place
A native of Moab,
she moves to
Bethlehem.

The Time
In the time of
the Judges

The Sources
The Book of Ruth

Attributes
Generally Ruth is
portrayed gleaning
grain.

Variants
The most commonly
depicted episodes are
Ruth and Naomi;
the gleaner in the
field of Boaz; and
the marriage of
Ruth and Boaz.

**Diffusion of
the Image**
Quite widespread,
since, as David's
great-grandmother,
she was considered
an ancestor of
Christ's.

◄ Willem Drost, *Ruth and
Naomi* (detail), 1650–52.
Oxford, Ashmolean Museum.

After her husband's death, Ruth decides to return with her mother-in-law to Bethlehem. Here Ruth is portrayed behind the reapers, gleaning what remains from the harvest in Boaz's fields.

Boaz, a relative of Ruth's husband, falls in love with the girl. Nevertheless, by virtue of the law of the levirate, Ruth is intended for another kinsman who is more closely related. Only after overcoming this obstacle are Ruth and Boaz able to marry.

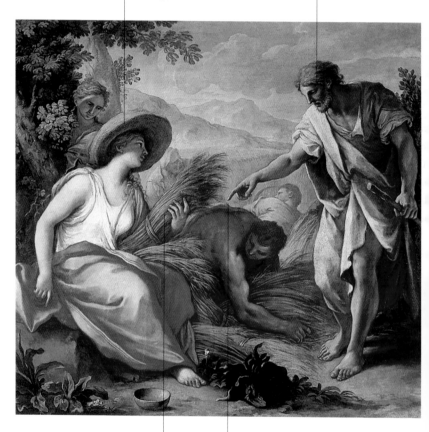

According to an ancient custom still practiced today by Arab peoples, the poor—especially foreigners, orphans, and widows—are allowed to gather grain that is left over during harvest time.

The story of Ruth and Boaz reprises the popular theme of a rich man and a poor woman united by love.

▲ Nicolò Bambini, *Ruth and Boaz*, 1682–83. Prague, Národní Galerie.

God tests even those who fear him and are faithful to him, such as Tobit and Job. Nevertheless, the Lord stays close to them and guides them to a happy ending.

Tobit and His Wife

Tobit is a Hebrew from the tribe of Naphtali. He resides in Nineveh in Assyria, to which the Israelites were deported after the destruction of Israel's northern kingdom. In the Bible, Tobit is described as a man who preserves his faith despite being banished to a foreign land.

During the exile, the Jews suffer repression, and many are killed. Tobit devotes himself to burying the victims as prescribed by Hebrew tradition, even though the king forbids it. As a result, his goods are confiscated and he is forced to go into hiding. After returning and repossessing his property, droppings from a passing swallow fall into his eyes, and Tobit becomes blind.

His wife, Anna, must thereafter support the family by spinning. One day, as she hands in her work, she receives a goat kid as a gift. She brings it home to her husband, who, believing it stolen, reproaches his wife. The woman responds angrily, saying: "Where are your charities and your righteous deeds now? You seem to know everything!" Anguished, Tobit prays to the Lord for help.

The Place
Nineveh, ancient capital of Assyria

The Time
Eighth century B.C.

The Figures
Tobit and his wife, Anna

The Sources
The deutero-canonical Book of Tobit, 1–4

Variants
The elderly Tobit burying the dead

Diffusion of the Image
Not very common

◄ Rembrandt Harmensz. van Rijn, *Anna and the Blind Tobit* (detail), ca. 1630. London, National Gallery.

Tobit and His Wife

Tobit's blindness is described in the biblical text as shadow, darkness, and death. Blindness in the Bible is often used as a metaphor to express a lack of spiritual sight, distance from God and from goodness, and as a contrast with the Messiah's salvation, which is presented as light.

Believing that his wife has stolen the goat kid, Tobit reproaches her. At her bitter reply, the man addresses a prayer of supplication to the Lord.

Tobit's wife, Anna, brings her husband a goat kid that was given to her when she handed in her work.

The scene is enrich by numerous det taken from farm lif wicker basket, ga hanging on the u and tools for Ann spinni

▲ Rembrandt Harmensz. van Rijn, *Tobit and Anna*, 1626. Amsterdam, Rijksmuseum.

The story of Tobit has numerous parallels with that of Job, especially in his relationship with his wife. Even Anna cannot explain why the order of justice seems turned upside down: honesty is punished and generosity humiliated.

▶ Giovan Antonio Guard *The Story of Tobias*, 176 Venice, Angelo Raffaele.

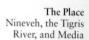

Tobias, Tobit's son, journeys toward Media, accompanied by a young man who advises him and guides his actions. Afterward, the man reveals that he is the angel Raphael.

Tobias and the Angel

In answer to the prayer of Tobias's father, Tobit, God sends the archangel Raphael to earth. Tobit feels death approaching, and since he has deposited his fortune with a relative in a faraway city, he sends his son Tobias to retrieve it. The elderly Tobit, however, asks the young man to seek out a companion for the journey. Tobias finds Raphael, who conceals his angelic appearance. After saying good-bye to Tobit and Anna, the two companions set out.

One evening, upon reaching the Tigris River, Tobias bathes, and a fish tries to devour his foot. Raphael invites the young man to catch the fish and extract its heart, liver, and gallbladder. These organs will prove useful as remedies against demons and eye diseases. Continuing their journey, Tobias and Raphael reach the house of Raguel, a distant relative of Tobit's, whose daughter Sarah is tormented by suffering: she has been married seven times, but each time her husband has been killed by a demon on their wedding night. Raphael tells Tobias to marry Sarah, and the young man does so, not without some trepidation. On their wedding night, he manages to expel the demon that has vexed her by burning the fish's heart and liver. When the couple returns to Nineveh, Tobias heals his father's blindness with the gall he had extracted from the fish.

The Place
Nineveh, the Tigris River, and Media

The Time
Eighth century B.C.

The Figures
These vary according to the episode: Tobias and his parents; Tobias and the angel; Tobias, the angel, and Sarah; Tobias, the angel, and his parents

The Sources
Tobit 5–12

Variants
The departure of young Tobias; Tobias and the fish; the marriage of Tobias and Sarah; the return of Tobias; and the healing of his father

Diffusion of the Image
Quite widespread, especially the episode of Tobias with the angel dressed as a wayfarer and followed by a dog. The subject was often commissioned on the occasion of a son's departure.

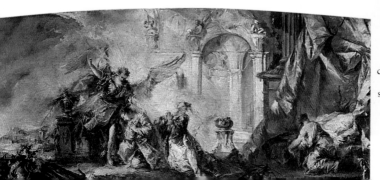

Tobias and the Angel

The archangel Raphael, who accompanies the
young Tobias on his journey to Media, tells
him to catch a fish. The name "Raphael" is
significant, since it means "God heals." The
figure of the angel contrasts with that of the
demon that Tobias will have to defeat.

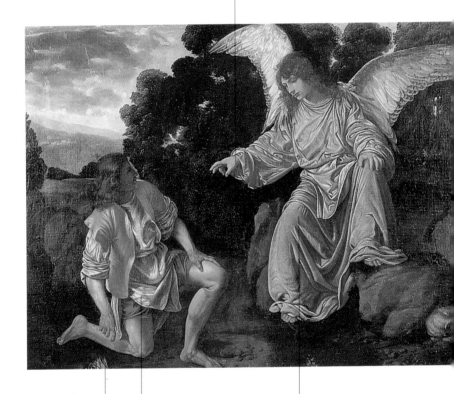

The fish that
Tobias is about to
seize is the size of
a large trout.

On the banks of the
Tigris River, Tobias is
shown kneeling next
to the fish.

The garments of the two travel-
ing companions glow with the
silvery light that distinguishes
the style of Savoldo.

▲ Giovanni Girolamo Savoldo, *Tobias
and the Angel*, 1527. Rome, Galleria
Borghese.

Raphael tells Tobias to take the fish's liver and heart in order to make remedies that will be useful to him in the future. The belief in the therapeutic powers of these organs was common even among doctors in antiquity. The Latin writer Pliny the Elder speaks of the therapeutic powers of the pike in connection with some eye diseases. Egyptian oculists also used the bile of various animals as medicine.

The fish, which the Bible describes as "large," appears to be of truly enormous size in this depiction.

The scene is set on the Tigris River, which originates in Armenia, then waters the plain of Nineveh, and today unites with the Euphrates. In ancient times the two rivers did not join and took different courses.

▲ Battistello (Giovanni Battista Caracciolo), *Tobias and the Angel*, 1615. Private collection.

Tobias and the Angel

The archangel Raphael strides forward, pointing out the way for Tobias.

Young Tobias, who is elegantly dressed, takes the arm of the archangel Raphael. The idea of the guardian angel was widespread, especially in Renaissance Italy.

In his left hand Tobias carries the fish he caught in the Tigris River.

The biblical text reports that a dog follows the two young men as they set out on their journey. Its presence contributes a lively and picturesque detail.

Dogs are mentioned rarely in the Bible, except in negative terms. In Palestine, in fact, they were scorned because they were considered thieves and predators. Only rarely does the biblical text present the dog as a friend of man. Still, for other peoples of the Near East the dog was a sacred animal, and this could have determined its presence in this context. From the Middle Ages on, it became a symbol of fidelity in art.

▲ Antonio and Piero del Pollaiolo, *The Archangel Raphael and Tobias*, 1460. Turin, Galleria Sabauda.

This scene is set in the house of Raguel, a distant relative of Tobit's. Tobias and Raphael visit him so that the young man can take Raguel's daughter Sarah to be his wife.

This painting depicts the signing of the marriage contract, in which Raguel, Sarah's father, gives his daughter to Tobias, his nearest relative.

According to a Hebrew rite, an only daughter was supposed to be given in marriage to a member of her own tribe. For this reason, Sarah's father consents to her union with Tobias.

Jan Steen, *The Marriage of Sarah and Tobias*, 1668–70. Braunschweig, Herzog Anton Ulrich-Museum.

Tobias and the Angel

This painting shows the beautiful young Sarah waiting for her husband on their wedding night.

Each of the girl's previous seven husbands was killed by the demon on their wedding night.

Tobias, following the archangel Raphael's suggestion, burns some of the fish heart and liver and places it on the embers of incense. He is thus able to expel the girl's demon forever.

▲ Rembrandt Harmensz. van Rijn, *Sarah Waiting for Tobias*, ca. 1649. Edinburgh, National Gallery of Scotland.

Tobias's worried mother had waited each day for her son to arrive. Here she helps him treat his father's eyes.

Later Tobit will want to reward his son's companion. But Raphael disappears after revealing his true angelic nature.

Following the archangel's advice, Tobias spreads bile from the fish he killed at the Tigris River on his father's eyes, and Tobit begins to see again.

This subject appears frequently in votive paintings offered by those who are afflicted by disease and seek healing.

The story of Tobit is a celebration of the clear-headed man who, even in the midst of difficulties, remains faithful to the biblical commands. As a consequence, God ultimately blesses him.

The dog, which appears frequently in the Book of Tobit, is again presented here together with the rest of the family. Its presence recalls the consideration given this animal in Persia, as opposed to Palestine.

At the right is the legendary fish, which, in contrast to the faithful dog, represents a wicked animal.

Bernardo Strozzi, *Tobias Healing His Father*, ca. 1635.
Petersburg, Hermitage.

A heroine of the Hebrew people against the ancient oppressors of the Near East, Judith is generally portrayed holding up the head of the Assyrian general Holofernes, whom she beheaded.

Judith

The Place
The city of Bethulia

The Time
The figure of Judith can be placed during the time of King Nebuchadnezzar (sixth century B.C.). This king was mistakenly identified as Assyrian, when in fact he was Babylonian.

The Sources
The deutero-canonical Book of Judith

Attributes
The sword and the decapitated head of Holofernes

Diffusion of the Image
Widespread, especially the episode of her slaying Holofernes

▶ Giorgione (Giorgio da Castelfranco), *Judith with the Head of Holofernes*, ca. 1503. St. Petersburg, Hermitage.

Like Deborah, Jael, and Esther, Judith is a heroine of the Old Testament. She is described as a model of fidelity and observance of God's laws. She also represents widows, who, like foreigners and orphans, were a vulnerable segment of society. The religious and civil tradition of ancient Israel counseled its people to treat them with gentleness and assistance.

This heroine symbolizes the people of Israel, who are in exile and at the mercy of their enemies, but always beloved by God. To save her city of Bethulia, the beautiful woman deceives the

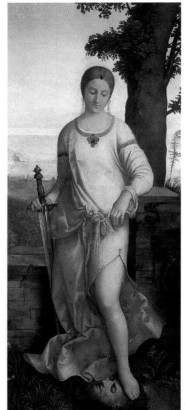

Assyrian general Holofernes and kills him.

The tale of Judith, like that of Esther, is not historical but rather exemplary, aiming to celebrate the protection that the Lord reserves for his people in moments of difficulty.

The figure of Judith has been interpreted freely in Christian tradition as a Marian image and was seen in the Middle Ages as a symbol of virtue triumphing over vice. The subject of a female figure's victory can also be compared with the episode of Samson and Delilah.

Like the Book of Tobit, the Book of Judith is also part of the deuterocanonical books and has reached us in Greek.

Judith appears splendidly dressed and adorned with precious jewels.

Judith is a heroine, a widow whose name means "the Judean," or "mother of the homeland." This name is attributed to the courageous woman who kills Holofernes because she is a sort of personification of the entire Jewish nation.

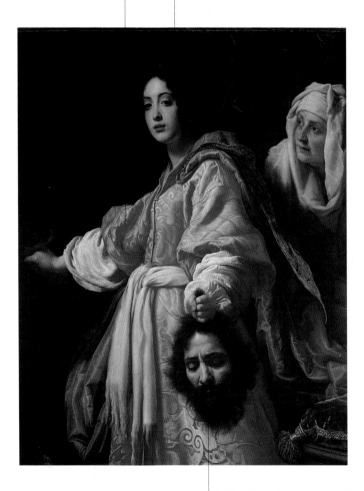

Cristofano Allori, *Judith with the Head of Holofernes*, 1617. Florence, Palazzo Pitti.

Despite being weak and widowed, Judith is chosen by God to become the heroine who overthrows the powerful general Holofernes. She grasps his severed head by the hair.

In one of the most frequently depicted episodes of the Old Testament, Holofernes represents pagan power blinded by pride, while Judith represents the fidelity and cleverness of the Hebrews

Judith and Holofernes

The Place
The city of Bethulia

The Time
These events can be placed during the time of King Nebuchadnezzar (sixth century B.C.), who was identified mistakenly as an Assyrian king but in reality was Babylonian.

The Figures
Judith, Holofernes, and a maidservant

The Sources
The Book of Judith

Variants
Judith at the banquet of Holofernes; Judith killing Holofernes; Judith and the servant with the head of Holofernes; the triumph of Judith

Diffusion of the Image
Quite widespread, both the scene of Judith with the head of Holofernes and the other episodes of the story

▲ Agostino Carracci, *Judith with the Head of Holofernes*, ca. 1600. Private collection.

The Assyrian army has besieged the city of Bethulia. Its population cannot hold out any longer and is on the point of surrendering. The rich and beautiful widow Judith devises a plan to save her city. Making herself alluring, she journeys to the enemy camp with her maidservant and, pretending to have

deserted her people, approaches General Holofernes. Spending several days in the camp, with the excuse of proposing a plan to conquer Bethulia, Judith causes Holofernes to fall in love with her. He invites her to a banquet. At the end of the feast, Judith fatally strikes the general, who is overpowered by drink. She severs his head, and her maidservant places the trophy in a bag. The two women move quickly through the camp and return to the city of Bethulia undetected. The death of Holofernes causes confusion among the Assyrians, who flee and are pursued by the Israelites. The next morning Judith has the severed head of Holofernes set up on the walls of Bethulia.

Judith is shown in the moment
that precedes her act. Just before
striking the enemy general, with
her hands joined and her gaze
toward Heaven, she addresses a
prayer to the Lord, saying, "Give
me strength this day, O Lord God
of Israel!"

The body of Holofernes, flung across
the bed in a state of intoxication,
constitutes the central element of the
composition. The intensity of the
light that strikes it emphasizes the
dramatic power of the moment.

The faithful maidservant with
whom Judith will accomplish
the feat is by her side.

▲ Giulia Lama, Judith and
Holofernes, 1730–40. Venice,
Gallerie dell'Accademia.

Judith and Holofernes

Judith's maidservant participates actively in the mission by helping her mistress hold Holofernes still. In contrast with other representations, here she seems to be a young woman.

Taking off her widow's weeds, Judith has put on a festive gown to look attractive and to seduce the men who see her.

▲ Artemesia Gentileschi, *Judith and Holofernes*, 1625–30. Naples, Capodimonte.

This scene is dominated by Judith's fearlessness as she cuts off the man's head with the stroke of a scimitar.

The wrinkled face of Judith's maid-
servant, who is ready to take
Holofernes's head, contrasts with
the young, glowing face of Judith.

The quickness and violence of the gesture
astonish Judith herself, whose face
betrays a sickened expression.

Caravaggio depicts the culminating
point of the action, when the heroine
cuts off the head of the general, who
had previously been asleep.

The painful expression on
Holofernes's face is seen again in
another Caravaggio figure, one of
the fallen giants in the hall of the
Palazzo Te in Mantua.

Michelangelo Merisi da Caravaggio, *Judith
and Holofernes*, 1598–99. Rome, Galleria
Nazionale d'Arte Antica, Palazzo Barberini.

Judith and Holofernes

The figure of the servant, who is ready to take the head of the defeated general, can barely be made out at left.

In this scene, Judith, who has already cut off Holofernes's head, is painted in the background, almost separate with respect to the principal subject. The young woman is shown at the moment when she thanks Heaven for being able to free her city from the enemy general.

The depiction of this episode seems to have been contaminated by the subject of Salome presenting the head of John the Baptist, which was just as popular. In that case, however, the roles are reversed: good is defeated, while evil, personified by the female character, is victorious.

Holofernes's body, in the foreground, has been delineated with great care for physiognomic detail, such as the veins of the hands and the powerful limbs.

▲ Mattia Preti, *Judith and Holofernes*, 1656. Naples, Capodimonte.

Mantegna's painting follows faithfully what is reported in the biblical text, where it says that, having accomplished her mission, Judith "went out, and gave Holofernes' head to her maid, who placed it in her food bag."

The tent forms a sort of symbolic curtain for the scene.

The heroine turns her head coldly as she hands her maidservant the general's bloody head.

...ith a somewhat ...rrified expression ... her face, the fear-... old maidservant ...s the trophy fall ...o the bag.

Holofernes's foot is the last visible element in the composition's background.

The presence of the bed is significant, because such furnishings were used only by royalty and the rich. Common people, in fact, slept on the ground, wrapped in a cloak, or on a mat that could be easily transported. Typically a bed was made of wood and decorated with gold, silver, or other precious metals.

▲ Andrea Mantegna, *Judith and Holofernes*, ca. 1495. Washington, D.C., National Gallery of Art.

Judith and Holofernes

The beautiful young Judith heads victoriously back to her native city. The city, like Judith herself, has a symbolic name: "Bethulia" may allude to Bethel, or "house of God."

Judith's face reveals an expression of melancholy. She holds a scimitar, a curved sword similar to the blade of a scythe, and an olive branch.

Behind the tr women, the ene army begins to s

The heroine is followed by her young maid-servant, who carries the sack containing their trophy on her head and has two water bottles tied to her wrist.

▲ Botticelli (Alessandro di Mariano Filipepi), *Judith Returns to Bethulia,* ca. 1472. Florence, Galleria degli Uffi

The Assyrian soldiers appear shaken at their unhappy discovery. From this moment on, they flee and are pursued by the Israelite army.

The fact that Holofernes was killed at night while he slept is unusual; the ancient Semites, in fact, avoided killing at night because they held nighttime to be sacred. The circumstances of the general's death are similar to those of General Sisera's at the hand of Jael: both are carried out by a woman's hand while the victim sleeps.

The figure of Holofernes, who battles Israel, symbolically struggles against God. More than just defending Bethulia, Judith defends Jerusalem, the temple, and the faith of her people.

The decapitated body of Holofernes, the commander at the head of Nebuchadnezzar's army, is found by his soldiers the morning after he is killed.

Botticelli (Alessandro di Mariano Filipepi), *The Discovery of the Body of Holofernes*, 1472. Florence, Galleria degli Uffizi.

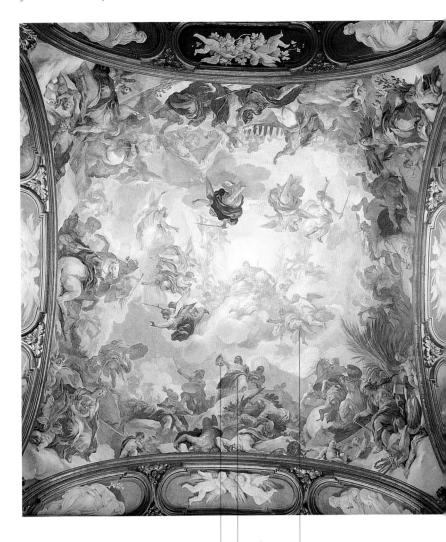

Displaying Holofernes's head from the city walls was, in antiquity, a gesture of great contempt and desecration. The head of the conquered enemy was thus left to be eaten by wild beasts.

The praise and blessings addressed to Judith recall the blessing that Melchizedek gives Abraham (Genesis 14:19–20) and the greeting that Elizabeth addresses to Mary (Luke 1:42).

▲ Luca Giordano, *The Triumph of Judith*, 1704. Chapel vault. Naples, Carthusian monastery of San Martino, Tesoro Nuovo Chapel.

Judith's victory is considered a triumph of God.

Judith is portrayed with the head of Holofernes, which will later be hung from the walls of the city.

Another heroine illustrated in the Old Testament is Esther, a young Hebrew woman who, thanks to her bravery, saves her people from being massacred.

Esther

The heroine Esther bears a pagan name that stems from "Ishtar," the goddess considered the Venus of the East, or from a Persian word for "star." Her role, together with that of her cousin Mordecai, is to be an instrument of salvation for the Jews, who are persecuted because of the hostility of Haman, the minister of the king of Persia.

After her mother Abigail's death, Esther is raised in Susa by her cousin Mordecai, a court dignitary. After King Ahasuerus repudiates his wife Vashti, young Esther is presented at court. The sovereign, in fact, is seeking out the most beautiful virgin in the entire kingdom to take his wife's place. Falling in love with Esther, Ahasuerus crowns her queen without knowing anything about her origins. The prime minister, Haman, proclaims a law to exterminate the Jews; the edict cannot be canceled, but thanks to the intercession of the heroine, who dares to present herself to the king, the Jews are allowed to arm and save themselves from slaughter.

The Book of Esther has reached us in Hebrew and in a longer Greek version. The Greek, so-called deuterocanonical, additions began to be considered part of the Bible only during the Middle Ages.

The Place
Susa

The Time
This figure can be placed in the time of Ahasuerus-Xerxes, king of Persia from 486 to 465 B.C.

The Sources
The Book of Esther

Attributes
A crown, elegant clothing, and youthful beauty

Diffusion of the Image
Broad, especially those episodes set in the court of King Ahasuerus. The Church saw her intercession with the sovereign as prefiguring the Virgin Mary in her role as mediator at the Last Judgment.

Made in Lorraine, *The Coronation of Esther,* ca. 1200. Detail from the Trivulzio Candelabra. Milan, cathedral.

The episode of Esther interceding for her people with the Persian king Ahasuerus spread throughout Christian iconography and prefigured the role of the Virgin Mary at the Last Judgment

Esther and Ahasuerus

The Place
Susa

The Time
These events can be placed in the time of Ahasuerus-Xerxes, king of Persia from 486 to 465 B.C.

The Figures
Esther, Ahasuerus, Mordecai, and Haman

The Sources
The Book of Esther

Variants
Esther before Ahasuerus; the triumph of Mordecai; Ahasuerus and Haman dining with Esther

Diffusion of the Image
Broad, especially episodes of Esther crowned by Ahasuerus and of Ahasuerus and Haman dining with Esther

Gifted with rare beauty, Esther is named the new queen by the Persian sovereign. However, a court favorite, Haman, hates her cousin Mordecai and envies his growing influence. As a result, he convinces Ahasuerus to authorize a massacre of the Jews. Mordecai, in turn, persuades the girl to risk her life by revealing her ethnicity to the king and asking him to abolish the law to wipe out her people.

Coming before Ahasuerus, Esther faints in front of the sovereign, who is enraged at her boldness. In fact, those who dared to present themselves spontaneously before the king were subject to capital punishment. Ahasuerus, however, impressed at the young woman's courage, allows her to voice her request, and she invites the king and Haman to dinner. That night the sleepless king reads passages from the annals of the time, in which it appears that Mordecai is still to be rewarded for having uncovered a conspiracy. When Haman comes to Ahasuerus to obtain permission to execute Mordecai, the king orders him to lead Esther's relative through the streets of the city with full honors. Once again Esther invites the king to dinner and asks Ahasuerus to favor her people. The sovereign, after amending his order to persecute Jews, has Haman hanged.

◀ Filippo Abbiati, *Esther Fainting before Ahasuerus*, 1695. Milan, Castello Sforzesco, Civiche Raccolte d'Arte.

This scene is set in the rich palace
of Ahasuerus, where the sovereign
is surrounded by his soldiers.

Through his gesture, the king indicates that
he intends to listen to her. Esther's overcom-
ing this obstacle emphasizes the heroism of
her actions; in order to help save her people,
she is ready to pay with her life.

Just prior to this, Esther fainted. This
touched the heart of the king, who raises his
scepter over her in order to save her.

Sebastiano Ricci, *Esther before
Ahasuerus*, 1733. Rome, Palazzo
el Quirinale.

The scene of Ahasuerus extending his golden scepter
toward Esther indicates that the young woman may
live, despite violating the prohibition against presenting
oneself before the king unless summoned.

Esther and Ahasuerus

Esther is the Persian form of the Hebrew first name "Hadassah," which means "myrtle." Esther is clothed according to the rank of queen.

The name "Ahasuerus" is a transcription of the Hebrew name for Xerxes I, the son of Darius.

Ahasuerus is portrayed in regal splendor, holding a scepter and wearing a cloak adorned with precious stones and an elegant headdress.

▲ Konrad Witz, *Esther before Ahasuerus*, 1445–50. Basel, Kunstmuseum.

Esther invited Ahasuerus and Haman to her lodgings for dinner.

There are numerous guests sitting at the table laid before them.

Ahasuerus is depicted at the end of the table. The sovereign can be recognized thanks to the crown on his head.

The beautiful Esther watches the sovereign, who is seated at the other end of the large table.

Hyacinthe Collin de Vermont, *The Banquet of Esther*. Aix-en-Provence, Musée Granet.

Esther and Ahasuerus

Queen Esther points at Haman and accuses him of betraying her people.

Esther invites Ahasuerus and Haman to a banquet. The young woman wears a queen's crown.

The king is recognizable thanks to his crown and his particularly sumptuous clothing.

This episode revolves around a subject found frequently in the Bible: a reversal of fortune thanks to divine intervention. Here the cruel man will be subject to the same punishment that he hoped to inflict on the just.

The disconcerted sovereign has Haman killed and names Mordecai, Esther's cousin, as his prime minister.

Haman is a character who plays a negative role throughout the story. The minister of Ahasuerus here sits with his back turned toward the viewer and his face in the shadows.

▲ Jan Lievens, King *Ahasuerus and Haman at Dinner with Esther*, ca. 1625. Raleigh, North Carolina Museum of Art.

During the reign of Seleucus IV, the minister Heliodorus is sent to Jerusalem with the task of seizing the temple treasury. An armed rider and two angels prevent him from doing so.

The Expulsion of Heliodorus from the Temple

This episode is set during the centuries preceding the Christian era, when the Hebrews in Palestine were ruled by the Seleucid dynasty of Syria.

Seleucus IV, who is in financial difficulty because of a debt that his father contracted with the Romans, sends Heliodorus to confiscate the treasure kept in the temple of Solomon.

Upon reaching Jerusalem, the minister manages to obtain detailed information about his future spoils and, following his royal orders, proceeds with the confiscation.

When Heliodorus and his bodyguard reach the temple and ask the high priest to see the money collected there, the priest answers that there are only small sums destined for widows and orphans. Heliodorus insists and enters the temple with the bodyguard. As soon as they make their entrance, however, they see an elegantly harnessed horse mounted by a fearsome man. The horse attacks Heliodorus, rearing up on its hind legs and striking the minister with its hooves. Two young men accompany the rider, and they flog Heliodorus and throw him to the ground. The priest of the temple, however, takes care of him, and the minister of Seleucus IV returns to his sovereign bearing testimony of the great works of the Lord.

The Place
Jerusalem

The Time
In the time of Seleucus IV, king of Syria (186–174 B.C.)

The Figures
Heliodorus, his bodyguard, the rider, and two angels

The Sources
2 Maccabees 3

Diffusion of the Image
Fairly widespread, since the episode was seen as prefiguring Jesus cleansing the temple of merchants and moneylenders

Eugène Delacroix, *The Expulsion of Heliodorus from the Temple* (detail), 1850–61. Paris, Saint-Sulpice.

The Expulsion of Heliodorus from the Temple

This episode, which has become quite famous in the history of art, is set during the reign of Seleucus IV, the brother of Antioch IV Epiphanes, who succeeded him to the throne after Heliodorus assassinated Seleucus in 175 B.C.

In the background of the compositio the priest of the temple is absorbed i prayer, kneeling in front of an alta illuminated by a huge candelabr

Pope Julius II, carried by throne bearers, witnesses the episode, which alludes to the inviolability of the Church's possessions and its intention to stamp out usurpers.

Critics have identified the pope's throne bearers as Marcantonio Raimondi, Giulio Romano, and perhaps Raphael himself.

► Raphael, *The Expulsion of Heliodorus from the Temple*, 1511–14. Vatican City, Stanza d'Eliodoro.

Some deposits belonging to widows and orphans" are kept in the temple of Jerusalem. For the ancient peoples, in fact, the practice of depositing goods in care of the temple was common, since sacred places were held to be inviolable by even political authorities.

The temple has been delineated as a magnificent building set off by a succession of domes and arches that create strong contrasts between areas of light and shadow. It represents a sacred place that the divine will does not allow to be desecrated.

Apparitions of horses and riders are described in other passages of the Bible and were common in the ancient Near East, especially after the Persian era. During the Persian and Macedonian empires, in fact, the king was often portrayed on horseback, and this influenced how the gods appeared: depictions of the gods in turn were inspired by those of earthly sovereigns.

Heliodorus, who attempted to desecrate the temple, is thrown to the ground by the hooves of a mysterious rider's horse.

Two angels accompany the rider and move threateningly toward the minister. The presence of these two celestial figures is indicative of how God himself intervenes to defend the temple.

301

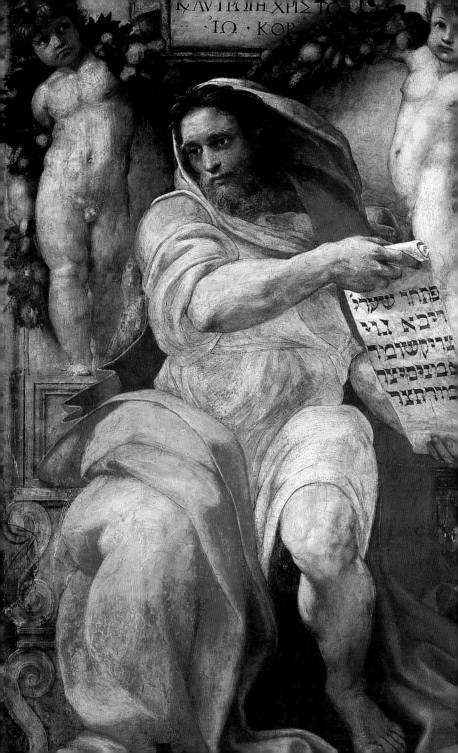

WISE MEN AND PROPHETS

Job
Elijah
Isaiah
Jeremiah
Ezekiel
Daniel
Daniel in the Lions' Den
Belshazzar's Feast
Susanna and the Elders
Jonah and the Whale

Raphael, *Isaiah*, 1513.
ome, Sant'Agostino.

Bruges School
.minators, *The Israelites
.seech God to Send the
.ssiah*, late fifteenth
.ntury. Miniature from the
.imani Breviary. Venice,
.blioteca Marciana.

Job is a just man who, despite his misfortunes, does not set himself against the will of God. The adventures of this wise man sum up the entire question of human suffering.

Job

The Place
Uz, an unknown
place located
between Edom
and Arabia, east
of Palestine

The Time
Around 1500 B.C.

The Sources
The Book of Job

Attributes
Typically represented
as an elderly man
with a white beard,
covered only by a
loincloth and seated
on a pile of manure.
Sometimes he holds a
musical instrument,
which points to his
love for musicians.

**Diffusion of
the Image**
Broad, particularly
episodes that
portray the suffer-
ings inflicted on Job,
either as a prefigure-
ment of Christ's
suffering or as a
saint invoked
against the plague

A rich and respected man named Job lives with his numerous family in the land of Uz. He behaves in a manner that is upright and respectful of the will of God. Nevertheless, a controversy arises between God and Satan about the motivations for Job's piety. According to the tempting angel, Job's devotion is due to the fact that the Lord has given him riches and health. For this reason Satan, with divine permission, decides to put Job to the test, barraging him with every sort of misfortune. Satan kills first his cattle and servants and then his children, and finally Job himself is struck by "loathsome sores from the sole of his foot to the crown of his head," forcing him to scratch himself with potsherds as he sits on a heap of ashes. His wife advises him to curse God and wishes him death, while his friends admonish him to accept the divine will as punishment for his sins. In the end, God heals Job and gives him back twice as much as he previously had.

▶ William Blake, *The Complaint of Job*, ca. 1786. San Francisco, Fine Arts Museums.



Job's wife does not understand the meaning of the suffering imposed on him by God. She insults him, saying, "Do you still hold fast your integrity? Curse God, and die."

Job is stricken by a horrible malady in which his body is covered with sores. He is shown naked, sitting on a stool, as he turns his astonished gaze toward his wife.

The figure of his wife, wi[th] candle in hand and a w[hite] handkerchief on her he[ad] towers over the sick [man]

A fragment of broken pot[tery] at Job's feet is the tool he [uses] to scratch his body, whic[h is] struck by "loathsome sore[s"]

▲ Georges de La Tour, *Job Being Mocked by His Wife*, 1632–35. Épinal, Musée Départemental des Vosges.

▶ Jean Fouquet, *Job on His Dungheap*, 1450. Miniature from the *Hours of Etienne Chevalier*. Chantilly, Musée Condé.

ob and his friends hold different opinions as Job is tormented by
a dilemma: How can he, who has always lived in an upright way,
deserve such suffering? Can God possibly have made a mistake?
In the end, Job is able to find some justification for what has
befallen him. He realizes that the reason for his pain is so that he
may arrive at a more complete communion with God.

The three figures shown at the right are
Eliphaz the Temanite, Bildad the Shuhite,
and Zophar the Naamathite. These are Job's
three friends, who, after pitying and consol-
ing him for his misfortunes, accuse him of
having committed a sin. They tell him that
as a result he deserves divine punishment.

After being insulted
by his wife, Job is
portrayed lying on a
pile of manure.

The representation of the
manure pile derives from
the Septuagint through the
Vulgate. The Hebrew text,
in fact, says only that Job
sits among the ashes.

The three friends express the typical
human attitude toward God and an
existential problem. Since God is all-
powerful and omniscient, when a man
is struck by suffering it must mean that
he has sinned.

Job's wife pours water
over his body to alleviate
the pain from the sores.

Job appears in a state
of deep suffering.

Despite the weight of the trials that he
endures, Job never rebels but submits
patiently to God's will.

▲ Albrecht Dürer, *Job and
His Wife*, 1503. Frankfurt,
Städelsches Kunstinstitut.

This episode portrays the triumph of Job, who in the end is rewarded by God with twice the amount of goods he previously had.

The figure of Job occurs in Christian art of every era, beginning in the Roman catacombs, where he is shown as prefiguring the sufferings of Christ.

The name "Job" derives from a Hebrew term that means "someone persecuted who bears adversities," and, in fact, he became one of the saints who was invoked against the plague.

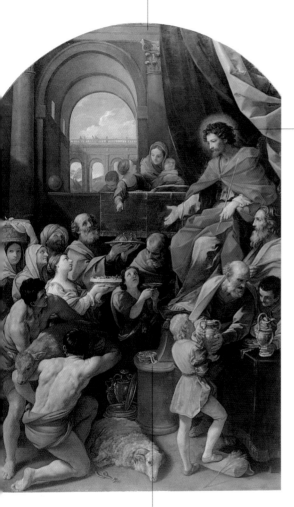

Job's numerous family and friends are shown around him, offering gifts.

Guido Reni, *The Triumph of Job*, 1636.
ris, Nôtre-Dame.

The prophet Elijah struggled victoriously against the spread of the cult of Baal during the reign of King Ahab in Israel. His adventures are illustrated in the sacred art of all periods.

Elijah

The Place
A native of Gilead, Elijah lives in the kingdom of Israel.

The Time
He lived during the reign of King Ahab of Israel (876–854 B.C.) and died during that of Ahaziah (854–853 B.C.).

The Sources
1 Kings 17,
2 Kings 1–2

Attributes
The raven, the wheel of the fiery chariot that brings him to Heaven, clothes of animal skins, and sometimes the white mantle of the Carmelites

Diffusion of the Image
Widespread, especially the episodes of Elijah fed by a raven and an angel. Some have seen St. John the Baptist as his reincarnation. The episode of Elijah ascending in the fiery chariot has been seen as representing the Resurrection.

▶ Bernardino Luini, *Elijah and the Angel*, 1521. Milan, Museo della Scienza e della Tecnica (on loan from Brera).

In the first half of the ninth century B.C., the king of Israel, Ahab, marries the Phoenician Jezebel and converts to the worship of Baal. Elijah assails his idolatry and announces three years of drought. During the ensuing famine, the prophet himself suffers from hunger despite being fed by ravens at the stream of Cherith. Fleeing toward the city of Zarephath, he meets a widow gathering wood to prepare a last meal for herself and her son. He asks her for food and tells her that her scanty food reserves will not run out before it begins to rain again. Later the woman's son dies, and Elijah, calling upon God, restores him to life.

After challenging the priests of Baal on Mount Carmel, the prophet convinces the people to kill all idolatrous priests. In the wake of Elijah's activities, Queen Jezebel threatens him with death. Fearing for his life, he flees into the wilderness opposite the Sinai Peninsula. There an angel brings him food and urges him to continue on to Mount Horeb.

An angel appears in the wilderness and gives Elijah food and drink. Regaining his strength, he continues his journey for another forty days.

Entering the wilderness to flee Queen Jezebel's death threats, Elijah feels close to death and lies down under a juniper bush.

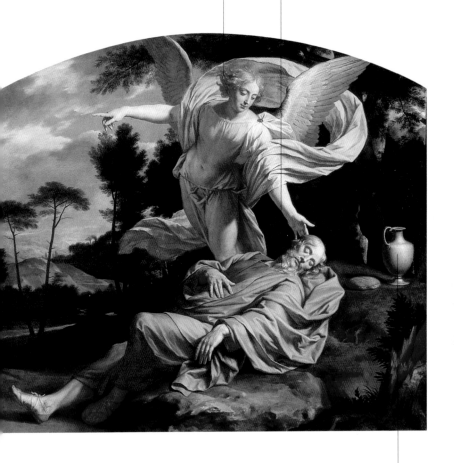

Phillippe de Champaigne,
Elijah in the Desert, 1656–62.
Le Mans, Musée de Tessé.

In depictions of this subject, the angel brings the prophet bread and a chalice, which are symbols of the Eucharist.

Elijah

The angel comes to the aid of Elijah, who has fallen asleep in the wilderness opposite the Sinai Peninsula.

The name "Elijah" means "Yahweh is God."

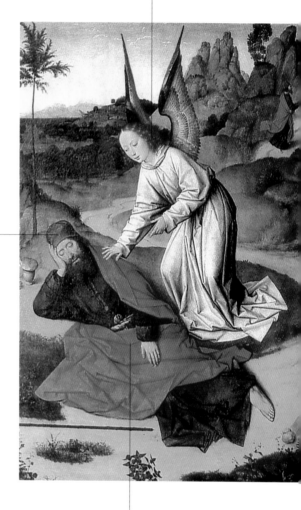

It is said that the prophet lived for periods of time in the caves of Mount Carmel and, in fact, Elijah is considered the founder of the Carmelite order. Because of this, he is often portrayed beside the Virgin Mary in Carmelite churches.

▲ Dieric Bouts, *Elijah in the Desert*, 1464–68. Detail from the *Last Supper* polyptych. Louvain, Saint-Pierre.

Ravens nourish St. Paul the
Hermit, St. Anthony Abbot,
and other hermits in the
desert in the same way.

According to the biblical text,
"the ravens brought him bread
and meat in the morning, and
bread and meat in the evening;
and he drank from the brook."

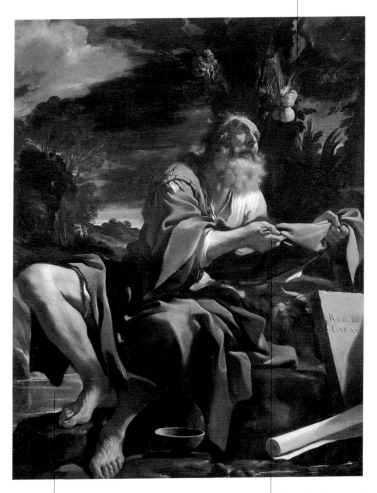

The Lord orders Elijah to go to the stream of
Cherith, which is located just before the Jordan
River. There he drinks from its waters while
ravens bring him food.

The prophet is portrayed
on the banks of a stream
as a raven brings food in
its beak.

Giovanni Francesco Guercino,
Elijah Fed by Ravens, 1620.
London, National Gallery.

Elijah

Elijah meets a
woman and asks her
for some water and a
tiny piece of bread.

The woman, who is preparing
a last meal for herself and her
son, offers the prophet what he
asks for.

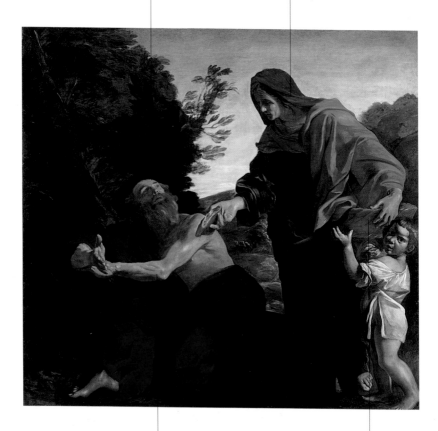

Eventually, the stream from
which Elijah draws water dries
up, and the prophet, following
the Lord's commands, goes to
Zarephath, a foreign city on
the sea.

The prophet tells the woman that her
reserves of oil and flour will not run out
before it begins to rain again, saying, "The
jar of meal shall not be spent, and the
cruse of oil shall not fail, until the day that
the Lord sends rain upon the earth."

▲ Giovanni Lanfranco, *Elijah
Receiving Bread from the Widow of
Zarephath*, 1621–24. Los Angeles,
J. Paul Getty Museum.

▶ Joan Gascó, *Isaiah*,
1499. Barcelona, Museu
d'Art de Cataluña.

Considered the first of the four "major prophets" (together with Jeremiah, Ezekiel, and Daniel), Isaiah is often present in iconographic depictions of the Old Testament.

The prophet Isaiah experienced firsthand the tragic events between 735 and 701 B.C., which saw Assyrian power assert itself and dominate the entire Middle Eastern world. Isaiah in particular had relations with the sovereigns Jotham, Ahaz, and Hezekiah, who followed each other in leading the kingdom of Judaea after King Uzziah's death.

Isaiah

The presence of Isaiah within diverse sacred-art depictions is due, above all, to two of his prophecies. The first, "Behold, a young woman shall conceive and bear a son, and shall call his name Immanuel" (Isaiah 7:14), a name which means "God with us." In artistic representations, this prophecy is often written on a scroll held by the prophet. According to St. Bernard, the book from which the Virgin Mary reads in depictions of the Annunciation quotes this famous prophecy of Isaiah. His iconographic attribute—the scroll bearing the words of the biblical passage—derives from this episode.

His second prophecy, "There shall come forth a shoot from the stump of Jesse" (Isaiah 11:1), gave rise to the iconographic subject of the Tree of Jesse, in which the prophets Isaiah and Jeremiah often appear as well.

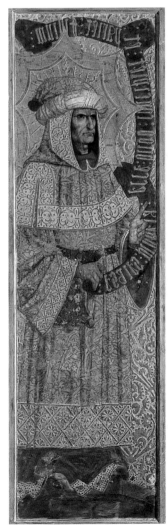

The Place
Jerusalem, the capital of the kingdom of Judaea

The Time
In the second half of the eighth century B.C., between the year of the death of King Uzziah (between 742 and 736 B.C.) and 701 B.C.

The Sources
2 Kings 18–20, the Book of Isaiah

Attributes
A book, a scroll bearing the text that tells of a virgin who will give birth to a son, a flowering branch, sometimes a burning coal, or a saw that, according to a nonbiblical tradition, was the instrument used to torture him

Diffusion of the Image
Quite widespread, especially in Gothic sculpture, in depictions of the Last Judgment, the Coronation of the Virgin, and the Tree of Jesse

Isaiah

Isaiah's hair, long beard of striated locks, and
undulating garments give the figure a new
dynamism with respect to the Romanesque style.

Isaiah is shown standing with
a scroll in hand. According to
some, this work shows the
moment when God calls the
prophet.

The scroll, or rotolus, is a
roll of parchment or paper
that in iconography often
stands for a book as an
attribute of an author or
a prophet.

▲ *The Prophet Isaiah*, 1120–35.
Relief from the interior west wall.
Souillac, the former church of the
Abbey of Saint-Marie.

The second of the "major prophets," Jeremiah was persecuted and imprisoned because of his prophecies and, to his great sorrow, witnessed the fall of Jerusalem.

Jeremiah

Living about seventy-five years after Isaiah, Jeremiah became a prophet during the reign of Josiah, a time of profound corruption and moral decadence.

After receiving his calling, Jeremiah begins to dictate his prophecies to his friend Baruch. Imprisoned and freed a number of times because his prophecies are judged too pessimistic, Jeremiah is saved and freed by an Ethiopian eunuch. In 587–586 B.C. he watches the fall of Jerusalem at the hands of the Babylonians and is welcomed favorably by their sovereign, Nebuchadnezzar. Abducted by Jews in flight toward Egypt, Jeremiah dies at an unknown location.

The prophet is often portrayed afflicted by pain at the destruction of Jerusalem.

According to tradition, Jeremiah wrote the biblical book of Lamentations during the siege of Jerusalem. The inscriptions that so often occur in the prophet's iconography are taken from this text.

The Place
Jerusalem and Egypt

The Time
Between 628 and 583 B.C., during the reign of Josiah

The Sources
The Book of Jeremiah

Attributes
An elderly appearance and a beard, a book or scroll, and an iron staff or a boiling pot of water, which allude to his prophecies of future misfortunes

Diffusion of the Image
Broad, especially as an isolated figure in a deeply meditative pose due to the tragic events of his time, and within the iconography of the Tree of Jesse

Moretto da Brescia (Alessandro Bonvicino), *The Prophet Jeremiah*, ca. 1550. Milan, Castello Sforzesco, Civiche Raccolte d'Arte.

Jeremiah

Other books appear on
the shelf in the upper
part of the niche.

Jeremiah is
shown reading
a book, which
is his principal
attribute.

The prophet
inserted within
nich.

▲ Barthélemy d'Eyck, *The Prophet
Jeremiah*, 1443–45. Brussels,
Musées royaux des beaux-arts.

The city of Jerusalem appears in flames in the background at the left. People flee and a winged figure rises above the fire.

The prophet wears a rich, fur-lined garment and leans his elbow on a large book, upon which the letters "BiBeL" can be read.

Jeremiah is shown in the foreground at the foot of a great column. He leans his head on one hand, lamenting Jerusalem's destruction.

After three years of siege, Jerusalem was conquered and burned by the Babylonians between 587 and 586 B.C. The prophet Jeremiah, who was in prison at the time, was freed by the city's conquerors and watched Jerusalem burn.

One of the prophecies told by Jeremiah was concerned precisely with the fall of Jerusalem.

▲ Rembrandt Harmensz van Rijn, Jeremiah Mourns the Destruction of Jerusalem, 1630. Amsterdam, Rijksmuseum.

One of the four "major prophets," Ezekiel is taken as a prisoner to Babylon, where he lives in exile for nearly twenty-two years. His visions are often illustrated in Christian art.

Ezekiel

The Place
Jerusalem and
Babylon

The Time
During the exile in
Babylon, where he
was brought in
597 B.C.

The Sources
The Book of Ezekiel

Attributes
A winged double
wheel, which refers
to the vision he
saw at his calling.
Generally he is pre-
sented as an elderly
man with a white
beard and he is
often portrayed
with inscriptions
taken from his
book.

**Diffusion of
the Image**
Quite widespread,
whether as the
single figure of
prophet or in
relation to two
episodes of his life:
the vision of his
calling and the
vision of the
resurrection of
the bones

▶ Benedetto Antelami,
Ezekiel, 1214–18.
Fidenza, cathedral.

The son of Buzi, a priest in the line of Zadok, Ezekiel is raised on the teachings of Jeremiah. After four winged beings with multiple faces appear to him in the vision of his prophetic calling, he is charged by God to speak in the name of the exiles. During a first deportation that occurred during the reign of Jehoiakim in 597 B.C., ten years before the fall of Jerusalem, the prophet is brought in exile to Babylon. As a result, he does not witness Jerusalem's fall.

During the Babylonian exile, Ezekiel has various apocalyptic visions by the river Chebar. In the first, he sees a field covered

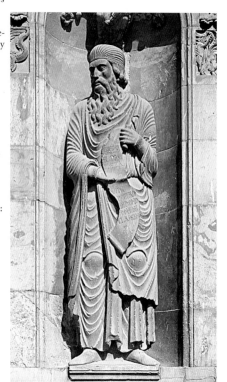

with bones, which he resurrects and, by invoking the spirit, transforms into a powerful army. In the same way, God explains to the prophet that he will restore life to the house of Israel so that it returns to its homeland. In another vision, one of the gates of Jerusalem closes, since no man will be able to pass through it after the passage of God.

Ezekiel died in Babylon some decades later.

The biblical text reads: "As I looked, behold, a stormy wind came out of the north, and a great cloud, with brightness round about it, and fire flashing forth continually, and in the midst of the fire, as it were gleaming bronze. And from the midst of it came the likeness of four living creatures. And this was their appearance: they had the form of men, but each had four faces, and each of them had four wings."

The prophetic calling of Ezekiel reveals itself through a vision of God on a throne, encircled by four creatures with faces of various appearances (man, lion, bull, and eagle), all of which have wings.

Raphael, *The Vision of Ezekiel*, 1516. Florence, Palazzo Pitti.

These are tetramorphs, the four-sided creatures described by Ezekiel in the story of his vision.

Based on an association that St. Jerome pointed out, these four figures were used as symbols for the four evangelists, indicating Matthew (the man), Mark (the lion), Luke (the bull), and John (the eagle), respectively.

This painting is an allegorical portrayal of a plain filled with bones. At the divine command they reassemble, giving new life to the people.

The bones, which have been transformed into a large army, signify God's resurrection of the house of Israel, which can then be led back to its homeland.

God says to the bones: "Behold, I will cause breath to enter you and you shall live. And I will lay sinews upon you, and will cause flesh to come upon you, and cover you with skin, and put breath in you, and you shall live."

▲ Francisco Collantes, *The Vision of Ezekiel*, 1630. Madrid, Museo del Prado.

This motif has been interpreted as prefiguring the resurrection of the dead on Judgment Day, and it sometimes appears in depictions of the Last Judgment.

The life of Daniel, the fourth of the "major prophets," is enriched with numerous legendary elements that have frequently inspired the iconography of sacred art.

Daniel

Born into a noble family, Daniel is deported as a prisoner by King Nebuchadnezzar to Babylon, where he enters into the service of the court. Educated so that he will be able to hold high office in the state, he distinguishes himself for his interpretations of dreams and assumes an important role in governing the city. Then in 538 B.C. the Persians, headed by Cyrus (600–529 B.C.), conquer and destroy Babylon. During the years the prophet spends in the court of Nebuchadnezzar, he stays faithful to Judaic law, making many enemies for himself as a result.

The Book of Daniel presents additions that were not accepted by Jews and Protestants, and as a result these are not included in all editions of the Bible. These parts, which are called "deuterocanonical" and are accepted by Roman Catholics, include a number of passages that became the subjects of many iconographic representations: the song of the three young men in the furnace; the story of Susanna; that of Daniel and Cyrus in the temple of Bel; and, within the episode of Daniel in the lions' den, the appearance of the prophet Habakkuk.

The Place
Babylon

The Time
During the period of Babylonian exile (586–538 B.C.)

The Sources
The Book of Daniel, and deuterocanonical additions to the Book of Daniel

Attributes
A ram with two horns, a characteristically Jewish pointed hat, a cartouche, or a written scroll. Generally he is shown as a beardless young man wearing a short garment.

Diffusion of the Image
Widespread, especially certain episodes such as Daniel in the lions' den, Belshazzar's feast, Daniel's rescue of the innocent Susanna, and Daniel and Cyrus in the temple of Bel

◄ Moretto da Brescia (Alessandro Bonvicino), *The Prophet Daniel*, ca. 1150. Brescia, San Giovanni.

When he is named governor, Daniel provokes the envy of the satraps, who through trickery have him condemned to death in a lions' den. Nevertheless, the prophet emerges unharmed.

Daniel in the Lions' Den

The Place
Babylon

The Time
Under the Persian
king Darius
(522–486 B.C.)

The Figures
Daniel and lions

The Sources
Daniel 6, and the
apocryphal additions
to the Book of Daniel
(Daniel 14:23–42)

Variants
Accompanied by an
angel, the prophet
Habakkuk is often
portrayed bringing
Daniel food and
water.

**Diffusion of
the Image**
Broad, especially
within medieval
and seventeenth-
century
iconography

▶ Jacopo Guarana,
*Daniel in the Lions'
Den*, 1757. Udine,
Museo Civico.

The Persian king Darius installs three high officials, including Daniel, to direct his kingdom. Thereafter he decides to entrust the entire government to the prophet. This causes the other officials, and the satraps under them, to be envious. The satraps, hoping to find a reason to accuse Daniel, make Darius approve a religious decree. According to this law, those who pray to any god or man who is not the king in the next thirty days are to be thrown into a den of lions.

Despite this edict, Daniel continues to pray three times a day to his God as usual, and his detractors accuse him of not having respected the prohibition. Reluctantly, King Darius has him thrown into a lions' den, but he wishes him well: "May your God, whom you serve continually, deliver you!" The next day, the king rushes to check on Daniel's condition and finds him untouched. Rejoicing, he frees him from the den and has the slanderers thrown in, together with their wives and children. Although God saved the prophet, the beasts devour the others immediately.

An angel leads Habakkuk, who is
unfamiliar with Babylon, to the spot
where he can find the den.

The angel has been identified as the
archangel Michael.

The apocryphal text tells how an
angel leads the prophet Habakkuk
by the hair to the exact place
where the lions' den is located.
Habakkuk brings Daniel a basket
containing food and water.

Daniel recognizes the prophet
Habakkuk's gesture as a sign
that God has not forsaken him.

Daniel is portrayed with only a
piece of burlap to cover him,
shut inside a den of lions.

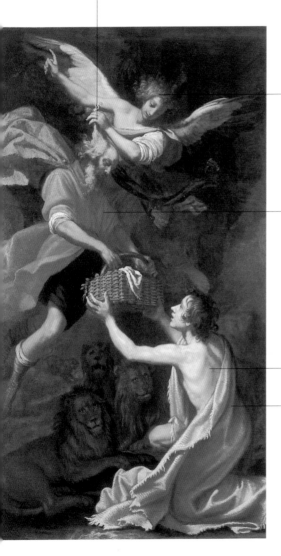

▲ Giovanni Bilivert, *An Angel Leads Habakkuk
to Feed Daniel in the Lions' Den*, 1618. From a
series of paintings in the Cathedral Tribune.
Pisa, cathedral.

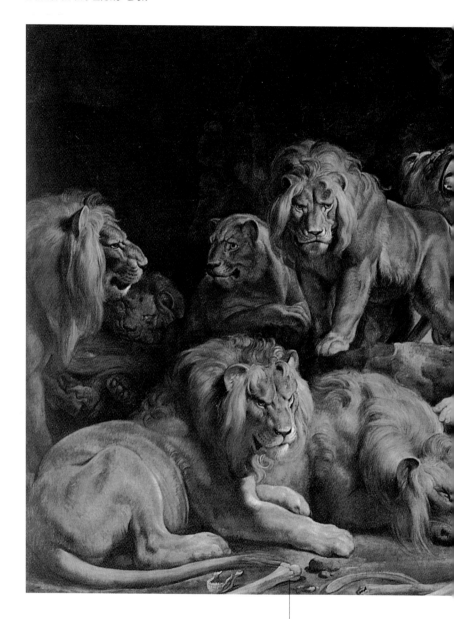

*The skull and bones in the fore-
ground are visible demonstrations
of what happens to any flesh
thrown to the ravenous lions.*

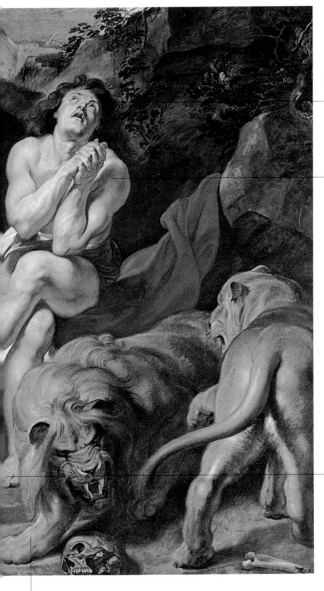

Daniel is shut in the lions' den for having continued to worship his God three times a day. He is clothed only in a piece of cloth as he prays to the Lord.

The apocryphal text, however, tells how the prophet is thrown into the lions' den for having caused the death of a dragon revered by the Babylonians. He had given it a meal of cakes made of pitch, fat, and hair.

In the apocryphal version, Daniel is put in the lions' den, where he remains for six days. On the seventh day, finding him alive, the king proclaims the greatness of Daniel's God.

The lions, which have been portrayed with great naturalism, seem not to notice Daniel's presence. Indeed, despite being famished, they do not even approach the prophet.

▲ Peter Paul Rubens, *Daniel in the Lions' Den*, ca. 1613–15. Washington, D.C., National Gallery of Art.

Daniel in the Lions' Den

The tale of Cain killing Abel is shown in the frame above to point out that human ferocity can exceed that of animals.

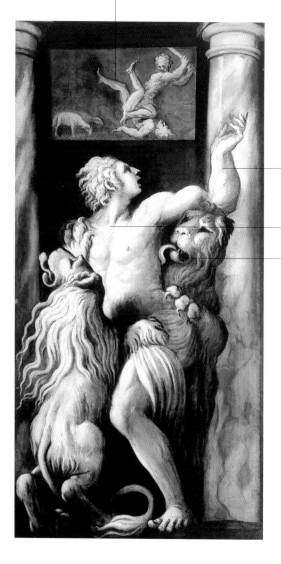

Daniel is shown standing in a vertical space that is bounded by two columns. Two lions nuzzle him.

Daniel is also seen as the incarnation of justice.

The biblical text tells how God sends Daniel an angel to close the lions' mouths, since the prophet is innocent in his eyes. In this depiction the lions seem to even lick the prophet.

◄ Andrea Schiavone,
Daniel in the Lions' Den,
1532. Venice, San Giacomo
dell'Orio.

As happened to Joseph in Egypt, Daniel becomes an influential member of the Babylonian court thanks to his special gift for interpreting dreams.

Belshazzar's Feast

Belshazzar, the son of Nebuchadnezzar and the last sovereign of Babylon, has a banquet prepared, which the men of his court, their wives, and their concubines attend. At one point, while drunk, Belshazzar has silver and gold vessels that his father stole from the temple of Solomon in Jerusalem brought in to use as tableware. Suddenly a mysterious hand appears among the guests and writes letters on the wall that none of the king's wise men are able to read or understand. The frightened Belshazzar sends for the wise Daniel to interpret the mysterious text. The prophet reads the words *mene, tekel, parsin,* or "measured, weighed, divided," and explains their meaning: "*Mene,* God has numbered the days of your kingdom and brought it to an end; *Tekel,* you have been weighed in the balances and found wanting; *Peres,* your kingdom is divided and given to the Medes and Persians." These words foretell the fall of Babylon and the death of the king.

That same night Belshazzar is killed and the Persian king Darius seizes his kingdom.

The Place
Babylon

The Time
Under the rule of Belshazzar, between 553 and 539 B.C.

The Figures
Belshazzar, the men of his court, their wives and concubines, wise men, and Daniel

The Sources
Daniel 5

Variants
The Banquet of Belshazzar

Diffusion of the Image
Fairly widespread. In the Baroque period a special emphasis was laid on portraying the pomp of the court. In Christian art, the figure of Belshazzar represents the Antichrist or paganism.

◀ Jusepe de Ribera, *Belshazzar's Vision,* 1650. Milan, Quadreria Arcivescovile.

Belshazzar's Feast

Belshazzar is portrayed in a cloak of splendid brocade, with a royal crown placed on top of a typically oriental headdress

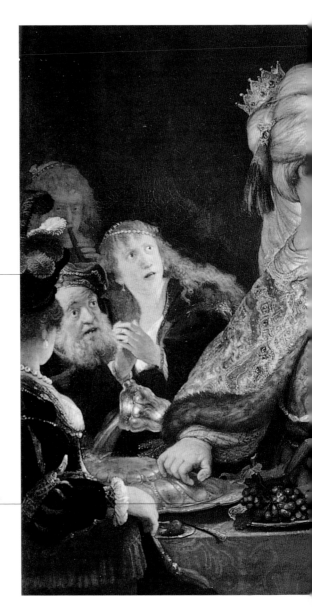

Belshazzar's dignitaries and their wives and concubines, all elegantly dressed, witness the extraordinary apparition and are astonished.

This episode shows a banquet organized by Belshazzar, king of Babylon, during the siege of the city by the Persian general Cyrus.

► Rembrandt Harmensz. van Rijn, *Belshazzar's Feast*, ca. 1635. London, National Gallery.

Only the prophet Daniel, who is eventually called to solve the puzzle, is able to decipher the meaning of the mysterious letters: mene, tekel, parsin, or "measured, weighed, divided."

Daniel explains their meaning: "Mene, God has numbered the days of your kingdom and brought it to an end; Tekel, you have been weighed in the balances and found wanting; Peres, your kingdom is divided and given to the Medes and Persians."

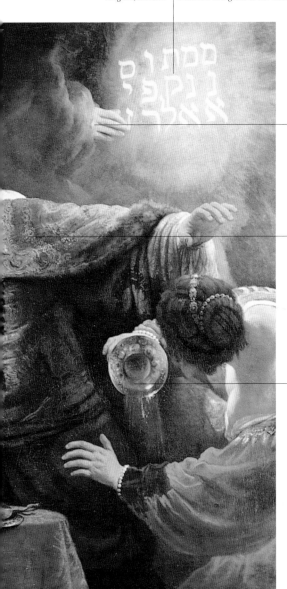

A mysterious hand traces an illegible inscription on the wall of the room.

That same night, Belshazzar is killed and Darius the Persian takes over his kingdom.

For the occasion of this reception, the inebriated Belshazzar brings out the sacred gold and silver plates that his father, Nebuchadnezzar, had pillaged from the temple of Jerusalem, for use as tableware.

Belshazzar's Feast

The numerous guests at the banquet organized by Belshazzar turn in dismay when the mysterious letters appear.

Laid upon the vast table are the gold and silver vessels that Nebuchadnezzar stole from the temple of Jerusalem.

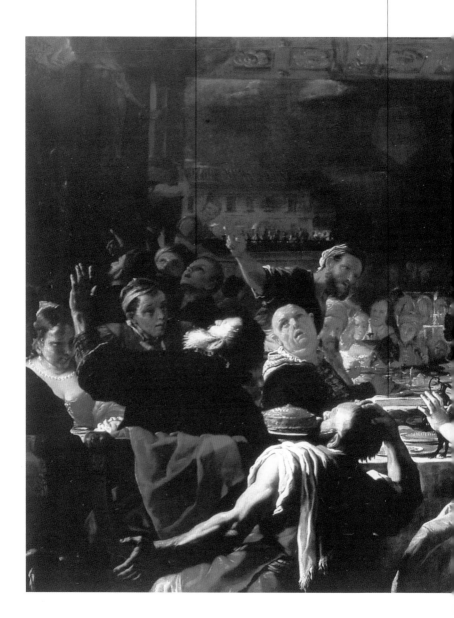

This episode, like others narrated in the first part of the Book of Daniel, has no historical foundation. Rather it was written in the second century A.D., to give strength to the Hebrew people. In a period characterized by harsh persecutions, examples taken from the Jewish people's past history helped them to endure their hardships.

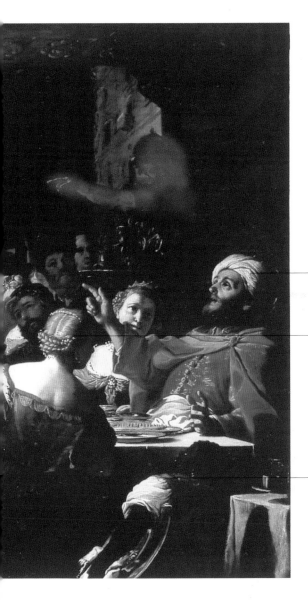

Belshazzar seems to be spell-bound at the appearance of the writing, which none of his wise men are able to read.

Particular attention has been given to depicting the clothing and hairstyles of the wives and concubines who have been invited to the banquet.

Mattia Preti emphasizes the event's dramatic power and uniqueness by using strong contrasts of light and shadow.

◄ Mattia Preti, *Belshazzar's Feast*, 1658. Naples, Capodimonte.

This often-depicted subject was variously used to symbolize the
threatened Church or the triumph of innocence. Sometimes it
was simply an opportunity to portray a female nude.

Susanna and the Elders

The Place
Babylon

The Time
During the
Babylonian exile,
586–538 B.C.

The Figures
Susanna, maid-
servants, two elders,
and Daniel

The Sources
The apocryphal
additions to the
Book of Daniel
(Daniel 13:1–64)

Variants
Susanna bathing;
Susanna before the
judges; Daniel
defending Susanna

**Diffusion of
the Image**
Quite widespread,
from catacomb
paintings through
the Renaissance to
the present day

Among the Hebrews exiled in Babylon is a man named Joakim
who marries Susanna, a beautiful woman educated according
to the Law of Moses. The Jews often assemble in the house of
the wealthy Joakim to discuss juridical questions before two
elders. One day, after everyone has taken their leave, Susanna
walks in the garden with her two maidservants. Since it is very
hot, she decides to bathe. She orders the maidservants to bring
oil and ointments and to close the garden door.

The two elders, who for some time have lusted after Susanna,
spy on her in her bath. They approach and demand that she lie
with them, threatening that they will denounce her for commit-
ting adultery with a young man if she doesn't submit.

Susanna indignantly rejects the two elders, who then swear
publicly that they caught her in the act with a young man. The
assembly, believing the two men's version of events, condemns
her to death, and she prays to the Lord. Daniel then intervenes

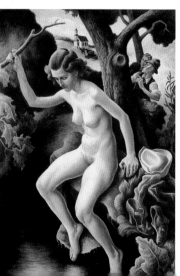

and challenges the accusers' testi-
monies, making them speak sepa-
rately. Since their versions of
events are contradictory, the two
men are unmasked as liars and
stoned to death.

▶ Thomas Hart
Benton, *Susanna and
the Elders*, 1938.
Private collection.

▶ Albrecht Altdorfer, *Susan*
Bathing, 1526. Munich, A
Pinakothe

Susanna sends a maidservant to close the door of the garden so that she can care for her body in peace.

In Altdorfer's composition, a great deal of space has been devoted to the scene's setting, especially the ornate building that must represent the house of Susanna's husband, Joakim.

The house of Joakim, an exiled Jew in Babylon, has become a meeting place for numerous Israelites.

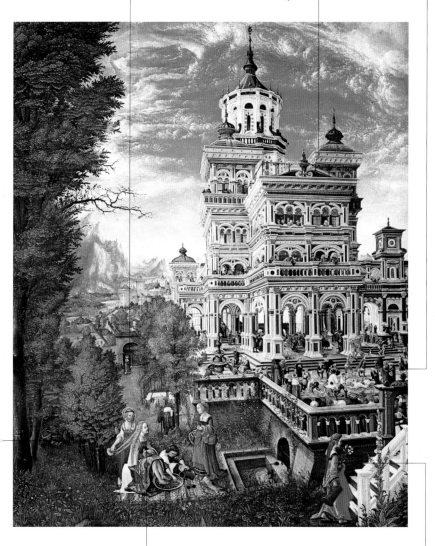

he two elders hide themselves nder the leafy branches of the rees in order to admire the eautiful girl from close by.

Joakim's wife Susanna is shown washing, aided by her maidservants.

Another maidservant is shown walking away holding a pitcher and a bunch of lilies, which symbolize Susanna's purity and chastity.

A hedge of roses acts as a barrier between the beautiful, chaste Susanna and the two elders, who are intent on spying on her from either end of the leafy curtain. Their lively colored garments are symbols of vanity.

The chromatic contrast between Susanna's naked body and the figures of the two elders further accentuates the characters' psychological and moral opposition.

Next to the female figure, Tintoretto gathers numerou articles that allude to Susanna's chastity and purity int a sort of still life: a basin of water, a comb, a pea necklace, a jar of ointment, a mirror, and a white cloth

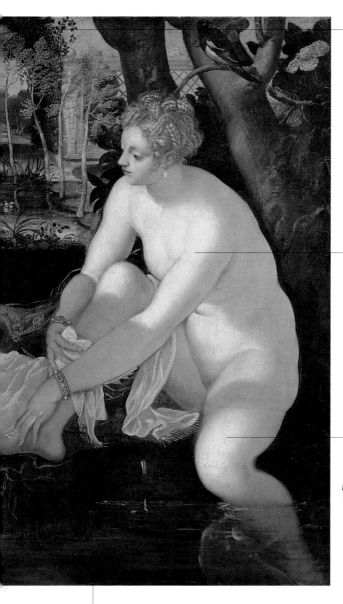

The landscape becomes a fundamental element of the composition; it is delineated meticulously in every detail and expresses the serene calm with which Susanna devotes herself to her toilet. Flourishing, unspoiled nature adapts well to the lyric moment rendered here.

Susanna's naked figure dominates the scene as she admires herself in the mirror, pleased at her own beauty. The girl's hair is gathered in a complex series of braids, allowing the pearl earring that illuminates her face to be seen.

Susanna is peacefully focused on her toilet, believing herself protected in her intimacy. Her figure, characterized by a luminous complexion, stands out against the dark background of the landscape.

Tintoretto's painting conveys a quiet and serene atmosphere. The artist, in fact, meant to represent the moment immediately preceding the two elders' assault.

▲ Jacopo Tintoretto, *Susanna and the Elders*, 1555–56. Vienna, Kunsthistorisches Museum.

Susanna and the Elders

The artist portrays the moment in which the two elders approach the beautiful Susanna, threatening to harass her.

The two men are shown they collude on how convince her to give in their advance

The young woman, who the biblical text describ as being educated accor ing to the Mosaic La turns away as the tw men molest her. H naked body is position on the edge of the po where she is washin

The scene, which is free any secondary elements, is s near a pool in which one Susanna's feet is immerse

▲ Artemesia Gentileschi, *Susanna and the Elders*, 1610. Pommersfelden, Schönborn Collection.

► Lorenzo Lotto, *Susanna and the Elders*, 1517. Florence, Galleria degli Uffi

Lorenzo Lotto takes great care with the landscape in which the scene is set. In particular, the church, the well with ducklings, and the enclosure of the garden adorned with rose bushes deserve mention.

The principal episode is shown in Susanna's bathroom, where the young woman washes herself.

Susanna is shown nude in her bathroom, defending herself from the false accusation that she had been meeting a young man there.

Failing in their attempt to seduce her, the two men call their servants so that they can give witness publicly to the offense of which they accuse Susanna.

Susanna and the Elders

After turning and praying to the Lord, Susanna receives help from the prophet Daniel.

Adultery was punishable by death. Since the assembly believed the testimony of the two elders, this would have been Susanna's fate.

The deuterocanonical text describes Susanna as "a very beautiful woman and one who fear the Lord."

Daniel intervenes and makes the two men testify separately. By telling different versions of the facts, they contradict each other, and their deceit is unmasked.

The subject of Daniel defending Susanna diffused broadly, especially during the Middle Ages, when the story of Susanna and the elders was seen as a symbol of the Church threatened by paganism.

In Hebrew the name "Susanna" means "lily" and denotes her purit

The story of Susanna and the triumph of her virtue have been illustrated in Christian art ever since the times of the Roman catacombs. Indeed, she was seen as a legendary heroine whose innocence triumphed over the wickedness of men.

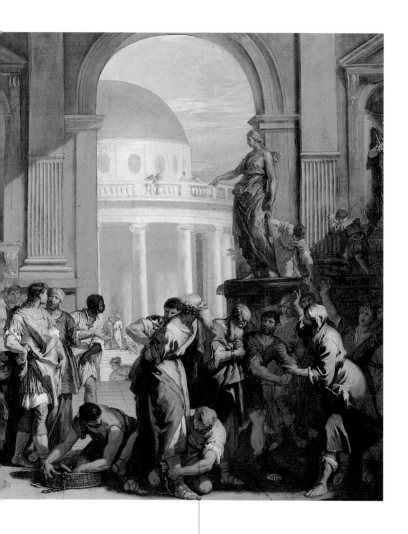

The two elders are chained and taken away.

Sebastiano Ricci, *Susanna before Daniel*, 1724. Turin, Galleria Sabauda.

The episode most commonly portrayed from Jonah's life is his adventure in the belly of a "whale," a subject often associated with the death and resurrection of Christ.

Jonah and the Whale

The Place
On the sea journey between Joppa and Tarshish

The Time
Eighth century B.C.

The Figures
Jonah, the crew, the whale, and other fish

The Sources
The Book of Jonah

Variants
Jonah being cast into the sea and swallowed by the whale; Jonah being cast back on land

Diffusion of the Image
Broad, especially for those episodes relating to the adventure with the whale, which were seen as prefiguring the death and resurrection of Christ. The evangelist Matthew (12:40) narrates that Jesus himself, who remains in the tomb for three days just as Jonah does in the belly of the whale, refers to the story of Jonah.

▶ Giotto, *Jonah Swallowed by the Whale*, 1304. Padua, Scrovegni Chapel.

When God charges Jonah with converting the pagans of the feared Assyrian capital of Nineveh, Jonah decides to flee and embarks on a ship at Joppa toward the distant Tarshish. To punish him, God unleashes a storm that puts the ship in danger, and when Jonah confesses to the members of the crew that he is the cause of their misfortunes, he is cast into the sea.

Swallowed by a "large fish," the prophet repents to the Lord, raises a heartfelt prayer, and is cast back onto the beach unharmed three days later.

Then God orders Jonah yet again to go to Nineveh. As soon as he reaches it, the prophet proclaims the imminent destruction of the city. Nineveh is spared, however, when the inhabitants and their king convert and ask God's forgiveness. Annoyed that his prophecy did not come to pass, Jonah sits outside the city. God causes a castor-oil plant to grow over him to give him shade, but a worm eats into it, and it withers. The Lord then explains to Jonah, who is angry once again: "You pity the plant . . . and should not I pity Nineveh, that great city, in which there are more than a hundred and twenty thousand persons . . . and also much cattle?"

After being thrown into the sea by
his traveling companions, Jonah is
swallowed by a whale. It later spits
him out onto a beach, unharmed.

The fish that spits out Jonah
is generally depicted as a
whale. Only rarely does it
present features of a dolphin
or hippocampus, a mythical
creature of classical origin
with the foreparts of a horse
and the backparts of a fish.

The various phases of the
story of Jonah are here set
in an imaginative seascape.
It features an extraordinary
variety of fish, whose atti-
tudes of aggression and
flight may symbolize the
struggle that the Christians
still faced with the pagan
world at the time.

As Matthew narrates it,
Jesus himself refers to the
story of Jonah: "For as
Jonah was three days and
three nights in the belly of
the whale, so will the Son of
man be three days and three
nights in the heart of the
earth" (Matthew 12:40).

▲ Jonah Being Spit Out by the Whale and
Jonah Lying under an Arbor of Gourds,
early fourth century. Floor mosaics.
Aquileia, cathedral.

Jonah is shown naked, lying
under an arbor of gourds
that the Lord grew to shelter
him from the sun. Sometimes
he is shown bald, since he
loses his hair in the belly of
the whale.

Due to its symbolism,
the story of Jonah
appears especially in
ancient funerary art
and particularly on
Roman sarcophagi
and catacomb walls.

Appendixes

The Structure of the Old Testament

The Pentateuch

Genesis
Exodus
Leviticus
Numbers
Deuteronomy

Books of Wisdom and Poetry

Job
Psalms
Proverbs
Ecclesiastes
The Song of Solomon
The Wisdom of Solomon
Sirach

Historical Books

Joshua
Judges
Ruth
1 Samuel
2 Samuel
1 Kings
2 Kings
1 Chronicles
2 Chronicles
Ezra
Nehemiah
Tobit
Judith
Esther
1 Maccabees
2 Maccabees

Prophetic Books

Isaiah
Jeremiah
Lamentations
Baruch
Ezekiel
Daniel
Hosea
Joel
Amos
Obadiah
Jonah
Micah
Nahum
Habakkuk
Zephaniah
Haggai
Zechariah
Malachi

Index of Episodes

Index of Figures

This index does not include the name "God," which recurs throughout the entire volume (as do the many titles and attributes of God).

348

Index of Artists

Photography Credits

Agence Photographique de la Réunion des
 Musées Nationaux, Paris
Archivio Electa, Milan
Archivio fotografico dei Musei Capitolini, Rome
Archivio fotografico dei Musei Civici, Milan
Foto Scala, Florence
The J. Paul Getty Museum, Los Angeles
The National Gallery, London
The National Gallery of Art, Washington, D.C.
Szépmüvészeti Múzeum, Budapest
Veneranda Fabbrica del Duomo, Fototeca, Milan

By permission of the Ministero per i Beni e le Attivitá
 culturali:
Soprintendenza per il patrimonio storico artistico e
 demoetnoantropologico di Bergamo, Como,
 Lecco, Lodi, Milano, Pavia, Sondrio, Varese
Soprintendenza per il patrimonio storico artistico e
 demoetnoantropologico di Venezia

The publisher would also like to thank the many
photographic archives of museums and the public
and private entities that provided photographic
material.

St. Louis Community College
at Meramec
Library